To Mrs Ceeshing

[signature]

Nov. 04

REFLECTIONS FROM

THE SHINING BROW

MY YEARS WITH

FRANK LLOYD WRIGHT

AND

OLGIVANNA LAZOVICH

KAMAL AMIN

2004 · FITHIAN PRESS, SANTA BARBARA

Published by Fithian Press
A division of Daniel and Daniel, Publishers, Inc.
Post Office Box 2790
McKinleyville, CA 95519
www.danielpublishing.com

LIBRARY OF CONGRESS CATALOGING-IN-PUBLICATION DATA
Amin, Kamal, (date)
 Reflections from the Shining Brow : my years with Frank Lloyd Wright and
Olgivanna Lazovich / by Kamal Amin.
 p. cm.
 Includes bibliographical references.
 ISBN 1-56474-439-6 (cloth : alk. paper)
 1. Wright, Frank Lloyd, 1867–1959. 2. Wright, Olgivanna Lloyd.
3. Amin, Kamal, 1928– 4. Architects—United States—Biography. I. Title.
 NA737.W7A874 2004
 720'.92-DC22
 2004000216

*To a few souls who touched my life and
intensified my sense of being alive:*

Frank Lloyd Wright

Olgivanna Lazovich

Eve Lloyd

Pamela Hopkins

ACKNOWLEDGMENTS

During a casual lunch with my long-time friend Pamela Hopkins at a delicatessen in Phoenix, she interrupted the conversation: "Mrs. Wright came to me last night," she said.

It was 1993 and Olgivanna had been dead eight years. I asked: "What do you mean, Mrs. Wright came to you last night?"

That was not the first time Pamela came forth with such a statement. Two years earlier she had told me that my father, dead twenty years, had come through her, seeking to make amends with me about issues we had had between us during his life. She was always so earnest and sincere about those pronouncements that I began to take them seriously. "Mrs. Wright came through me to tell you that she wants you to write a book about her," Pamela said.

The thought had never occurred to me. But the incident echoed suggestions I had received from some of my friends who thought that I had an insight that could illuminate Olgivanna's complex character.

What I experienced during the following seven years until the year 2000, was Pamela's persistent questions, "Did you start writing? How are you doing with the book? How far are you in it now? Can I help you make a recording?"

A time came when I would avoid Pamela for fear of having to answer why I had not started writing.

During those years of hesitancy, I must have been subconsciously thinking, "What if I do write a book, where and how would I begin?"

After eight years of drop-by-drop prodding by Pamela, I eventually had a book project. Without Pamela this book would not have come into being. For that I will be eternally grateful.

Many thanks to my long-time friend, David Dodge, for his generous support and valuable friendship.

My deep thanks and gratitude to Roberta Binkley, a highly accomplished writer herself, for her generosity with her time, knowledge and experience. That was the key to illuminating my direction toward this finished product.

Thanks to my long-time friends, Vern and Cille Swaback, for their generous support and insightful comments and their encouragement.

Thanks to Gail Larric for her editorial assistance.

Thanks to the late Professor Ali Seireg, a long-time friend and a published writer, for his moral support and for his intelligent remarks and advice.

Thanks to my long-time friends Earl Nisbet, Michael Sutton, and Gerry Willner for their confidence and encouragement.

I should also mention that in order to respect their privacy I have changed the names of a few people mentioned in Chapter 20 of this book. The views I express about the controversial people I encountered and the extraordinary experiences I had during my years at Taliesin are drawn from my own subjective memories, and others' memories may differ.

CONTENTS

A section of photographs follows page 112

REFLECTIONS FROM THE SHINING BROW

INTRODUCTION

In the late 1940s, while I was an architectural student at the University of Cairo fantasizing about postgraduate education in a foreign land, Switzerland was the country I most seriously considered. America never seemed like an option. It was too far from Egypt. No one I knew had ever been there. An uninformed notion in popular public discourse suggested that Americans had no sophistication, no history, and no culture.

As an Egyptian, with scant knowledge of the English language, I had not read Thomas Jefferson's letter to John Adams of October 28, 1813, in which he defined natural aristocracy as an attribute of the American spirit, thus asserting a uniquely American culture. As I learned more about America, this concept has dominated my belief system for fifty years.

In Cairo one day in the winter of 1948, I happened upon the work of Frank Lloyd Wright. During the few days that followed, I learned more about Wright, most important that he was still alive and that he accepted young people as apprentices. I decided that wherever Wright lived was where I would go, which was, I learned, in the United States.

~

Three years later I was a member in good standing of the Taliesin Fellowship, the community Wright had established in 1932 to receive his apprentices. Taliesin is a Welsh word meaning "shining brow."

I had traveled to America intending to stay one year with Wright, then move to Switzerland or Germany to obtain a Ph.D. in hospital

design. After that, I planned to return to Egypt and found an architectural practice specializing in that discipline. My father was a physician and this plan seemed to make sense at the time. What awaited me, however, was unexpected and eventually proved life-transforming.

The energy field generated by Wright's genius and his persona engulfed me, my thoughts, my senses and rendered the mere notion of leaving him unthinkable. He looked to me as the personification of something great and exciting. Inhaling that energy every day only made me hunger for more. By the time he died eight years later, I had become a fixture in the community. I was encouraged by his wife to remain in America and start my citizenship papers. I had not intended to live permanently in America, but a sense of mission following the death of my teacher and mentor prevailed. I reordered my priorities. Fifty-two years later, here I am.

While Wright surpassed my expectations, the true revelation was Olgivanna, the imperious, powerful, controlling third wife of the great architect.

Over the following year or two, I came to realize that she was the originator and organizer behind the Taliesin community. I began to see that without her neither I, nor anyone else, would have had the closeness to Mr. Wright that we all enjoyed.

When Olgivanna migrated to America, she already had the general parameters for an agenda that she would seek to implement in her new homeland. She was a Montenegrin of aristocratic birth. She had been educated in Russia. But the most significant event in her life before she left Europe was her meeting with George Ivanovitch Gurdjieff, who became her teacher and mentor. His followers, Olgivanna among them, traveled with him to Turkey, Berlin, and then to Paris, where they settled into a chateau Gurdjieff had bought near Paris, where he established the Institute for the Harmonious Development of Man. The Institute was a community, some of whose members were people of note. They lived together at the chateau, where Gurdjieff inspired and directed an intense program aimed at inducing self-awareness. He provided all the

components of a complete life within the boundaries of the chateau and its two-hundred-acre grounds.

At the Institute, the Work, as Gurdjieff defined it, included building, cleaning, cooking, maintenance, caring for livestock. Very long days, beginning before dawn and ending near midnight, included dance exercises, meditation, and discussion, all under the vigilant eyes of Gurdjieff, who was intensely aware of every detail of the goings on.

I learned these facts over the first few years I was at Taliesin, as I observed Olgivanna work with the Taliesin community as a group or as individuals. I realized that she was, in fact, duplicating the community in which she had lived with Gurdjieff. With a few devoted followers, she developed a shadow organization, which became centered on her and her private program. Young people who were attracted to an architectural apprenticeship under the master were individuals who, potentially, could become pupils to Olgivanna and the Gurdjieff teachings.

Some of us, including me, were excited by the unexpected activity she was introducing in our lives. I found no contradiction between what she was advocating and the declared principles of organic architecture. At their best, her ideas were intended to promote awareness, hard work, dedication, improvement of quality of work, perseverance, and other enhancements of personal qualities. She advocated renunciation of vanity, ambition, envy, jealousy, and other negative emotions, and she encouraged love and forgiveness. She became intensely interesting to me as I observed the complex overlapping of her advocacy pronouncements on one hand and her personal human qualities on the other.

Olgivanna spoke with me many times about the inner Work she had done to develop strengths where weaknesses had existed. That Work came to her aid as she held herself intact during the devastation after her daughter and her grandchildren were killed in a car accident.

The seven deadly sins, however, were not too far removed from her makeup. She had a predilection for total control. She used all available means to achieve her objectives, including convoluted manipulation and

coercion. Sometimes I thought her inner Work helped her to further hone her abilities to maintain control.

Many who joined the Fellowship were not disposed to her brand of teaching, and they resisted it, but Olgivanna had the power and she did not hesitate to use it, sometimes ruthlessly. Many resented the arm-twisting she exercised on a regular basis. They were often branded as unfit to remain in the community.

My relationship with Olgivanna spanned thirty-four years. Twenty-six of those years I was a member of the community she initiated. I had close contact with her on a daily basis. For me, she became a teacher who had unerring survival instincts accompanied by wisdom borne out of tough-minded pursuit of difficult-to-reach goals.

Much of what I experienced after I left the community remained rooted in the lessons I learned in associating with her.

I believed in her ideas and exercised them with enthusiasm. But I never lost sight of the occasional invasion to which her lower instincts subjected her ideological texture. We had bitter conflicts over a number of wide-ranging issues, from office policy to something as personal as her granddaughter. We were always careful not to tear the fabric from which the relationship was made. We would get to the brink and stop just before the fall.

Power can become a seductive circumstance that invites excesses. This tendency marked the years that followed. Olgivanna manipulated the lives of a number of individuals, often with successful results for all parties. But sometimes her efforts backfired, as she once told me, and brought the whole project to the edge of disaster.

CHAPTER 1

THE CHAPEL

> *Architecture is that great living creative spirit which*
> *from generation to generation, from age to age, proceeds,*
> *persists, creates, according to the nature of man, and his*
> *circumstances as they change. That is architecture.*
> —*Frank Lloyd Wright*

ON A HOT, HUMID AUGUST MORNING in 1959 the fields near Spring
Green were intensely green, with sharp shadows of great oaks and tall
evergreens among the rolling hills of Southern Wisconsin. Moisture
hung heavy overhead and the air was still and dense. The sun boiled the
humidity into steam. With numbing consistency, the locust communi-
cated its presence. The atmosphere of the family cemetery seemed eerie
as I observed the many graves, some of which were more than a century
old. They were the graves of the Welsh clan of Lloyd Jones, ancestors of
Frank Lloyd Wright on his mother's side. The clan had settled that val-
ley by the Wisconsin River in the early 1800s.

I was kneeling by the flowers we had planted around Mr. Wright's
grave when I heard the familiar sound of golf-cart wheels rolling over
the gravel on County Road "C," which runs by the cemetery. It was a
sound I had heard nearly every day as I worked around the flowers,
mowed the lawn, or watered the plants from a well that I had installed
earlier in the spring. I knew who had arrived on the golf-cart—Olgivan-
na Lazovich Wright, the recently widowed third wife of Frank Lloyd

17

Wright, who came to the cemetery every day to visit her dead husband's grave. She brought with her an air of resolute and magnificent grief.

I had been to the cemetery on occasion over the preceding few years as I visited the family chapel designed in 1866 by Chicago architect J.L. Silsbee. Silsbee was the first employer of Frank Lloyd Wright after Wright left the University of Wisconsin at Madison. Before finishing his education, Wright set out to seek his fortune in Chicago. Occasional services were still held in the old cemetery.

On this August day, being among the graves was different. Today I was working as I had for the preceding three months tending to the grave of Frank Lloyd Wright, who had died in Phoenix, Arizona on April 9. He was buried in a rectangular plot surrounded by a circle of stones. The shape of the circle left a space on each side of the rectangle with enough room for two more graves: "One for me and the other for Iovanna," Olgivanna had said.

I was one of a few of the Taliesin Fellowship who worked with Olgivanna to organize matters at the graveside. We did not have a traditional headstone. Instead, we hiked around the hills looking for a rock appropriate to the man and his strong connection with that countryside. It was a few days before we found a weathered and rugged limestone four-and-a-half feet long and one–and-a-half feet wide, with a point on one side. We placed it with the point down doweled into a concrete base at the head of the grave. On the middle section of the grave, we placed a two-foot by one-foot open iron design that had been created by Mr. Wright many years earlier. Integrated into the ironwork were the words "Love of an idea is love of God."

On Saturday, April 4, 1959, Mr. Wright had been at my desk in the drafting room in Arizona. He was working on what came to be known as The Donahoe Triptych, a spectacular residence he had designed for Mrs. Daniel Donahoe of Texas. It comprised three main parts to be built on three adjacent peaks on Mummy Mountain in Paradise Valley, Arizona. The various parts of the building were to be connected with decorative arched bridges. Mr. Wright had already signed off on the de-

sign drawings on March 28, just a week before. But in vintage Frank Lloyd Wright tradition, designs are completed only when the building has been constructed.

About noon, Olgivanna breezed in to announce that it was time for lunch. In a few minutes, Mr. Wright left with her.

↩

On Saturday, the Taliesin Fellowship met for its weekly formal evening, and we waited outside the theater for the Wrights to arrive around seven o'clock, as we always did. The wait was longer than we were used to. Then someone came to inform us that Mr. Wright had been taken to the hospital to be operated on for an intestinal block. Apparently, he had been in terrible pain the whole afternoon.

I was not sure what to think. He was almost ninety-two years old but he was very healthy. I could not imagine life without him. So I chose to think that he would be back in full force in a few days. But a few days later, a close friend, Allen Davison, walked a quarter mile across the desert to my tent at 5 A.M. I had just awakened. He said, "Mr. Wright is gone."

Mr. Wright's death affected me deeply. After eight years with him I felt an inconsolable sense of loss. When he lay in state in the living room at Taliesin West, I remember sitting on a chair near him until sometime in the early morning when one of the members, a friend of mine, put his hand gently on my shoulder, brought me back from my waking dream, and suggested that I go to bed.

When Olgivanna became aware of my intense sense of loss, she asked me to tend his grave. When I heard the sound of the vehicle on the gravel that summer morning, I stood up and walked across the lawn to greet her. She gave me a quick glance and walked to the stone circle. I followed and we both knelt and began our daily routine of pulling dead or dying blossoms in order to preserve energy for new growth. We exchanged no words. I heard only an occasional deep sigh.

Suddenly Olgivanna pointed to a small wide-leaf weed and said, "Watch out for the poison ivy."

I looked at the weed. It did resemble poison ivy. Olgivanna knew it was not poison ivy, but she wanted to know if I knew. I said, as I reached for the weed and pulled it out, "This is not poison ivy, Mrs. Wright."

She did not reply. But I could sense that she was satisfied that I was learning my Taliesin lessons. It struck me that in the depth of her grief she still had the sense of purpose to pursue her teaching.

DOUMYAT

> *The space within becomes the reality of the building.*
> —*Frank Lloyd Wright*

I WAS BORN IN MY MATERNAL GRANDPARENTS' house in Doumyat, an old, historically significant port on the Mediterranean Sea on the northeast coast of Egypt. It was near there in 1249 that the seventh and last wave of the crusaders under the leadership of Louis IX met with a crushing defeat by an Egyptian army organized by the budding Memluk dynasty. The demise of the French army marked the end of the crusades. It led to the capture and imprisonment of Louis IX. He was later released for ransom. It also helped establish the new Memluk dynasty that would rule Egypt and the Middle East for the following 300 years.

The Sultan of Turkey gave my great-grandfather, who was of Turkish origin, a large land grant in northeast Egypt. This land remained in the family, though at a diminished scale, throughout my mother's life.

At the time I was born, both my maternal grandparents were living. My grandfather had an autocratic Turkish attitude and demeanor: tall, pink-faced, with a white handlebar moustache. He wore a red *fez* and a white silk robe that went down to his ankles. He spent much of his time in the downstairs quarters near the main entry to his large house, where he met with farmers and business people in the process of managing his vast lands. I still have fond memories of that house, which has since been torn down and four apartment buildings built where it once stood.

21

My grandparents lived on the upstairs level of the big house, and we visited for long summers every year. To reach their level, we climbed one of two symmetrically placed grand staircases. That level was a large complex that included 32 rooms arranged around an enormous hall, with a tiled floor and a wood ceiling covered with paintings by Italian artists. My grandmother often pointed out to me the room where I was born.

The upstairs hall was large enough for us to race our bicycles when we grew a bit older. It extended onto a balcony, which looked over a lush garden where grapes, peaches, mangos and figs grew. Servants' quarters occupied a separate wing of the house. The largest room was reserved for "Dada Sabah," an elderly black woman who was treated with deference by everyone. She had brought up my mother and all the aunts and uncles.

What remains pleasantly vivid in my memory about those summers was the femininity that permeated the environment surrounding my childhood and my young years. My mother was the eldest of four sisters, so there were three aunts for me to play with. They all came from their married homes in different parts of the country to spend those long summers together. At age seven, I was sent several times a week to a nearby convent, where the nuns taught me French. My three uncles lived elsewhere. The oldest of them was a physician who died before his time, when I was eleven years old. He accidentally pricked his finger with a syringe carrying the infected blood of a typhoid patient. Immediately after that my grandmother went to bed, where she stayed until she was carried out to her grave ten months later. She had died of intense grief.

My father, who was a physician, never joined us in Doumyat. Besides the in-laws phenomenon that had a way of keeping a distance between the families of the spouses, he needed to spend his summers tending to his medical practice. He had built a large house in a town near Cairo, where he had his practice. We lived on the top level, his practice was on the lower level. At that level he also had a pharmacy

where he prepared some of his prescriptions. We saw him every day. He came up for the main meal of the day about 2 P.M. I remember the smell of chloroform every time he sat at the table.

I was emotionally dependent on my father in my early years. On some level I would have preferred to stay with him, rather than to spend the summers in Doumyat. But as I look back on him now, I become acutely aware of an oppressive presence that I tried to avoid at all costs when I became older.

I am not sure when my feeling of dependency changed to a feeling of resentment. All I know is that at about age six I developed a stutter that has plagued me all my life. I believe that a combination of anger and fear translated into a hesitancy of expression that stunted the flow of my speech.

My father was a strict disciplinarian. My favorite uncle, his youngest brother, once told me that their father was particularly hard on my father.

When I was 12, he made me read a monthly publication called *Social Affairs*, which dealt with contemporary social issues. He would discuss it with me to make sure that I did read it. Later in life I became grateful for that experience.

My father was also a bright, productive man with strong character and insight. He made a great deal of money, acquired a number of farms and established a prominent presence socially and professionally.

He was a complex man. In spite of being self-centered, he had an ability to extend himself to be of help in a crisis.

In the summer of 1947, British soldiers who had landed in some of the eastern ports as they arrived from India brought a cholera epidemic to Egypt. My father volunteered his services.

He received a letter dated December 20, 1947 from Princess Fawzia, sister of King Farouk. She would later become the wife of Mohamed Reza Pahlavi, Shah of Iran. It was an eloquently grateful letter thanking my father for "the great effort" he had made in vaccinating the public during the crisis. But I believe that a sense of security, which comes with

mass sentiment, imprisoned his perceptions about life, people and situations. A worn-out social institution dictated to him his role as a father, a man, a professional and a husband, never allowing his natural impulses to come to the surface. Nor did he ever have the chance or inclination to discover those impulses under the thick layers of "musts" and "shoulds".

My mother was emotionally remote. I have no clear memory of ever going to her seeking comfort. What lingers on is the image of a preoccupied woman. She was either tending to house duties or exchanging visits with her many friends.

She was only eighteen years older than I was. She was married at seventeen and I was her first born. My father was twice her age. He had been married before he married my mother. That was a secret I learned when I grew much older. In the society in which I grew up, secrets were an addiction that afflicted every one. But tragedy struck when my father's first wife, whom I was told he loved very much, and their two children died in an epidemic which had occurred in the twenties near Cairo, where he practiced medicine.

The help he received from family and friends in order to cope with overwhelming emptiness included an arranged marriage to my mother, who was living in her large family house in Doumyat. There were distant family ties between both sides.

The most valuable lesson my mother taught me was dogged optimism. Whatever she started, she felt would eventually come to fruition.

She only knew Arabic with a few words left over from a long gone acquaintance with French. But every time she started to speak with my American friends, she would start speaking in Arabic, assured somehow that something would happen to facilitate the communication. Something usually did.

On one of my trips to Cairo, I accompanied her to the doctor where she was being treated for rheumatoid arthritis. The doctor had started a protocol of injecting Novocain in her knees. In the waiting room, another patient, who had been through that protocol, described

to my mother her own experience, concluding that that method did not work. My mother said, "But it will work for me." For the following half-hour she resisted every form of discouragement thrown at her. This experience never left me.

FINDING MR. WRIGHT

> *The mother of art is architecture. Without architecture*
> *of our own we have no soul of our own.*
> —*Frank Lloyd Wright.*

THREE YEARS BEFORE I MET MR. WRIGHT, I was at the library of the American Embassy Cultural Center in Cairo. I was looking through a book called *The City* by Eliel Saarinen. I came across two small plans in black ink. They were the plans for the two-level Robie House, a 1906 residence in south Chicago. The caption below said, "Architect, Frank Lloyd Wright." It was the first time I had seen his name and it was, for me, the beginning of a long and varied journey.

The unusual feature about the plans that attracted my attention was that they looked beautiful and exciting as abstract line designs before looking at their spatial function. I was a third-year architectural student at the University of Cairo and I had been looking at plans of all shapes and sizes. I was disillusioned by what I had seen.

We had disinterested educators who regularly referred us to foreign magazines to look at and learn what was happening in the world. A notable example was a French publication called *L'architecture d'Aujourdhui*, or *The Architecture of Today*. I could see nothing but banal sameness. Everything looked alike. I could never see what had qualified those arbitrary, loosely connected forms to be singled out for publication.

The Robie House plans had everything that the others did not.

26

They had purpose and integrity. Soon after I saw those plans, I began looking for anything about or by Wright. I did not know whether he was still living. There were no books about him in the Embassy library.

As I thought about it later, I was astounded that the cultural center of an American Embassy had nothing to offer about a towering figure of its culture. Much later, in the nineties, I gave as a gift to the Embassy Cultural Center a book and a video on Mr. Wright.

Eventually I discovered an Egyptian practicing architect, Mahmoud Omar, who had spent some time with Wright in the States. When I saw Mahmoud at his office the day after my discovery, he showed me several publications that contained Wright's work, particularly *In the Nature of Materials* by Henry-Russell Hitchcock. It was an astounding world that I did not know and could not imagine existed. I could not believe that a living human had the imagination and force to design such buildings, and I immediately and without plan began to wonder what I was going to do with my life.

I was an active youth of nineteen. I had a restless and probing mind, and I had changed my major from physics to architecture. I was passionately engaged in the tumultuous debate that was raging in Cairo in the late forties. The revolution that, in 1952, ousted King Farouk and brought Nasser and his revolutionary officers to power was brewing to the point of boiling over. I was the target of numerous energetic efforts for recruitment in the various ideologies that proliferated in Egypt after the war. During the preamble to that event, the emotional pitch was compelling.

Although I was seeking an intellectual purpose beyond the immediate anguish of Egypt, it was impossible not to become identified with the day-to-day activities that were taking place underground, as well as above. My inner goal was deeply felt but it had an undefined shape. It was not associated with the revolution. I was subconsciously seeking answers to inner yearnings that would bring repose to my life. I was not easily swayed by demagoguery from the right or from the left.

Most of my close friends were deeply involved in the underground

organizations and cell structures around the city. Some of them went to prison for brief times and wore the experience like badges of honor. My closest friend was on the executive board of a radical militant party called "Young Egypt" after Kamal Attaturk's "Young Turkey." He tried hard to persuade me to join, without success. Yet I never enjoyed so much for so long the company of someone with whom I disagreed on everything. He and I were almost genetically on the opposite side of every issue. In music, he liked the native sound; I enjoyed classical music. In women, he was attracted to young teenage girls, and mature women excited me. His political persuasion leaned to the left; mine leaned to the right. He believed that social reform can be accomplished only by altering the complexion of the political system, and I believed that reform is a uniquely individual conversion that takes place within. He was a member of an organization; I was the ultimate loner.

During my university years in the forties, I was writing for a magazine called *The Daughter of the Nile*. It was the banner for the women's movement and it was owned and published by the woman who had founded the women's political party. My writings were mostly about accomplished women such as Eleanor Roosevelt, Vija Lakshmi Pundit, sister of Jawahalal Nehru and the first Indian ambassador to the United Nations. I also wrote about the women in the life of Bernard Shaw, including his intellectual affair with Ellen Terry and his frequent *rendezvous* at the Library of London with the daughter of Karl Marx.

I had a half-dozen close friends of divergent backgrounds with whom I spent most of my time. One was in medicine, another in law. A third was a young woman, an *avant-garde* artist, who later became a force in the artistic movement in Egypt and sold a number of her paintings to American actor Vincent Price. Yet another was in the government-sponsored radio industry and later became the Walter Cronkite of Egypt after television took hold. Together we had chipped in to rent an apartment in a quiet neighborhood in Cairo across the Nile from downtown. We all needed to avoid the probing gaze of our families.

Among our activities was a meeting we had once a week on a liter-

REFLECTIONS FROM THE SHINING BROW

ary quest. One of us would outline a book he or she had read and initiate a discussion about the subject matter. Some of the books I read and discussed were *The Trial* by Franz Kafka, *Les Mouchs* by Jean-Paul Sartre, and *The Interpretation of Dreams* by Sigmund Freud. Some read from the classics; others read material pertinent to the contemporary scene.

One time, we were joined by a prominent Communist who, despite a long-term prison sentence, had escaped while under medical care. Through one of my friends, who was a communist sympathizer, he found his way to our apartment, where he hid for ten months before he was whisked out of the country with a false passport. Our Cairo apartment was a setting that helped promote privacy, camaraderie, and intellectual pursuits as well as the pleasures of the night, copiously offered by this intensely interesting city.

For the remaining two years in architectural school, I conducted a crusade aimed at challenging the simplistic manner in which architecture was being taught and encouraging the study of Frank Lloyd Wright, who was not even a part of the curriculum. This did not endear me to academia. My professors were practicing architects of note. They were producing work that was both banal and expensive, having staked their careers on simplistic formulas that had originated around the turn of the twentieth century and were later reiterated by the Bauhaus, founded in 1919. The founder of that school, Walter Gropius, whom I later met in Berlin, had according to Hans Wingler's *The Bauhaus* written a memorandum in April 1910 to Berlin industrialist Emil Rathenau. That document was titled "Artistic Uniformity as a Prerequisite for Style," in which Gropius wrote in part:

> A convention in the best sense of the word cannot be
> hoped for by emphasizing individuality. It results rather
> from the achievement of an integration that will develop
> from the rhythm of repetition and from the uniformity of
> proven and recurring forms...

This sentiment eventually gave the machine the opportunity to become the form giver of modern times; hence, the deadly sameness that covers our urban existence.

The mere mention of Wright's name had a disquieting effect on the smug contentment my professors had fashioned for themselves. A city planning professor, who had taken a liking to me, told me at graduation, in good humor, "We graduated you to get rid of you. You were ruining the department."

CHAPTER 4

CAIRO TO PHOENIX

> *Organic buildings are the strength and lightness of the*
> *Spiders' spinning, buildings qualified by light, bred by*
> *native character to environment, married to the ground.*
> —*Frank Lloyd Wright*

As I LOOK BACK ON IT YEARS LATER, I see that my discovery of Frank Lloyd Wright was the turning point in my life. It was like delineating the deeper truth I had been seeking, which had eluded my young years. Clearly Wright's architecture answered the professional question. But more significant was Wright's uncompromising dedication to an idea. His work and thought ignited my own capacity for love and dedication. It gave me a deep and true cause for which to work and along which I could fashion my path. It was an evolution that came to me at the young age of nineteen and continues undiminished in the autumn of my life. It awakened in me capacities I never knew I had and opened vistas I never knew existed. Suddenly everything was possible. Barriers looked self-made and self-imposed. A world was waiting for me to explore, and it seemed inevitable that I would work with Frank Lloyd Wright.

By the time I was graduated in June 1951, I had made up my mind to join Wright. I had learned from my new friend Mahmoud Omar that Wright had founded a fellowship for young people to learn architecture by training under him in his office. He called it Taliesin. During Mah-

moud's couple of years at Taliesin, he had found it to be an enlightening experience, particularly because of the proximity to genius.

I began writing to Mr. Wright as soon as I was graduated, asking to join his group. In my first letter I enumerated my qualifications, which included a bachelor's degree in architecture from the University of Cairo. Much later after I had met him, I learned that he had a particular contempt for formal education, declaring that its superficiality and inherent constraints robbed a young person of a natural initiative. He used to say that a young person enters the university as a juicy plum and after a few years of formal education exits as a dried-up prune. I hoped that he had forgotten about my qualifications and never mentioned them again. For several months no response was forthcoming. But somehow I was sure that an answer would arrive in due course.

The wait for a response from Wright was the least of my problems. I had a few other formidable hurdles. To enter the United States I had to have a student visa. I was told by the cultural attaché at the United States Embassy that I could apply for a visa after I was accepted by a recognized educational institution. He further told me that Taliesin was not a recognized institution. It was discouraging but eventually proved not fatal to my plans. I asked the cultural attaché to give me the names of all recognized educational institutions in America. He obliged, and I set out to write each one of them a letter requesting to be enrolled in a postgraduate program if they offered one in architecture. Then I found myself in another period of waiting for that response. Eventually, I received a letter from Rensselaer Institute of Technology in New York accepting me in their post-graduate program.

The largest hurdle was my father. As the oldest of seven, all the associated expectations in a traditional society fell to me. Although I was dependent on him in the first few years of my life, the passage of time had managed to create between us a distance filled, as I grew older, with more and more hostility.

During all the years we shared we had never had a relationship. Nor had we ever had an intimate conversation about any aspect of my life.

At the time of graduation he had lost control over me and I had felt indifferent toward him. Yet formally I needed him to sanction my next move, if only to pay the passage fare. He could have eased my difficulty as I worked my way through the bureaucratic maze of the Egyptian government offices. But I did not ask him and he did not offer.

He had expressed his disapproval of my impending move, citing the folly of a qualified young man, who could be working in his profession, marching into the sunset to an unknown destination with undefined goals and uncertain results. He could not take seriously my intuitive impulse that this move was correct for me because it answered inner yearnings I needed answered if I were to build a wholesome life for myself. I could have been talking in Chinese. While most parents could always foist feelings of guilt on their children as a means of control, my father was a master at that art of parenting. This time, it did not work and he was forced to let me go.

Fifty years later, while visiting my brother Ismail in his home in Zurich, he said to me, "Fifteen years after you left for America, my father told me, 'Kamal might not be making money, but he is building a life'". At that moment I had to revise some of my early notions about my father.

One of the features of the Egyptian government's control over its citizens was what was called an "exit visa." I learned about that the hard way in 1951, when I first tried to come to the United States. To leave the country one had to get permission from Immigration. That office had to check the legitimacy of the reasons for your departure. A visa by the United States Embassy was a legitimate reason to exit and also to release a small amount of hard currency.

I was more than elated when I rushed to the American Embassy to apply for a visa. An inner voice rose in my chest asking me how I was going to reconcile my intention of going to Arizona to work with Mr. Wright with a visa that specified that I reside in New York. I answered the voice in Scarlett O'Hara style: *"I will think about that tomorrow."*

I justified in my mind that distorting the truth this time was accept-

able because my life depended on it. It had never occurred to me to go anywhere but Taliesin. In a most unbecoming manner, I simply ignored the invitation by Rensselaer. The American Embassy had given me a one-year student visa. After my first year at Taliesin, I would have to face the inevitable situation that I had placed on the back burner for that year.

All this administrative action went on while I was waiting for the letter of acceptance from Mr. Wright. Nothing arrived. But I had packed and was leaving anyway, over the strenuous objections of my father. Finally, three days before my departure, a letter arrived from Taliesin urging me to travel to Arizona. On October 26, 1951, I was on board a Linge Air Italienne plane to Rome, Shannon, Gander, and finally Washington, D.C.

When I went to book passage to Phoenix from Washington, the young lady at the travel agency in Washington suggested that I take the bus. The perception of distance in America is unfathomable to someone who comes from Egypt or Europe, where the longest travel distance averages three hours by train. I was told that my trip could take ten days, depending on the route she would map for me. She had suggested that I take the southern route so I could see the sites where historical events had taken place.

That suggestion would have meant a great deal more had she made it thirty years later, when my knowledge of American history had become wide, deep, and detailed. But a month after I arrived from Egypt, the only name I knew in American history was George Washington. I did not know the significance of any of the strange names she identified as she was mapping out my route. I certainly could not imagine Chattanooga as a name of a town, let alone singling it out as a place I must see.

Every day during the trip to Phoenix, the bus arrived at the predetermined destination in the evening after a long day trip. The towns where we stopped looked all alike and they all closed early. I found my way to the local YMCA where I spent the night. During the daily bus ride I encountered a number of fellow travelers who would initiate a

conversation. My knowledge of the English language was marginal and my understanding of southern English was even less. A pleasant man, apparently from Kentucky, talked to me extensively for the better part of a day about something that seemed important to him. The only word I understood was "Kentucky." When the bus arrived in Phoenix one evening in December, it was something of a relief.

Vladimir Ivanovic Lazovich, affectionately called "Uncle Vlado" by everyone, came from Taliesin to pick me up at the Luhrs Hotel in downtown Phoenix one late morning in December 1951. I had arrived from Washington by bus two days earlier and was unable to obtain from anyone I had asked any information as to the whereabouts of Taliesin. Nor could anyone give me a telephone number to contact someone, to alert Taliesin of my arrival. I took a room in a hotel within walking distance from the bus depot and wrote to Taliesin again.

&

Uncle Vlado's big voice, carrying his long and impressive name, had startled me as I answered the telephone at the hotel room that morning. I came down the stairs carrying my luggage to meet a large, pleasant man, probably in his late sixties, with a white moustache. He reminded me of some members of my family. Besides his big voice, he greeted me with a big laugh. I am not sure what he had expected an Egyptian to look like, but he said, "Are you sure you are not French?" That broke the ice. He was an older brother of Olgivanna's. We would have a rather close and pleasant relationship until his death in 1967. He lived at Taliesin and drove a truck thirty miles every day to Phoenix (the closest town with any urban conveniences) to pick up the mail and buy groceries.

After this initial encounter we had lunch at the San Carlos Hotel on Central Avenue in downtown Phoenix, where we consumed a number of Manhattans. He told me that Taliesin was located about thirty miles northeast of Phoenix on an isolated mountain slope, with no roads leading to it except for old rugged horse trails which generally needed four-wheel-drive vehicles to provide access.

He said that the location was too remote for the telephone company to provide services. The Taliesin office did not have a telephone (it eventually had one in 1957). Much later, I remember that Wesley Peters, Mr. Wright's right hand at the time, would drive fifteen miles to Scottsdale in order to make a telephone call. He would get into a telephone booth and try to open the extra large drawings of the Guggenheim Museum in the booth to refer to them as he spoke with the job supervisor.

During that pleasant lunch, Uncle Vlado filled me in on much that I did not know. He said that I was accepted in Arizona because I had arrived in December, during the time the Wrights and the Fellowship reside in their Arizona winter headquarters. Mr. Wright had founded his Fellowship enterprise in 1932 near Spring Green, Wisconsin. In 1927 he was invited to travel to the desert to help with the work on the Arizona Biltmore Hotel in Phoenix. In the process, he fell in love with the desert and in 1937 bought a section of land in the wilderness in northeast Phoenix. In 1938 he, with the Fellowship, began to drive down to Arizona every winter to build an office/home complex on that property. They called it "the camp," as opposed to the Wisconsin headquarters, which was home. The Fellowship spent the winters in Arizona and the summers in Wisconsin all the years I lived there.

Uncle Vlado and I drove in about four o'clock in the afternoon. The late afternoon winter sun had spread a golden cast on the magical display of forms and colors that constituted the headquarters of Frank Lloyd Wright's office and home complex.

I had seen photos of those buildings in Cairo before I left. But those were black-and-white photos. What I was looking at was another thing entirely. The buildings looked as though the colorful boulders that covered the desert floor had frozen, for a moment, into a series of abstract geometric masses in exotic attitudes. They were joined together by functional spaces enclosed with canvas and wood structures. It was not like anything I had ever seen. But its appeal was enormous. It was difficult to span the visual and emotional distance between what I was sensing at that moment and the place I had just arrived from in Egypt.

Eugene Masselink, the noted artist and long-time secretary of Frank Lloyd Wright, greeted me and took me on a quick tour of the complex. By the end of that tour I was virtually transported to another level of sensuality. I finally came to when a young man approached me in a businesslike fashion and told me that he was going to show me to my tent.

CHAPTER 5
A REALIZATION

> The heart is the chief feature of a functioning mind.
> —Frank Lloyd Wright

DURING THE LAST TWO-AND-A-HALF YEARS of my life in Egypt, when I was largely preoccupied with Frank Lloyd Wright, I had not known that he had a wife. It was not an issue and it never occurred to me to ask. No one volunteered the information. It was not long after I arrived at Taliesin that I became aware of the strong presence Olgivanna Lazovich Wright commanded.

In the first day or two as I wandered about trying to familiarize myself with the environment, quite a number of the fellows approached me and asked, "Have you seen Mrs. Wright yet?"

Every time, it sounded like that was the most important thing to do. At first I said that I had, thinking that Aunt Sophie, wife of Uncle Vlado, whom I had met with him when I first arrived, was indeed Olgivanna. My English, or the lack of it, was no help. But my thinking was straightened out one morning.

I was handed a paintbrush and asked to put white paint on the canvas ceiling in Gene Masselink's room. The room was located close to the Wrights' residence and it extended onto a generous terrace. I had been painting most of the morning with the white paint equally distributed between the canvas ceiling and my face when I heard the heavy door to the residence open and close.

I looked down from the ceiling to see a graceful woman in a flowing colorful dress that extended to the middle of her shins. She breezily swept by at an energetic pace and sat on one of the chairs on the terrace. She was an attractive woman with an interesting and distinctive face, probably in her fifties, with bright brown eyes. Her dark hair was arranged tightly around her face. It was parted in the middle with two small white swirls located tastefully, one at each side of the part over her forehead.

My supervisor said, "This is Kamal Amin, Mrs. Wright. He arrived two days ago."

So Mr. Wright has a wife, I thought, and this is she. She looked at me with a pleasant smile and a deep gaze, which I would experience many hundreds of times during the next thirty-four years. It was a characteristically focused look, as I realized later, that was intended to detect the disparity between what one was feeling and what one was saying.

Over the years I witnessed firsthand her unusual ability to discern a quality or the basic tendencies of a person by spending a mere few minutes with them in casual conversation. As it became clear to me later, that was the center of her work. She asked me how I was getting along, how I liked my tent, and if I were enjoying my work. Her questions were planned and deliberate. But I had a positive answer to all of them.

Two sensations took place in me simultaneously during that first encounter. On one level there was instant bonding. I felt she accepted me, and even liked me. I was also attracted to her and felt I could speak with her. On another level, I felt a faint hint of discomfort. Her focused gaze and deliberately designed conversation left me with some uncertainty.

When I arrived at Taliesin, Mr. Wright had been ailing for a few days. I was told he had shingles. I did not know what shingles were. But Saturday was only two days away. On Saturday, he and Olgivanna would join the group for a formal evening in the theater. Dinner would be served to us, and we would watch a movie. That first Saturday evening I stood with the others, waiting in anticipation to lay my eyes for the first time on the one person who had dominated my life in the

recent past. Mr. Wright walked in with Olgivanna a half step behind him. His white mane framed a strong, interesting face. He wore his famous cape on his shoulders over a dark suit. He looked at me warmly and asked me if I were settled and comfortable.

"Yes, sir," I said eagerly.

The days marched along briskly, turning into weeks and eventually into months. Egypt receded into a distant mirage. I did not miss anyone or anything there. My life was full of activities I could never have imagined.

According to Egyptian standards, I was supposed to have been a qualified architect who carried a license to practice architecture. But I had never held a hammer or a saw in my hand. Using tools was not a part of our education. Now, this was what I was doing all day long as I participated in building the yet-to-be-constructed parts of Taliesin West. At first I felt awkward and ignorant. But in time I was forming desert masonry walls, learning how to weld (which became a favorite activity of mine for many years), plumbing, finishing concrete, and practicing carpentry and many other building activities.

Mr. Wright's frequent visits to construction sites were the most exciting feature of that exercise. He would drop in, pointing his cane at various parts of the project to make suggestions, give instructions, and talk about design and building craft. He was always inventive and generous with his knowledge. He would point with his cane at a feature he had designed at the end of the wall and say, "Take care of your terminals and everything will take care of itself." He was extraordinarily handsome at eighty-four. He was healthy and he walked briskly, spoke with a strong voice without ambiguity, and made quick decisions about whatever was going on.

↜

I loved him and I could never view him as just another human being. He possessed a dimension that made him larger than life. Over time, I saw him in many different situations, and I have never been less than grateful and fascinated to exist within his energy field. The plans for the

Robie House that I had seen in the American Embassy Cultural Center in Cairo had a sense of order; every line and dimension had to be where it was to accomplish the integrity of the whole. The drawings were complete and they were noble. They were simple without being simplistic, like a multifaceted diamond: simple along each facet with the whole becoming a complexity of simple facets.

That is how I found Mr. Wright during the years I knew him. His views and actions at any given moment were unambiguous and disarmingly simple. Over time, however, as these expressions remained valid, they became multidimensional, eventually creating a kaleidoscopic whole of the man—brilliant, exciting, and unpredictable.

In time, what began to emerge slowly was the pervasive influence wielded by Olgivanna. In every aspect of life outside the drafting room, everyone deferred to her for direction. Whenever I asked a question, the answer would inevitably be preceded with the words, "Mrs. Wright said so-and-so." From the broad task assignments that appeared on the bulletin board every Monday morning to the smallest details of executing each assignment, instructions came directly from Olgivanna.

From the start, she had had a vision for the community—its ideology as well as its physical shape. That shape was very definite and it derived its animation from her. It was surprising and unexpected to discover the singular power Olgivanna had, considering that I had never known she existed. But her authority was not difficult for me to accept. I liked her, basically, and in time I began to glimpse her wisdom and her abilities and, most of all, her genuine interest in people.

She seemed to like talking with me and I enjoyed talking with her. She was like an elder family member, even a mother. Sometimes I would look for excuses to knock on the door of her room to go in and see her just to have a talk with her—maybe unconsciously to make sure that she still liked me. I could see that she was not particularly answering the questions I posed to her but trying to shape larger issues about my character. She couched her responses in a manner that looked as though she were answering my questions. I would sometimes ask her

about a love situation I had gotten myself into, and she would answer my questions in the context of the Work ethic.

Once I talked with Olgivanna about the ethics and morality of sexuality as it related to a young woman in Phoenix, with whom I had a relationship. She said, "Sexuality is the life force and it is an essential component in the human condition. But you can express it like insects meeting casually in the night, thus squandering this valuable energy. Or you can behave like a man. For this you need to be working toward being a complete person within. That means intense work on yourself. In terms of life here at Taliesin, it means long hours of consistent hard work free from resistance."

⌒

I look back with some embarrassment at the trite excuses I sometimes made up in order to find a reason just to be with her. But she always took me in and spent with me as much time as I wanted.

In the conversations I had with various members of the community, the name Gurdjieff sometimes came up, usually uttered in a hushed tone. He had remained a nebulous presence all the years I lived at Taliesin. I came to understand that he was Olgivanna's teacher. I did not know what his teaching had been until much later. But I remember that within days of joining the community, I had wandered into the small library and come across a book called *In Search of the Miraculous*, by P. D. Ouspensky. I plowed through it with some difficulty, with my sketchy knowledge of the English language. The message was rather unfamiliar to me, yet rooted in concepts that were not foreign to my intellectual reach.

Themes about the human being as a machine, ancient knowledge, inner struggle, absence of unity, the many "I's" that constitute one's self, fundamental laws of the universe, cosmic consciousness, remembering one's self, the law of three, the law of seven, learning to pray, and many other human concerns filled that volume. They were the basis for *the Work*.

The central character in the book was referred to as "G." Much later I came to realize that it was Gurdjieff.

GURDJIEFF

> *The evolution of Man can be taken as the development in him of those powers and possibilities which never develop by themselves.*
>
> *—G.I. Gurdjieff*

In 1919, in Tiflis, a Russian city in the province of Georgia, George Ivanovitch Gurdjieff—philosopher, mystic, and teacher—accepted Olgivanna Lazovich, along with a number of others, as a student. In the years that followed, Olgivanna traveled to Turkey, Germany, and France with the group that surrounded her teacher.

Gurdjieff was born in Alexandropol in either 1870 or 1872 to a Greek father and an Armenian mother. He was still a boy when the family moved to nearby Kars in the Caucasus, a crossroad for multitudes of cultures and religions. During his growing up years, fifty languages were spoken there—down from seventy during classic times.

The family suffered from poverty. George and his brother Dimitri could never go out on the same evening because they had only one pair of shoes between them. The family's difficult conditions developed George's resourcefulness and sharpened his survival skills. In his boyhood in Kars, George was influenced by his father, as well as his father's friend, Russian scholar and musician Father Borsh, who was dean of the cathedral at Kars. His father was what was known in Asia and the Balkan Peninsula as an *ashokh*, a local bard who composed, recited, and

sang poems of legends or folklore. Young George developed an insatiable curiosity about eternal questions concerned with the meaning and purpose of human life and the significance of the inordinate struggle one undertakes on its behalf.

In the mixing pot of humanity at Kars, George was exposed to practices of supernatural phenomena that he could not explain, nor could his elders. Within the rich environment of Kars, he searched for sources that might illuminate for him the mystery-laden questions burning in his mind.

Gurdjieff took up the practice of hypnotism and studied to be a physician and a priest. Eventually, he became a professional hypnotist. While learning about the more shrouded aspects of Christianity, including ancient rituals and symbolism, he became aware of the possible presence of secret societies. These societies, he believed, possessed ancient knowledge that they had likely practiced in its original form for thousands of years. Such societies by definition never sought the approval of the outside world. They remained sheltered in obscurity, protected from the curious.

Gradually, this quest defined his task. Between the years of about 1889 and 1895 he undertook a number of expeditions to Armenia to visit with monastic orders, to the north of Iraq, to Constantinople, to various places in Asia, searching and visiting dervish monasteries. About the year 1895 he gathered a group of about fifteen individuals, his friends and others who had the same passion for the search, and set out with them on an expanded journey. They were a group of remarkable people; among them were engineers, doctors, and archeologists. One was a prince. One owned several ocean liners, and more. In his book *Meetings with Remarkable Men*, Gurdjieff writes about some of those men, describing their characters and their contributions to their journey.

As Gurdjieff describes his journey, it is difficult to separate fact from allegory. That was to become his style in all his writings. It was sometimes said that he devised this intentionally obscure style in order to test the seriousness of the reader and weed out the simply curious. Yet the

REFLECTIONS FROM THE SHINING BROW

message becomes clear, because in the context of the search, the allegorical narrative contributes to the depth of the meaning.

The group traveled for a number of years—it is unclear how many—in the Middle East and Central Asia, including Egypt, India, Persia, Kurdestan, Tibet, and other places unknown. They were seeking and finding through clandestine connections those hidden societies. Gurdjieff was able to finance this long and involved trip by trading in carpets, oil wells, starting a restaurant and then selling it as it became successful; he even put yellow paint on sparrows and sold them as rare American canaries.

The group was able, over time, to find and collect fragments of knowledge that illuminated their questions. An important component of that knowledge was sacred dances that were part of the ritualistic practice of those monasteries. A moment came after intense focus when Gurdjieff could see the beginning of his path. At that moment he received what looked like an answer to his questions. It took his work by himself and his pupils to establish a method.

Gurdjieff had intended his work to be disseminated in the West. Thus the other task that loomed before him was to transpose this knowledge into concepts palatable to contemporary Western seekers. Like a Japanese master sword maker, he took the material he gathered, fired it, shaped it, and honed it into a complete system, which he organized in order to disseminate the message. Around the turn of the century, his concepts and the system he constructed were startling. Eventually, the language devoid of the substance found its way into the popular culture.

In 1912 he started to attract a few pupils and to conduct his work between Moscow and St. Petersburg. He moved with his pupils between Petrograd, Finland, and Essentuki in the Caucasus. In 1916 or so he was still moving along the Black Sea in order to avoid the shadow of the civil war. By 1919 he and his pupils had settled in Tiflis, where Gurdjieff accepted a number of new pupils, Olgivanna among them. At that time he put on the first performance of his sacred dances. The group traveled to Turkey and Germany. With the help of substantial financial

infusion from England he bought, in 1922, the Prieure du Basses Loges at Fontainebleau near Paris, where he established his Institute for the Harmonious Development of Man.

The Prieure would become the place most identified with his work. It was a rambling estate with a large central building, a chateau, where the Institute's activities took place. A number of smaller functional buildings, such as a kitchen or servants' quarters, were scattered across the two hundred acre grounds, extending to the edge of the forest and terminating with a high stone fence.

Gurdjieff had bought the estate from the widow of a lawyer, Laborie. Laborie was part of the defense team that had succeeded in 1904 in securing the release and eventual reinstatement of French officer Alfred Dreyfus, who had been imprisoned for alleged treason. The chateau was given to Laborie as payment for his services.

When Gurdjieff took possession of the chateau it had been neglected for at least ten years. Under his supervision, and often with his physical participation, newcomers to the Institute renovated the interiors and weeded, cleared, and trimmed the grounds. There were probably seventy individuals in residence in the chateau in 1922. Most were Eastern Europeans, with a prominent number of British. According to Gurdjieff, there were also a fairly substantial number, several hundred, elsewhere in the world.

The main venue through which Gurdjieff communicated his message to his followers was the instructions he gave during the everyday life at the Institute. By design, that life was made into a difficult experience that challenged everyone's human quality and endurance at every turn. Physical labor, which included building, gardening, cleaning, maintenance, taking care of the livestock such as cows and pigs, was hard work and it lasted for many hours, which often extended into the early morning hours.

Gurdjieff's powerful, mesmerizing presence dominated the atmosphere of the Institute and its inhabitants. With the slightest intentional change in his demeanor he could force the mood he desired on all or

some or just one of the members, in order to prepare the ground for planting a new lesson. He could feign any emotion, be it anger or joy. He could assume any attitude, be it kindness or cruelty, in order to make a statement appropriate to the situation.

Olgivanna told me that often in the evenings, after a twelve- or fourteen-hour day of grueling work, Gurdjieff would have everyone sit on cushions on the ground around the fountain, in soft light. With the background of the hypnotic sound of the fountain and soft music, he would demand that everyone maintain a state of complete awareness and total concentration. The overwhelming tendency to doze off in their state of physical exhaustion, under this combination of conditions, was monitored by the ever-vigilant eyes of Gurdjieff.

Collectively, the activities Gurdjieff prescribed constitute the concept of *conscious suffering*—difficulties in which one chooses to participate with volition, in order to gain some understanding of one's self. Conscious suffering is the opposite of the struggles and discomforts one happens upon as one automatically goes about everyday existence in pursuit of survival, without the benefit of volition or will. The practice of conscious suffering helps one store energy. Automatic existence dissipates energy. A life consciously disturbed by friction is touted as a worthy life that encourages self-observation.

Active self-observation was encouraged as the first step toward the freedom to know oneself. Knowing oneself has been a cornerstone in all philosophic and religious disciplines since the beginning of time. In 1400 BC the temple of Delphi had inscribed on its wall the words *Know thyself.* Jesus said to Thomas, "While you accompany me, although you are not comprehending, you have come to know, and you will be called 'the one who knows himself,' for he who has not known himself, has known nothing." The central objective in Gurdjieff's philosophy was self-knowledge. That meant looking in to observe one's body, emotion, and thought process. Affecting a meaningful change in one's life by definition means a change in all of these features.

The ritual dances Gurdjieff had collected during his truth-seeking

expedition served as another venue he used to impart his knowledge. He had abstracted and choreographed them into a series of complex and demanding exercises, intended to promote awareness and coordination. The sacred dances offered a suitable medium for planting seeds of conflict, thus affording another chance for self-observation.

Olgivanna said that, in spite of his large physical size, Gurdjieff had a feline manner of moving. In his book *The Anatomy of a Myth,* James Moore quotes Jean Toomer, the American poet and novelist who had attended the Gurdjieff Institute in 1926 and had led Gurdjieff groups in Harlem and Chicago in the twenties and thirties. Toomer commented on the way Gurdjieff moved on stage:

> I saw this man in motion, a unit in motion. He was completely one piece. From the crown of his head down the back of his head, down the neck, down the back and down the legs there was a remarkable line. Shall I call it a gathered line? It suggested coordination, integration, knittedness, power...

The ritual dances were taught as a matter of course. They became the one feature of the teaching that could be communicated to the public, since dance was a possible language to be exchanged with someone who was not necessarily involved in the Institute's day-to-day activities. Gurdjieff put on a number of dance demonstrations for the public. Besides adding to the pressure within the group, the performances were intended to attract new applicants to the Institute.

In 1923, Gurdjieff first performed the movements in Europe, and in 1924, he sailed to America, where he gave performances in New York, Boston, Philadelphia, and Chicago. During those years, he attracted a number of notable individuals who became his pupils for extended periods. Among them were Alfred Richard Orage, the British social thinker and editor of *The New Age;* Katherine Mansfield, the New Zealand-born master of English short novels; P. D. Ouspensky, the noted mathemati-

cian and writer; composer Thomas de Hartmann; Margaret Anderson, founder and editor of *The Little Review;* Jean Toomer; and many others. In 1934, accumulated debts forced Gurdjieff to abandon the Prieure.

In June or July of that year, Gurdjieff visited Olgivanna at Taliesin in Wisconsin, where he met Mr. Wright and made a good, strong impression on him.

In the fifteen years following his meeting with Mr. Wright, until his death in 1949, Gurdjieff continued to move and teach in a loosely knit group, mostly in France, with possible excursions to Germany and Central Asia.

Two years after Gurdjieff's death, Mr. Wright wrote a guest column in the *Wisconsin State Journal* of November 3, 1951, saying, in part:

> Here in the work of this remarkable man we believe we
> have for the first time a philosopher distinguished from the
> others…sacrificing much during his lifetime to make the
> ancient wisdom of the East not only intelligible to the
> thought of the West but to make it a way of Work.

Gurdjieff's view of the human condition held that human beings live in a perpetual state of sleep where all actions, thoughts, and feelings become mechanical responses to life's events. They become an automatic behavior pattern that is learned over the years at home, in school, or during normal social interaction. The habitual nature of these phenomena spares the human from having to think or to decide.

The state of sleep is a desirable condition that human beings are keen to maintain, and they strenuously resist having it disturbed. When life becomes difficult, as it is apt to do, or when disaster strikes, people are awakened from slumber and forced to take stock of themselves. They might gain an insight into their true aims and motivations that might add a dimension to their understanding of the world.

The object of Gurdjieff's work is to awaken human beings and show them the way to act consciously and affect a realization of the true

self, not unlike being born again. This approach applies the phenomenon of conscious suffering as it relates to self-observation. If people will look into themselves honestly and objectively, they will inevitably find unflattering features that they have diligently avoided looking at, in order to sustain their contentment in their sleep. Since difficulty is the catalyst required to wake people up, it would then be of immense value for human beings to place themselves as often as possible in situations of conflict and friction. As they do that, they must also observe their own behavior patterns, the nature of their feelings, and the quality of their thoughts. Thus one lets a ray of light illuminate the darker side. Eventually, if a person is to lead a higher life, he or she must deal with that side.

As Gurdjieff explains it, the human being consists of five basic centers: intellectual, emotional, moving, instinctual, and sexual. Each one of us is born with one dominant center. So we say that a person is intellectual, emotional, or physical. On the developmental scale, all three are on the same level since what each one possesses is a fragment of the whole. The objective is to develop the weaker centers so that one moves harmoniously and receives life with all of his or her being instead of in fragments.

Life as we know it tends to delude us into believing that only one person exists within one's frame. He or she calls it "I." Gurdjieff believed that there are numerous I's resident within the human psyche, each appearing at different times, due not to one's willful decision but rather as a response to an outside circumstance that brings it about. None of these I's is aware of the others because of the presence of buffers between them. The different I's often work against each other, creating the waste and fragmentation that marks human behavior. This further illustrates the mechanical nature of life on Earth. Events take place and things happen as a response, without the participation of a person's real will. Thoughts, feelings of love or hate, attractions or revulsion, work, habits, and convictions simply happen without volition.

In his book *In Search of the Miraculous*, Ouspensky deals competently with an abstract component of Gurdjieff's work. This has to do with

natural laws such as the law of three, the law of seven, the octave, the enneagram, and other laws. I will not elaborate on these laws in this book.

We can say, then, that Gurdjieff's doctrine is based on the existence of mechanical, unconscious, hypnotized, fragmented human beings who move into life like autumn leaves in the wind. Forces completely outside themselves push them about. They lack all power to steer their course, not even realizing that they have no control over that course. Gurdjieff devised a system to awaken people to their condition and guide them in recovering a sense of self—a system that helps them take command of their lives. That takes desire, focus, alteration of value system, hard work, and a long time.

CHAPTER 7
OLGIVANNA

> *As in the physical world, so in the spiritual world, pain
> does not last forever.*
> —*Katherine Mansfield*

DURING A SMALL LUNCH AT Paradise Valley Country Club near Scotts-
dale, Arizona, in 1981, with Dr. Karl Menninger and his wife Jean, I was
chatting with the other guest, Florence Mahoney, an acquaintance who
was a Washington health-industry lobbyist. The conversation drifted to-
ward Taliesin and the Wrights. Suddenly Florence looked at me intently
with an expression of contempt that seemed to rearrange the features
of her face and asked, "Do you like Mrs. Wright?" Clearly she was dar-
ing me to say that I did.

After a pause, I said, "Well, Florence, I have known Mrs. Wright for
thirty years. No one likes anyone for thirty years. But, yes, I like her—
and often I do not. Sometimes I love her and at other times I hate her.
My relationship with her has been through the entire spectrum of emo-
tional colors."

꩜

Many who met Olgivanna disliked her. Many who never met her also
disliked her. A number of very close individuals worshipped her. We
have grown with the notion that Mr. Wright was indeed a controversial
figure. As I came to know Olgivanna, she emerged as just as controver-

sial. No one felt indifferent or lukewarm toward her. Nor could anyone simply dismiss her.

My feelings about Olgivanna included all of the many sides of her character. She was a loyal friend, but it did not surprise me that she sometimes talked about me behind my back, twisting the facts of her story to individuals who she thought could bring pressure to bear on me to alter my behavior. She was generous, but I was not fazed when she appeared to be grabbing for money out of a sense of entitlement. She had a lofty sense of ethics, but I was not startled when she used questionable means to achieve her desired end.

Today, a few individuals still continue to believe, or at least feel they must show that they believe, a simplistic notion that Olgivanna was a woman as pure as the driven snow who never made a mistake in her life, nor behaved in any manner with less than Christian love.

To enhance their own sense of importance, they use her as a cause to defend against imaginary demons. They make out of her a kind of digital creature composed of the most unlikely combination of distilled qualities, and thus deprive her of her humanity.

The fact remains that for the sixty years she lived in the United States, Olgivanna worked using all of her considerable human potential to reach a point where she presided over a world-renowned endeavor with absolute power. One does not accomplish that simply by being a "nice guy." She understood power and she used it, sometimes ruthlessly. She stretched the concepts of simplistic propriety to limits that could justify (in her mind) crossing the line into a more multidimensional and ethically ambiguous region. From my experience with her, methods that would be considered marginally questionable from an ethical perspective were quickly and decisively employed by her in order to keep her kingdom intact.

Keeping that kingdom intact was the only way she could do the good she said she had dedicated her life to doing, and that could happen only with her at the helm. She had lived and worked with Gurdjieff for six years, during which she discovered herself and delineated her pur-

pose in life. She set out with unusual determination to fulfill her dream.

The embryo of Olgivanna's dream, which later developed into Taliesin, was conceived one day at the Café de la Paix in Paris, where she and Gurdjieff had sat many times. But this time it was different.

As they sat across from each other, there was apprehension in the air. Without introduction he told her that he had taught her all he could teach her and that her time with him had come to a close. He said, "You must start a new life." Stunned by this startling and unexpected notion, she asked with disbelief: "When? How?" "You must leave France," was his firm and distant answer. "Do you mean I must leave you?" Olgivanna said, trying to regain her balance. "Yes." During the following moments as she examined her options out loud, she thought of returning to Russia to be with her sister and her friends. But Gurdjieff said: "No. No. Do not go to Russia. Go to America."

She had first met Gurdjieff in 1919 shortly after the Bolshevik Revolution. Their meeting completely altered her life and gave it the direction it took until her death in 1985. She had been married to a conventional architect, Vladimir Hinzenberg, since shortly before the revolution. She had met Hinzenberg when she was nineteen years old. He was thirty-one. Hinzenberg had fallen in love with Olgivanna and she eventually married him after she was emotionally pressured by his mother, who loved Olgivanna like a daughter.

Olgivanna and her husband had a three-year-old daughter, Svetlana. The marriage was faltering. Other than an interest in art and art books, nothing held the two together. Hinzenberg loved Olgivanna and she respected him, but there was no passion.

The vacuum in her life brought her together with a childhood friend, Luigi Valazzi, whom she called Gigino. Unexpectedly for each of them, they fell in love. But this love came to an abrupt end when Gigino's parents forbade him to see Olgivanna. They could not accept their son causing the divorce of a woman, then marrying her and taking on a three-year-old daughter. She continued to have love for Gigino for many years, a feature of her character that I always admired. She spoke

of him to me occasionally. During a European tour in 1964, Olgivanna made the point of having me for dinner with Gigino in Rome so I could meet him. When he died a few years later, she asked me to come to see her in her room where she spent some teary moments reliving their relationship.

Her life was at low ebb. She was lost and very unhappy. She was spending a great deal of time alone. It was physically difficult for her and her daughter. The economy was distressed and food was rationed.

One day in Tiflis a close friend and talented artist excitedly told Olgivanna about an interesting man she had just met. She said he taught dances rooted in knowledge he had gathered in the Far East.

Olgivanna's state of mind allowed no room for anything like dances and she summarily dismissed the idea.

The fact is that Olgivanna had grown up in a cultured environment. She was an avid reader, by nature introspective, and philosophy was not beyond her reach.

Her friend pleaded. After some soul searching, Olgivanna decided to seek out that man, just to please her friend.

After climbing the wooden stairs that led to the upper level of the two-story house where Gurdjieff conducted his practice, she walked into a room where there was a small group of people, but she was immediately struck by a remarkable looking man with a beautiful, closely shaven head, and classic features, including a fine nose and strong jaw. His eyes were dark and luminous. It was a noble face with the traditional Oriental black moustache that seemed natural on his face. His expression was one of profound strength and great compassion.

He was the part-Greek, part-Armenian George Ivanovich Gurdjieff, who would become Olgivanna's teacher, mentor, and the most significant source of knowledge in her life.

The first conversation between them has appeared in a number of publications because of its importance in defining the ensuing relationship between her and her teacher. She had told me that she had intended to divide her upcoming autobiography into three parts, each

dedicated to one of the three most significant men in her life—her father, Gurdjeiff, and Frank Lloyd Wright.

In answer to Gurdjieff's question about her wishes, she said, "I wish for immortality."

He asked, "How do you live now?"

"I look after my home and my daughter," she said.

"Do you cook?"

"No, I have maids who do that."

He said deliberately, "If immortality is your aim, your first task is to dispose of your maids and do the work yourself. Thus, you will be on your way to an inner life." She did just that, on the same day, much to Gurdjieff's surprise and delight.

Between this conversation in Tiflis and their meeting at the Café de la Paix in Paris six years later, Olgivanna was a member of deep commitment and a star pupil of Gurdjieff at the Institute for the Harmonious Development of Man. From the outset, while the group was still in Tiflis, she was close to Gurdjieff and he singled her out for many private moments.

Her teacher coached Olgivanna personally in sculpture and cooking. He took her shopping and taught her how to buy the right produce and meat, then how to dispense of the waste. He taught her the ritual exercises and showed her how to dislodge the mechanical process of thinking and replace it with a conscious approach to using her mind. She taught the dances with the same intensity as she looked after the pigs, carried the garbage, took care of the guests, did the laundry, and all the other tasks demanded of her.

Much later, as she would instruct me about self-containment and inner peace in the context of what Mr. Wright would call, "The Gospel of Work," she would remember what Gurdjieff had told her: "You must struggle to overcome the addiction to your weaknesses and work to acquire independence and inner strength. Only then will you approach the image of God."

Little Svetlana was with her when they left Tiflis for Constantinople,

where the group lived and worked for a time. After Constantinople, they traveled to Germany, where they resided in Dresden, then Berlin, continuing to work on the ritual exercises.

The central and constant theme in the relationship between Gurdjieff and Olgivanna was the inner tasks he gave her on a regular basis in order to strengthen her inner core. She was a willing pupil who was eager to learn. Her Work prepared her for the most important sacrifice she had to make up to that moment. Gurdjieff had instructed her that she separate herself from her daughter for a time. It was an unthinkable notion that she was trying to understand and adjust to. In the meantime, her eldest brother, Lubomir, had died. Her second brother, Vlado, had for an extended period taken care of his brother and watched him as his life slowly flickered away. Then he plunged into deep loneliness. Vlado and his wife Sophie, who did not have children of their own, were going to New York to live. It appeared reasonable that they take little Svetlana with them. The presence of this young life could lend credibility to Vlado's loss, while responding to Gurdjieff's urging. Olgivanna struggled mightily with herself as the sacrifice of letting go of her daughter loomed so large. She spoke with Gurdjieff again, and he reiterated that the sacrifice would indeed be beneficial for Svetlana and her future.

Much later, when she sometimes spoke with me about true freedom of spirit, she would refer to this heart-wrenching experience as an exercise in breaking the chains of slavery, in spite of the appearance of cold-hearted indifference to a noble emotion.

↩

From Germany, Gurdjieff took his group to France, where he bought the Chateau du Prieur in Fontainebleau, outside of Paris. At the Prieur, the demanding pattern of hard work and intense concentration continued without pause. The celebrities who had joined the work were all enlisted to perform the duties and chores required from the inhabitants of the Institute.

One of these celebrities would touch Olgivanna's life to its core.

She would leave an impression that remained evident, even when she spoke of her fifty years later. Katherine Mansfield, the New Zealand-born master of the English story, had been ailing for a long time. She was in the last stage of tuberculosis when, upon Alfred Orage's request, Gurdjieff received her at the Institute. She had been through all the available treatments and some experimental ones, without relief. Her doctor had concluded that she had only three months to live. When she joined the Institute she was convinced that Gurdjieff was the only one who could heal her.

Olgivanna was immediately drawn to this woman. Besides her pale face, her hauntingly sad and intense eyes, her dark, straight hair cut short and arranged in a bang over her forehead, and her ravaged body, she had a spiritual presence that gave her a transparency beyond ordinary mortals. Gurdjieff asked Olgivanna to go to her and care for her.

Olgivanna shyly approached Katherine and introduced herself. Katherine did the same.

When Olgivanna had brought in a load of wood to keep Katherine warm, a delicious conversation ensued. Olgivanna, a literate and cultured young woman, was more than elated to learn that this unusually attractive woman was a writer of short stories.

In his book *The Harmonious Circle*, James Webb writes: "Gurdjieff had directed a balcony to be built for his invalid pupil above the animals (three cows and a mule), in the cowshed of the institute. On this balcony, Katherine Mansfield now spent the day lying on a divan, receiving visits from her friends and watching the cows being milked. What was the reason for that strange regime?" Then Webb goes through a variety of possible reasons such as "animal magnetism, the smell of manure, the Indian medical notion about the bacillus carrying cows as a tuberculosis cure." Then he concludes that it was clear to Ouspensky, and even clearer to Gurdjieff, that Katherine Mansfield had not long to live. Gurdjieff had agreed to admit her to his community. But although she was in need of spiritual help as well as physical, her invalid condition had disqualified her from full participation. In Gurdjieff's opinion, she

REFLECTIONS FROM THE SHINING BROW

needed to regain contact with the soil and with her body. She had herself felt the need to learn to look after animals, though a view from the stable balcony was as much as could be managed.

During the following three months, until Katherine departed in January 1923, Olgivanna was painfully aware of the forces of death steadily encroaching on Katherine.

But, strangely, that was also a period when Katherine felt more spiritually alive than she had in the preceding months. Gurdjieff had carefully outlined for her a pattern of physical activities, such as rug making, flower arranging, learning the Russian language, engaging in complex counting exercises as she watched the dances. It was a refreshing departure from the activity in which she had spent her life as a writer.

During all this, Olgivanna was her constant companion. She was infusing Katherine with her own energy as she herself was being spiritually energized. Their bonding became stronger as life was steadily draining out of Katherine's body. One day in early January 1923, Olgivanna walked into Katherine's room, carrying some firewood. As Katherine lay still in bed, she looked beautiful and peaceful. She was dead.

∽

Life continued at the Prieur as Olgivanna relentlessly pursued her work with Gurdjieff.

She often told me that Gurdjieff had helped her rid herself of her illusions and the pretense associated with them, and replace them with a true evaluation of herself and the universe around her.

The pain of tearing away deeply established mental and emotional habits was in itself the major lesson in her development. She had faith in Gurdjieff, and she readily accepted the process of being remolded from within.

Olgivanna Lazovich had been a willful, goal-oriented, determined young woman. She was born in Cetinje, the capital of Montenegro, before it was absorbed by Yugoslavia, to Iovan Lazovich, who later became chief justice of the supreme court in Montenegro.

Her mother was the fiery, beautiful youngest daughter of the revered hero General Marco Milianov, whom she accompanied into battle. She was imposing, imperious, and a strong fighter. Olgivanna was not close to her mother. Some years after, Olgivanna was in her twenties, during her travels with Gurdjieff and his group in Germany. She had not seen her mother for twelve years. Gurdjieff, who had known about the rift between Olgivanna and her mother, advised her to take the train to Belgrade and spend some time with her mother.

With some apprehension and fear, she went to Belgrade only to discover that the gulf between them was too wide to bridge. The experience was a cause of disappointment and regret.

Olgivanna's father was stricken with glaucoma and blinded at the early age of thirty-five. He was a sensitive and poetic man. Her kind, reserved father nurtured his daughter and she in turn was totally devoted to him. At age nine she read her blind father the newspaper as well as his favorite books. It was difficult reading for her but instrumental in her early development. She had gone to Russia to live with her sister while she attended school. She had lived with her until she met her husband-to-be, Vladimir Hinzenberg.

At the Café de la Paix, Gurdjieff had told her to start a new life in America. But while that meant a change of location it did not mean a change of objective. She was young, strong, seasoned, and, like a tiger cub, she was ready to fashion a life completely her own. The ideas Gurdjieff had planted in her had become the only worthwhile purpose for which to live. She wanted to continue to manifest those ideas in her own life.

Olgivanna was a strong-willed woman, and she had become aware of her own personal powers and of her effect on people. She knew that she was going to carry on her experience with Gurdjieff in some way in America.

Soon after she arrived in America, she met by chance, at the Chicago ballet, Frank Lloyd Wright. For a time, they shared the box with a gentleman who was trying to make conversation with Olgivanna. Mr.

Wright's immediate attraction to her was evident, when I heard him say once with a chuckle, recalling this first encounter, "I looked to see how far down he would go if I threw him over the balcony." Their meeting was a providential event that foretold her future for the next sixty years. It was an instant attraction. She was twenty-six years old. He was fifty-seven.

At intermission he took her to the Congress Hotel where they had tea in the dining room. He was motivated to open himself and his life to her in the first encounter. He was in the throes of professional difficulty, nearly a social outcast because of his disregard for social convention. He spoke of his first wife and his children and of the death of his first love, Mamah Cheney, and of his love for her and hers for him. Then he told her of the tragic events that led to the murder of her and her children.

Mamah was the wife of Ed Cheney, a client. Her intelligence and high spirit drew Wright away from a wife and six children. She was as smitten by him as he was by her. In 1909 he took her on a trip to Italy and Germany, where some of his work was being published. Then, in 1911, Wright began building his home in the rolling hills of southern Wisconsin, later to be known as Taliesin. In his autobiography he writes, "Taliesin was the name of a Welsh poet, a druid-bard who sang to Wales the glories of fine art."

Mamah lived in the new home with Mr. Wright and her children. In 1914, she was still at Taliesin. Shortly before, Wright had hired Julian Carlton and his wife, Gertrude, as butler and cook to the household. On August 14, 1914, Julian Carlton murdered seven of the eight other occupants—Mamah and both her children, three workmen, and a draftsman. Only William Weston, a carpenter-craftsman, survived. After the slaughter, Carlton set a fire that razed Taliesin to the ground. He was found after a day or two hidden in the fire pot of the steel boiler down in the smoking ruins of the house. Still alive, although nearly dead, he was taken to the Dodgeville jail, where he died without uttering a word.

When it happened, Mr. Wright told Olgivanna, he had been in Chicago with his son John to see how the finishing work was progressing on

Midway Gardens. The horror and devastation sent Mr. Wright reeling. Mamah was buried in the family cemetery within the chapel grounds. In his autobiography he wrote:

> Thirty-six hours earlier I had left Taliesin, leaving all living and happy; now the blow had fallen like a lightning shock.… I cut her garden down and with flowers filled a strong, plain box of fresh, white pine to overflowing.… My boy John, coming to my side now, helped me lift the body and we let her down to rest among the flowers that had grown and bloomed for her.

Mr. Wright had had as many triumphs as tragedies. He told Olgivanna of the Imperial Hotel in Tokyo and how it survived the great earthquake of 1923, which had destroyed most of Tokyo. He spoke of Midway Gardens and other cutting-edge projects. Then he spoke of the sympathetic, intelligent letters he had received from Mariam Noel, a woman unknown to him. He said that the vacuum and desperation he had experienced at that time led to a companionship with Mariam Noel that resulted in his second turbulent, unsuccessful marriage, which was still in effect as he and Olgivanna spoke that evening.

When he had partially emptied his emotions, he looked at her and said, "But now, tell me about yourself."

Time seemed to stand still as she told him about her experience with her teacher, Gurdjieff, and the Institute. She spoke of her own first marriage and her daughter Svetlana, now seven years old. Later that afternoon, they danced together waltzing their way into each other's sensibilities. By evening's end, they were completely enveloped in each other.

↩

There was no doubt about their intense attraction to each other. This made for an environment suitable for more heartfelt exchanges of past experiences, confidences, and possible future plans.

His energetic courting inspired him to make a number of visits (sometimes unannounced) to her apartment. She demurely, but decidedly, encouraged these visitations. When once they were earnestly talking as they were immersed in each other's auras, he ate a whole bowl of fruit that happened to be placed on a nearby table.

The next day, a messenger carrying several baskets of fruit, flowers, and candies rang the doorbell and left with her the baskets, as well as a note from Mr. Wright asking her for her forgiveness for his indulgence. He also announced that he was going back to Taliesin to prepare for her visit the following week.

Olgivanna and I had an exchange many years later, in 1971. I had married a wealthy woman from Oakland, California, Barbara Kaiser, widow of Henry J. Kaiser. I had in 1966 given away all my inheritance from my wealthy father to my family. I, like everyone else at Taliesin, was given a small monthly stipend that was enough to buy little more than toothpaste. I had felt awkward about my complete lack of funds in view of my wife's wealth. To make me feel comfortable, Olgivanna told me one day, "Do not feel sensitive about it. When I married Mr. Wright one of the attractions was that he had a farm and a home to go to."

Although the dynamics of the two situations were different, Olgivanna did make her point.

Between their meeting and August 1928 when they were married, Olgivanna and Mr. Wright suffered untold abuse by the press and the general public. Technically, they were married to other people, and they were living together "in sin." He spent a night in prison as an alleged violator of the Mann Act. In the meantime, their daughter Iovanna was born and by the time of their marriage, she was three years old. He printed her likeness on the wedding invitations.

As Olgivanna was getting settled at Taliesin, she never lost sight of the objective for which she had migrated to America in the first place. She was always preparing the ground for the community that she would eventually establish. For that she had to have Mr. Wright's sanction and

enthusiasm. She received both. Although this issue was to be revisited many times over the years, she was almost always able to give the impression of his support. She spoke with him about Gurdjieff and introduced him to his teachings. A few times she even attempted to show him some of the movements, another name for the sacred dances, persuading him to take on the mental challenge they represented.

At Taliesin in Wisconsin, near Spring Green, Mr. Wright had a studio where he had hired draftsmen to produce the work on his projects. They kept regular hours and then went home. As Olgivanna told me on many occasions, she frequently spoke with Mr. Wright and eventually persuaded him to replace that group of draftsmen, whose job descriptions did not necessarily include inherent loyalty, with a group of young people who believed in Mr. Wright's work. They would become disciples, or apprentices, as they were to be called, learning about architecture directly by working with the master. He then would have an environment of admiring hero worshippers—as I was and still am. The apprentices would have an unparalleled opportunity to experience genius at a close range and Olgivanna would have an inexhaustible supply of young people who could become candidates for Gurdjieff's teachings. In addition, the new apprentices would each pay $600 per year for the privilege. In 1932, at the depth of the Depression, without any work in the office, $600 was most needed to support the endeavor. That was the beginning of what has become known worldwide as the Taliesin Fellowship.

Olgivanna stunned me one day when she said unexpectedly, "You are the only one like him who ever came here."

It took me a minute or two looking at her deep gaze into my eyes to realize that the "him" she meant was Gurdjieff. She did not say it as a compliment. Rather, she was matter-of-fact about it.

CHAPTER 8

THE FELLOWSHIP

> *A woman is, for man, the best of true friends, if man*
> *will let her be one.*
>
> *—Olgivanna Wright*

OLGIVANNA WAS GOD'S GIFT TO MR. WRIGHT. She did everything for
him. She spared him all domestic and organizational concerns. She
watched his diet and through willing apprentices provided him with con-
stant care and support. He had all the time to work and create without
worrying about anything else. Mr. Wright was a warm human being with
a genuine sense of humor. But his interest in the personal lives of the
apprentices was marginal. On the other hand, Olgivanna's interest in
personal lives was central to her Work. Indeed, that was her Work. She
needed to consolidate her power in order to legitimize this interest into an
institution that could become an integral part of the total Work effort.

Until her death in 1985, Olgivanna designed the organizational
structure upon which the Fellowship operated all the years it existed.
She had unfettered control over all that went on anywhere at all times.
She initiated and monitored every program and had direct access to
and a personal relationship with every individual who became a mem-
ber of the community. No two relationships were alike. Each was cali-
brated to the nature of every person so as to be the most effective with
that person. Not everyone was a favorite of hers. But everyone repre-
sented a potential that deserved exploring. Those closest to her had a

65

natural quality for dedication and a desire for service, especially when they considered that personal service to her was service to the organization. She was keen on developing and promoting this concept. Her supporters had a better chance if they had flexible minds without strong prejudices.

One of the lessons I learned through my experience with the Wrights was that flexibility is a sign of intelligence. Certainly, Mr. Wright was the most flexible man I have ever known. Besides the personal qualities that qualified a member of the Fellowship to become close to Olgivanna, it did not hurt that he or she had had an absentee mother or a traumatized maternal experience—or paternal, for that matter. Olgivanna filled that space without sentimentality but with compassion and competence, which rendered her indispensable to some. She worked hard at restoring the balance in some of those lives, and, that was the price for the uncompromising loyalty she received from some of them. These individuals formed the base from which her program sprang. On one level, they fed on the towering strength of her soul; on the other, they became the lieutenants who did her bidding whenever she deemed it necessary.

I was driving from Arizona to our summer headquarters in Taliesin in Wisconsin with one of them, who would later become the CEO of the organization. He said to me, "I know that God is in heaven. But for me, now at this stage of my development, Mrs. Wright is my God."

I had been a member of the Fellowship for less than a year, and I was still trying to make sense of the environment. Only a few years later did I receive the impact of the statement. I believe it was another way to direct my attention to a side of Olgivanna I did not capture in the first few months. Whatever she said to me always made sense. It always rang true because she had an ability to cut through the crust and reach a universal truth with clarity and pure logic. Her delivery was straightforward and very effective. But a god she was not.

Over time, I became more aware of her agenda, which lurked near

the surface. She was always manipulating someone to take a course that would be of some use to her purpose. That is not to say that she had an evil purpose, but a purpose other than the one she expressed.

She was able to maintain this management style with great skill all the years I knew her. She often had to maneuver on a tight rope between a wide range of conflicting interests, ideological concerns, embarrassing situations, unforeseen forces, personal disputes—all as she was at Mr. Wright's beck and call at all times. If I must synthesize all her objectives into one overriding goal, I would say it was to maintain Taliesin as a thriving institution for the foreseeable future. Her inextricable link to the Institution meant her own thriving. That community was uniquely her own creation and it was the one tangible evidence of the validity of her long-term quest, which had developed with Gurdjieff by the mid-twenties.

On the altar of this value everything and everyone except Mr. Wright was dispensable. Anyone's standing or continued presence at Taliesin was completely contingent on her perception of his or her usefulness to the Institution. There was no ambiguity about what she wanted to accomplish and the method by which she intended to accomplish it. On a rudimentary level, some of her methods were questionable and, to some, revolting. She did not enjoy but did not shrink from the ill feelings she engendered in the many who were the recipients of some of her perceived betrayals.

In 1955, while I was in Egypt for a visit after four years at Taliesin, I called upon an Egyptian architect and his wife, both of whom had spent a few months at Taliesin in the forties. His wife had developed a close and affectionate relationship with Olgivanna during that short time. Olgivanna had praised her to me profusely many times over the years. During that visit, when reminiscing about Taliesin was the only topic of conversation, she related to me an event that she said had taken place during her tenure at Taliesin:

"Mrs.Wright did not like one of the apprentices and she wanted him removed. But there was no legitimate way to get rid of him. So,

when it became his turn in the kitchen, she did or had done something to the oven so it would break down when he used it, thus providing a reason for his dismissal."

This event may or may not have been true. Indeed, I find it a bit too simplistic for Olgivanna's Byzantine methods. But the significance of the story is that even the closest and most affectionate to her sensed an underhanded side in her methods and seemed to accept it, justifying it as a legitimate means to accomplish an end.

Olgivanna had worked systematically and hard to establish a small group of devoted followers within the body of the community in which she had instilled the notion that she represented the only means for their salvation from the vestiges of human bondage. Those devoted individuals quietly communicated that message to newcomers joining the group. Although I had not known of the existence of Olgivanna until I saw her two days after my arrival, I felt an instant bonding. Our bond lasted through a roller coaster of emotions until her death thirty-four years later. During the following years, I gathered that she had seen in me a potential she thought was worth developing, and she devoted a good deal of concentrated effort toward that end.

Olgivanna and her group of devotees became a kind of shadow organization with objectives not necessarily in contradiction to Mr. Wright's declared objectives of Organic Architecture but generally parallel to them and often intersecting. The ideas were not alien to one another, but some of the logistics occasionally were. In an ideal world, the principles of the Work as seen by Olgivanna would mesh beautifully with the hard work that must be invested in the cause of Organic Architecture. I had heard Mr. Wright repeatedly exalting his years on the farm and the work ethic associated with that experience. "Adding tired to tired," he would say, was a major component in forming his character and perseverance in pursuing his cause. From my experience in working with equal zest in both dimensions, fulfilling your obligations to the inner work as explained by Olgivanna was exactly what was needed to help you persevere in doing your work as a principled architect.

Indeed, Olgivanna had sometimes prevailed on Mr. Wright to include in his regular Sunday morning talks a mention of Gurdjieff, his Work, and the Work of *my intelligent wife*, as he often called her. The purpose was to give legitimacy to that activity conducted by Olgivanna on the peripheries of the architectural practice. Mr. Wright was not necessarily always aware of every detail that went into that activity, but he could easily find parallels between that and the notion of dedication to an idea.

The fact remained that activities demanded by Olgivanna's organizational layer could superficially conflict with the time constraints demanded by the architectural work. If you were serious about being a member of that community, you could easily accommodate both demands without much conflict. But if you had developed a dislike for her and her methods, you found every reason to condemn her for imposing an uncalled-for activity on the expressed purpose of the organization.

Olgivanna had unparalleled knowledge about people. It took her minutes of ordinary conversation to reach a reasonable assessment of the nature of someone she had interest in evaluating. Over a short time she would find a window in that person's character where she would let herself in and become forever lodged within the soft tissue of his or her makeup. Her passion (some would say addiction) to control would then find easy access to the inner buttons that manipulated that person's emotional complexion. (Svetlana Alleluyeva, Stalin's daughter, who lived with us for more than a year, told me once that she thought Olgivanna was a witch.) From her secure position, Olgivanna would at will give comfort, inflame anger, cause confusion, and induce jealousy at moments of her choosing with the intent of exposing the true quality of a person. No one looked forward to those moments. Those who thought she had saintly dimensions accepted this manipulation as a part of their learning experience. Being subjected to this manipulation enraged those who were inclined to see the devil residing within her frame. The latter were always the majority.

A question always remained in my mind. In spite of the strong

bonding I had with her, from the first moment I set eyes on her I had an intuitive urge to be cautious. Over time, although subject to her emotional manipulation, I always had an insight into the reasons for her actions. In general, I tried to find positive interpretations for her sometimes apparently unreasonable and often sordid outbursts.

Olgivanna's knowledge of people was to me one of her most appealing features. It was an ability I desired to acquire. She was generous in imparting her knowledge, although she never gave direct instructions. She would arrange game-like encounters where we were to assign to this or that person an animal that most resembled him or her. We would assign a color or a flavor or a piece of music that would be most suited to describe the character of the various people present. We would assign the elements (fire, water, air, and earth) to everyone. In human terms these elements meant passion, emotion, intuition, and productivity respectively.

This practice provided exposure in some depth to a wide variety of psychological types with highly refined delineations. A person with air and fire could have too much air for the size of the fire so that it blows it out, or have the right amount of both so the air keeps the fire aflame. A person can have a warm fire like that burning in a fireplace, which could be attractive to others, or a fire so large that it would burn that person and others around into a cinder. A person can have fertile earth in which a seed can easily grow, or a rocky earth that remains stubbornly fallow. One can have earth and water, with such disproportionately excessive water that it turns the earth into unwieldy muddy sentimentality. Or one can just have the right amount of water to keep the earth productive.

Everyone wanted to be a lion with a fiery nature and a glorious color. No one could manifest all of these qualities at the same time. But the objective was that we accept ourselves for who we were, realizing that no particular characteristic makes a better or a worse person. Only the work one does with the hand one was dealt was what counted. This acceptance was the key ingredient to those who were serious about their

interest in understanding themselves and others without judgment or prejudice.

These large groups were often contrasted with small ones, where discussions again were the order of the day.

One early afternoon in the mid-seventies, during the leisurely, relaxed Easter season, Olgivanna had a few of us for a drink before lunch. Among the guests was Ben Raeburn, publisher of Horizon Press, and a very close friend. He had been my best man when I married Barbara in New York. Another guest was Don Loveness, a chemical engineer at Minnesota Mining Company and a favorite client who, with his wife, had personally built the house Mr. Wright designed for them in Still Water, Minnesota. John Dekoven Hill, a senior staff member at Taliesin, who was, for ten years, the editor of *House Beautiful* magazine, was also there.

The discussion was extemporaneous and expansive and the conversation drifted toward colors and their psychological effects on people. There was general agreement that the color red was somewhat disturbing. In a familiar fashion, Olgivanna asked everyone present, in turn, to explore the reason.

Ben said, "I read a study recently that established that the color red gives out a short-wave vibration that penetrates to the nervous system and rattles it."

Olgivanna turned to Don, who said, "The chemical composition that produces the red color has a set of conflicting components, which emanate energy unsympathetic to molecule stability."

John Hill, who was an interior designer, said, "Red has an overpowering aura that can take over, and it must be used carefully in small measures."

When my turn came, I said, "Red is the color of blood and in the historical subconscious, it is associated with pain and death. So, looking at it brings up subconscious anxiety due to the association."

Again in a familiar fashion, we moved to the dining table without Olgivanna saying what she thought. At the table Ben asked her, "So, what do you think about the color red, Mrs. Wright?"

She said, "During our stay in Constantinople at a picnic we were having with Gurdjieff, a similar discussion took place. He told a woman who was particularly partial to the color yellow, 'most likely the reason you like yellow is that your nurse probably wore a big splashy yellow skirt and you had pleasant memories connected with it.'"

"Do you mean Kamal is right?" said Ben.

She did not answer and changed the topic. Later, when she read to me from her autobiography, I realized that that woman who was so fond of yellow was Jeanne de Salzmann, the loyal, long-time pupil and companion to Gurdjieff. After his death, she was the holder of the flame for more than forty years, until her own death at age ninety.

The unusual complexity of Olgivanna's character rendered her, for some, too difficult to understand and, for others, nearly impossible to predict. From the first moment I saw her I became intensely interested in her as a person. I made for myself a task of observing her moves, her words and her reactions. It was clear to me that she knew much that I desired to learn. It also became clear to me that the many faces she showed to everyone were faces that she sometimes assumed, in order to make a particular point at a particular time, to serve a particular purpose. She might make just the opposite point a day later under a different circumstance.

I saw her once tear into a fellow apprentice like a tornado, not because he had done something wrong, but because he was not completely aware as he performed the Work. When he left, he was vulnerable and deeply affected. She looked at me and said with a very sweet smile, "John looked nice, didn't he? Just like a little boy." The point was to shock him into awareness. It almost made me jealous that she singled him out for that experience, rather than me.

As the years went by, I became more certain that as the many facets of her character surfaced under differing circumstances, one underlying quality seemed to be at the base of all aspects of her behavior. She needed to be in total control of all situations and all people. In the com-

munity we shared, she had her fingerprints on every plan the group was to make. She endeavored to be a third party to every relationship. She would find access through either one of the parties, whomever it was easier to reach. She inquired about the details of the relationship and invariably offered advice in an attempt to manage that relationship. Indeed, she often endeavored to disrupt the autonomy of a relationship that took place outside her sphere of control. She used a variety of means, including the denigration of one side of the relationship to the other in a transparent but often effective "divide and rule" style. She never said anything that was not true. But she either highlighted or dimmed the right features in order to accomplish her purpose. Eventually these divisions would persist as a defining feature of the culture in the community and last well after she had passed on.

One of the tasks assigned to her group of faithful followers was to report to her at all times what was said or done anywhere and everywhere on the premises. Clearly that was an essential part of the control mechanism. In later years, as I became more familiar with the operation, I occasionally used it for my own purpose. When, during a confrontation with Olgivanna, she would not allow me to express my feelings about the situation at hand, I would deliberately tell one of her reporters my raw feeling about that situation and about Olgivanna, assured that it would reach her within minutes.

These Gestapo-like tactics did not endear her to her dedicated haters. They regarded her as a menacing presence, which existed for the sole purpose of causing them harm. I was not particularly comforted by or attracted to her methods either. Based on the culture we shared collectively, these methods had an odor of underhandedness and dishonesty, which made me even more cautious in dealing with her. The most intriguing aspect of all in my study of her was the extent to which her own natural tendencies overlapped the message of enlightenment—the announced purpose of founding the community of Taliesin in the first place.

In this dark cloud, if one chose to see it, was a silver lining. The

more information she knew about anyone in the community, the better chance she had to place that person where it was most suitable for his or her development. Then there was some justification for receiving information about unrehearsed actions and off-the-record comments, which would more accurately delineate the character of a person. On the other hand, knowing that Olgivanna possessed some embarrassing information was in itself an intimidating condition, which further enhanced her control over a person.

Under normal situations she would not abuse this information. However, in situations where she thought that something at Taliesin was being threatened, she became a genuine street fighter, using anything and everything at her disposal as a weapon to club her opponent. She maintained with every single member of the community, young or old, adult or child, a separate and individual relationship with a unique line of communication apart and uncluttered by any other relationship or consideration at all times. An issue always clouded the relationship. If none were there, she would create one, such as a job not completed satisfactorily or a person caught in a lie or someone waiting for a critical decision. Everyone had to feel guilty about something. Every time I turned, I encountered Olgivanna. The significance of these encounters often appeared later.

Thus my relationship with Olgivanna was at all times jostling, challenging, fencing—all manufactured to test the moment and quickly change. Regardless of the mood of the encounter, be it joyful, angry, sad, relaxed, overwhelmed, a crisis, or a combination of some or all of these states, I was always expected to be aware, conscious, and speaking from the heart.

Those who took on the task of working with Olgivanna found the relationship of constant excitement and ultimate benefit. I learned a great deal about myself, my potential, and my limitations by trying to maintain a constant state of awareness of all that went on around me, so that the next time Olgivanna forced me into a fencing match, I would be at the top of my game.

CHAPTER 9
THE WORK

> *Only conscious suffering has any sense.*
> *—G.I. Gurdjieff*

W̲HEN SMALL BEADS MADE FROM THE SHELLS of freshwater bivalves are enclosed in a small bag of mantel and introduced into the reproductive region of a living pearl oyster, the ensuing conflict between the prevailing life forces causes the stimulation that results in the formation of a pearl. Conflict is at the heart of the process. In the gospel of Thomas, Judas Thomas the Twin quotes Jesus: "Perhaps people think that I have come to impose peace upon the world. They do not know that I have come to impose conflicts upon the earth."

The body of activities, thoughts, and attitudes constituting the relationship with Olgivanna was referred to collectively as the Work, the same term Gurdjieff had used. At the heart of the Work is the notion of inner conflict as the path to higher consciousness and deeper understanding of oneself and the world around one. Inner conflict is the result of the constant confrontations between one's illusions about oneself and the realities as life presents them in everyday experience. The automatic image of oneself is highly decorated with values: virtue, courage, intelligence, generosity, abandon, fairness, wisdom, and more. On some level everyone is convinced that he or she is constructed in a near-perfect form and that life should be a glorious experience except for the faults of others. But life has a way of educating those who want to learn.

75

* * *

The inevitable confrontations that take place every day often demand the participation of some of those high qualities we think we have. Most of the time those qualities are not available because they were not there to begin with, and we behave simply as we are constructed, constantly preoccupied with justifications for the absence of courage, generosity, or fairness, and the other virtues. When we speak of the Work, we are speaking of an inner process that eventually brings fantasy and reality in alignment with each other, resulting in inner acceptance that brings peace.

Olgivanna made Taliesin a hothouse version of the world. In that small community, she had total control. She was able to manufacture on a regular basis circumstances where she placed people in situations they would not have chosen to be in should they have been left to their own devices.

People were assigned different tasks every week to undertake the process of maintaining and upkeep of the community. Such tasks included cooking, trash hauling, gardening, conducting guided tours, serving meals and washing dishes, preparing rooms for guests—everything that went into household activities. The assignment list appeared impersonally every Monday morning. It was pinned to the board in the kitchen, thus putting a distance between Olgivanna and the process.

An experience in my first year stands out. Olgivanna knew that I came from Egypt where there is a decided distinction between the social roles assumed by males and females. Females, particularly in the early fifties, were usually relegated to household matters, while males were responsible for the more worldly affairs. These roles generated a set of emotional responses so real that they became like nature itself. One of the first assignments I had at Taliesin West was to do laundry. That meant collecting towels, napkins, tablecloths, bed sheets, pillowcases, and the like; washing them in a most primitive washing machine, passing them through the mangle, hanging them on the clothesline. I collected them

after they had dried, ironed them, folded them, and put them in the various closets.

When I first joined the group I had a large black handlebar moustache. I must have felt in some way equal to that prominent feature that dominated my face. Besides, I was the first born of seven. I was brought up like a little prince with plenty of maids who did the laundry and household work. To be assigned to do laundry was a soul-searching experience, at best. I felt humiliated and unimportant. I could have rebelled and refused it, but I felt too proud to appear as though I were shrinking before an unpleasant task.

While these experiences might appear simple in their construction, they in fact command the same intensity in self-examination as any of the momentous situations one meets in life. The point always is to force a person to confront his habitual view of himself and maybe revise that view.

Each assignment lasted a week. At the beginning of that week I went through painful inner resistance, which twisted my outer attitudes. I became irritable and difficult to be with. As I observed that in the attitudes of others toward me, I began to appear unproductive and juvenile. By the end of the week I had a feeling of acceptance accompanied by relief and a sense of triumph. That was the only time I was given the task of laundry.

I had strong likes and dislikes. Olgivanna was aware of that. In fact she knew how I felt about almost everyone from the reports received from her close lieutenants. Often, when to perform the task required the participation of more than one person, I was placed with someone for whom I had a particular aversion. One time, I was on duty as a cook for the whole community, a demanding task that needed organization and cooperative help. The assistant who was placed with me was an arrogant, noisy, sloppy roughneck whom I disliked intensely. As the cook, I had total responsibility for producing the meals as well as total authority in the kitchen. But, sensing the way I felt about him, my assistant challenged my authority at every turn. Caught between my impulse to show

my feelings of anger and disgust and the time-sensitive meal imperative, I was forced to fashion a course new to my experience, accept the status quo, and supplement his unsatisfactory work by filling in the vacuum myself to produce the meal on time.

There was sometimes a windfall from these situations. By being forced to deal with someone for a week or two on a steady basis, you will inadvertently discover a human side of that person that you would have missed, had you dismissed him or her out of hand based on simple likes or dislikes.

Orchestrating a situation of conflict at times had some entertaining value. Prince Giovanni Del Drago, Italian royalty, descendant of Marie Therese of Austria, joined the Taliesin fellowship in the fifties. He was an affable, charming and handsome young man. He was about my age and we became fast friends. We were joined in many of the day-to-day tasks.

A year or two later, Marquis Franco D'Yalavalva became a member of the community. He was another tall, dark, and handsome Italian, with an air of aristocratic mystery. He was socially at ease and he kissed women's hands often.

Franco was included in a small, private dinner. By design, Giovanni was on kitchen duty. That meant that he would serve the dinner to the guests who sat conversing around the table. The dinner did not seem to be coming in a timely fashion. After what seemed like an eternity, another young man walked in carrying dinner plates. Giovanni had walked out, refusing to serve a marquis, a rank decidedly lower than his own. Giovanni's confrontation with himself had the same intensity it would have had, whatever the cause of the confrontation. It was reminiscent of my laundry experience.

There were as many ways to produce conflict as there were venues for life. An experience took place many years later during my marriage to Barbara, my wealthy second wife. I was intensely unhappy, suffering from abusive and addictive assaults on the marriage from a wife whose view of a union was radically different from mine. I had succumbed to

the charms of an attractive young woman twenty years my junior who had made a great effort to attract my attention. My wife's frequent trips to Oakland gave my new friend and me plenty of space to partake of a life-rejuvenating experience.

Olgivanna knew about the relationship. Being aware of my dilemma in my unworkable marriage, she realized the necessity for a valve that could release some of the pressure before it exploded. Mainly to add a note of discomfort to my bliss at the same time she showed me understanding, she spread to the community through her group of lieutenants an irate sense of indignation at my immorality, which brought pressure to bear on me. She could also ensure deniability should the circumstances require it.

At Taliesin in Wisconsin this delightful young woman and I would steal away and head for the woods or the open fields and have our time together among the birds under the sky.

One day Olgivanna called me in to have a talk. As I sat down on a chair in front of her, she said in a hushed voice that suggested intimacy as though we were sharing a secret only she and I should know about:

"Down in the guest wing there is a room that no one uses. It is all but abandoned because it has been in such a state of disrepair. The plaster is falling, the windows do not work, the lights need attention, the shelves need replacing, and more. You can use this room to spend your intimate time with your friend. But you need to address these construction problems and do what needs to be done to repair it."

I was not surprised by the offer. Over the years Olgivanna and I had talked about sexuality in objective and open terms. She was familiar with my appetites in that regard and she never discouraged me from following my instincts. What struck me, however, was that she knew that I had no money to spend on repairs of that kind, and she never suggested how she thought I should acquire such funds. Clearly, she expected me to gain access to some of my wife's money in order to accomplish that objective. I had never tried or wanted to try to have such access and was particularly sensitive to even talking about it. But I went to the guest

wing to look at the room as I was thinking about a graceful manner to deal with the matter. As she had said, it was truly in a state of disrepair. When I went to see it a day or two later, I was relieved to find that someone had been there and left a mattress leaning on one of the walls. So, I thought, the room was not as abandoned or as secure as Olgivanna had made it out to be. This gave me a way out of the project.

When I told her about my decision to abandon the idea, her face changed. I could tell that she was disappointed at missing the chance to have the room repaired with someone else's money, but more because a manipulative maneuver was thwarted by unforeseen circumstances.

Aside from the obvious, Olgivanna was making my blissful relationship with my young lady friend an irritating source of conflict. First, she had emphasized the immorality of my behavior to the group with which I had to deal all day long. Second, she had put me in a position where I had to decide between two objectionable courses. Either I had to gain access to my wife's money, which she knew would be the most abhorrent act I could think of, or I had to disappoint Olgivanna by not volunteering to repair the room, letting down the cause of Taliesin. Either would place a measure of guilt on me.

Significantly, this event coincided with Olgivanna's predilection for intrigue, a quality that influenced many of her actions. It always fascinated her to be able to hide in plain view, in order to witness people who were in their state of sleep and could miss an otherwise obvious phenomenon taking place under their noses.

She told me once about an incident during her time at the Institute with Gurdjieff. While doing laundry one day, out of curiosity, she pushed an old door which she must have seen many times before, and found an abandoned room. Intrigued by the discovery, she took stock of the space then got to work. She cleaned the room and whitewashed the walls. She moved in a chair and took a book and felt that she was in her own palace, a place she earned in order to enjoy her solitude.

When Gurdjieff discovered it one day, he gave Olgivanna a "divine smile" of approval without saying a word.

All this does not alter the fact that when I first knew her, she was particularly kind to me. Indeed, she treated me like a son.

~

On a Sunday afternoon in July 1952, I had been a member of the Fellowship for about eight months. I was standing by the Hillside Theater at Taliesin in Wisconsin, which we were in the process of rebuilding after the fire that had destroyed it. Mr. Wright was drawing plans for the new theater while the smoke was still rising from the old one. Olgivanna drove across the hill to the building site, where we were standing, in her new Ford station wagon, which Mr. Wright had bought for her one week earlier. He had had it repainted in the special red he had devised, which came to be called Taliesin Red.

I approached her apprehensively and asked her if I could borrow her car to go to Madison. She was unmistakably startled at the request. Years later, I learned that the request was a daring thing to do, something on the order of a fool rushing in where angels fear to tread. But she was kind to me and asked, "What are you going to do in Madison?"

"I will see a girl," I said.

"Who is the girl?" she asked inquisitively.

"Well, Mrs. Wright…" I took my time in answering. Then I continued, "She is a girl I met last week."

"How did you meet her?" she pressed.

I said that she had been walking down State Street.

"What do you mean?" she asked, in her distinct East European accent, lifting her eyebrows and feigning surprise. "You mean you just walked up to her and talked to her on the street?"

"Yes," I said.

"Well, what did you say?" she asked again.

By this time I could hardly wait for this conversation to be over even if she did not lend me her car. I said, "I told her that she looked like my sister."

I could see that Olgivanna was suppressing a smile, which gave me some relief. Then she said, "All right, I will lend you my car. But you

have to be back in time for the Sunday formal dinner with Mr. Wright."

Sunday evening was the time when we dressed formally in black ties and long dresses to participate in a family-like dinner, often with invited guests, when a choral and orchestral program would take place. It was a central part of the life at Taliesin. Olgivanna described to me in graphic terms what would happen to me if I did not.

"Of course," I said and quickly ran for the car. I went to Madison, met my girl and returned late that night, missing the entire evening. Needless to say, that was a sin.

When I saw Olgivanna the next day, she looked deep into my eyes meaningfully and said, "Well, you go your way and I go mine."

I was very sorry and embarrassed that I had not kept my word. But it was too late to do anything about it by that time. Those words were the only overt response she ever had to my act. However, for weeks afterward, this remained an issue in our relationship of which she, in subtle ways, made me aware every time we met, even in a group. She always made a subtle change of demeanor when she directed the conversation toward me. She was able to change her demeanor at will every time she spoke with anyone even in a group, thus maintaining the continuity of the relationship with that person at all times, without the use of words. She was able to look at someone with a faint smile, at the other with a stern expression, at another with no expression at all. She might simply look through the person as though he were not there. All this happened in the course of a normal casual conversation.

For those who hung a great deal of weight on their relationship with her, these nuances had a profound influence on their state of mind. The others simply recognized that she was the only game in town and they needed to pay attention to the signals. In that way, she commanded the attention of everyone—those who loved her and those who hated her—with equal intensity.

CHAPTER 10

SACRED DANCES

> ...*after the work of George Ivanovitch we can understand better that music helps to concentrate, to bring oneself to an inner state where we can assume the greatest possible emanations. That is why music is just the thing which helps you to see higher.*
>
> —*Thomas de Hartmann*

THE MOST VISIBLE ASPECT OF GURDJIEFF'S WORK, and certainly the most infatuating, was the ritual exercise performed to music of his composition, developed and played by Thomas de Hartmann. De Hartmann, a professor of composition at the conservatory in Tiflis, was a pupil of long standing in the Gurdjieff group.

When the Taliesin Fellowship started in 1932, Olgivanna had intended to teach Gurdjieff's sacred exercises to whoever of the Fellowship wanted to learn them. But Mr. Wright was too jealous to allow her to have such close contact with anyone other than himself. Eventually, she taught the movements to her daughter Iovanna and waited until Iovanna was old enough to conduct a dance class within the group.

One cannot talk about the movements without talking about Iovanna, the only daughter of Frank Lloyd Wright and Olgivanna. She was born soon after her parents met. I knew her when she was twenty-six, instructing the movements. She was intense and talented and she was somewhat wild. She had brown eyes and a large mass of brown hair

tastefully arranged on her head and around her face. She was attractive, forceful, and appeared to be spoiled. She seemed to have her way with her parents until I came to believe later that she was shadowed by her mother's strong and controlling arm all the years of her life. But she was a focused and competent instructor of the sacred dances.

Not long after I joined the Fellowship, during a chance encounter with Iovanna, she asked if I wanted to join the movements. I had just arrived from an Egypt that was on the eve of a revolution with all the attending forces inherent in an upheaval. When I heard the word *movement*, all I could think of was some kind of clandestine activity taking place underground.

I said, "What are movements?"

"Just come after dinner at eight-thirty and you will see," she said.

Iovanna lived in the Sun Trap, so named because it was designed to trap the sun's rays in winter, the only time the group spent in Arizona. It was a pleasant space, an exciting form built of desert masonry and canvas on the same order as the rest of the compound was to be constructed over the following years. It had a generous living room, a lovely bedroom, a kitchen, and a bath. Guest quarters were attached to one side of the space. The Wrights had lived in the Sun Trap when they first came to Arizona. It became Iovanna's residence after the main residence was constructed. In that space, the movements' practice was held three times a week after dinner.

When I walked with apprehension into the Sun Trap that evening, someone was playing the piano. The music was lyrical and catchy; it was pleasant and rhythmical. I do not remember ever feeling more awkward than I did when I was asked to take a place in the back row and simply follow the motions of the others. My arms went flying in the air in every direction in an attempt to copy the postures of whoever was in front of me, always arriving in a compromised position behind the beat. The experience seemed hopeless, especially since I had no context for these exercises. Hopeless as they were, they were seductive and challenging.

Within months I acquired some facility in remembering and performing. Not long after that I was placed at front row center. At first I did not make the connection between these exercises and the work of Gurdjieff. Only later on did I learn that the movements were based on the sacred ritual dances he had gathered during his expeditions to the Near East and Asia. He had first taught them in his Institute in Tiflis in the Caucasus and later at the Prieure. When Olgivanna joined him in Tiflis in 1919, she became involved in these dances and eventually taught them.

The movements were complex and intensely demanding exercises that at once involved three or four parts of the body—the head, the arms, the feet, and possibly the torso—each moving in a separate pattern and often to a different rhythm. Added to that was a counting pattern, invariably based on obscurely structured numerical statements that one had to make as one's body was moving. It was an exhausting experience but profoundly exhilarating when done correctly. The objective was the process of learning. The rigorous training of the body by forcing it to move in this highly disciplined fashion had the collateral effect of teaching one's mind to focus for extended periods of time. Thus the movements promoted mental awareness as one discovered the potential inherent in one's body.

Many years later, through fairly extensive reading, I learned how the incremental development of the skills performed by the human hand during the past 100,000 years was instrumental in expanding the complexity of the human brain and in developing language and culture. From a neurological perspective, interdependence between motor skills and brain function constitutes a special intelligence accessible only through demanding physical work.

When I had my first encounter with the ritual dances in the Sun Trap that evening, I had no idea about the complexity or the implications of those exercises. I was baffled but interested enough to continue. At that time I had not known of Olgivanna's involvement but having Iovanna as an instructor was an attractive circumstance that contribut-

SACRED DANCES 85

ed to my interest. I would later learn that Olgivanna was the initiator and generator of all matters concerning the dances to the last detail. A routine was developed over the months: we practiced three times a week, learning and improving the various exercises. But we seemed to reach a plateau where this activity became more habitual than stimulating.

When Gurdjieff traveled to America in 1924, his public demonstrations in New York, Philadelphia, Boston, and Chicago attracted a number of new pupils of note. Besides attracting new pupils, a demonstration represented a goal that the group could work toward, making a super effort to hone its skills, refine its performance, test its endurance and provide an environment for conflicts as encounters between performers intensified.

For the same reason, Olgivanna decided that our group at Taliesin should give a demonstration. After I had been in the Fellowship for just over a year, it was announced that we would give a full-length dance demonstration in the Goodman Theater in Chicago on November 3, 1953. The announcement was made in the spring of that year, so we had the summer to prepare. The repertoire of the exercises was long and wide. By then, I was placed front row center, and the task was overwhelming. I would have to learn all the exercises, perhaps thirty of them, during that summer. It was a daunting prospect. When sometimes in later years I was asked, "If you were to single out one lesson as the most significant of all the lessons you learned at Taliesin, what would that be?"

I would think of this experience and answer, "I learned how to learn."

In a process acquired through consistent and focused practice, one can shift one's mind into a gear that opens the receptive mechanism, absorbs and processes without resistance all the information directed at it. During that summer of 1953, I came to that realization as I was learning the large repertoire of dances. I was working with the group, then practicing alone in front of a mirror. Most of the day, I was rehearsing and reviewing the dances in my mind as I was engaged in other activities.

The dances had a wide range. Some, called prayers, included grace-
ful turning with the arms moving slowly from starting position to an
ending one with a series of variations in between. Some were per-
formed in rows, others in more complex formations. The movements
were generally performed by the whole group, although a few were gen-
der specific.

One dance, for a small group of six men in a symmetrical forma-
tion, had originated in Tibet. It was a series of powerful, hard-to-hold
positions sharply changing on a strong rhythm accompanied by a shout
of Ho-Ya falling on certain beats.

In another, which originated in India, a number of women moved
delicately in ever-changing circular patterns. As they swayed at the
waist, they slowly changed their arm positions, stretching or contracting
as the head changed its attitude.

A third dance, which came from eastern Asia, was particularly
difficult. In it, we counted in the Russian language. I led the group from
where I stood in the center of the stage surrounded by a one-line half-
circle of men situated at some distance from me. This exercise was quite
long, with a steady unchanging beat, much like a heartbeat. But the
movements, which were slow and deliberate, were ever changing with-
out a particular sequence or repetition. There were no patterns or refer-
ence points by which one could find one's position. We had to memorize
the whole long exercise by rote.

That summer, Mr. Wright was in New York directing the erection and
organization of an exhibit of his work on Fifth Avenue and 89th Street
on the property on which the Guggenheim Museum was constructed a
few years later. His absence from Taliesin allowed Olgivanna to direct
that the tables in the drafting room be moved to one end of the space in
order to provide an area large enough for the constant practice rehears-
als that went on under the direction of Iovanna.

During the endless rehearsals of that long summer where everyone
was learning, making mistakes, and being frustrated, the emotional

pitch often reached intolerable levels and tempers flared. Iovanna was often arbitrary and offensive, or so the rest of us thought.

Olgivanna, who was made aware of every detail of the happenings on a regular basis, manipulated the process from a distance. Besides defining the technical and mechanical criteria for the final product, she also manipulated the people who were working on producing the event. Through Iovanna she moved them from one position to the other in a manner that might look arbitrary but guaranteed to cause maximum distress. That way she could intensify the experience and produce an atmosphere where she could give her instructions about the human condition to individuals who were frayed at the edges and weak enough to accept the instructions. Some would complain to her. Some would seek her guidance. In my case I often flew into a rage at Iovanna or someone else. It is amazing, however, the relief accompanied by a sense of accomplishment one felt when the demonstration was over.

Another activity—the designing and making of the elaborate costumes by the same people who were doing the dancing—went on in parallel to the dance rehearsals. That was another stressful activity. Olgivanna checked every single one of the costumes and she would throw them out for the slightest defect. This happened so often that one of the group, Joe Fabris, who was on the telephone urging the calico shop on the other end of the line to hurry in sending a certain material, quipped, "We have to have it by Tuesday because we need to throw it out by Thursday."

By the first of November we were as ready as we were ever going to be. We carried ourselves in a bus and the costumes in a van and we were backstage at the Goodman Theater in Chicago on the morning of November 3 for some last-minute rehearsals. We hired a number of musicians to play. We also retained the services of Arthur Zack, then conductor of the Rockford Symphony, to conduct. We were to give a matinee at 2:30 in the afternoon and another soiree at 8:00 in the evening.

Olgivanna had prevailed on Mr. Wright to fly to Chicago to intro-

duce his daughter. Just before each of the demonstrations, he walked onto the stage dressed in an impeccable white suit and spoke for a few minutes, introducing his daughter as the producer. Not to be outdone, he referred to himself as the producer of the producer.

At that moment we were witnessing the fruit of the organization Olgivanna had single-handedly directed with unusual competence within the body of another unrelated and largely unsympathetic endeavor.

In Chicago, she appeared during the rehearsals and between demonstrations when the dancers were expecting reactions and comments on their work. She seemed to be the only person who could make those comments in a meaningful way. But her being there created an ominous presence, as she would wrap herself in an impervious and impersonal shield, looking through everyone as though she were seeing no one. That was one of her many ways of maintaining control. She was able to emanate an atmosphere of impending but indefinable doom, thus keeping everyone's attention focused on her to clear the air she herself had just polluted. This maneuver always made me angry and I usually responded by leaving the whole environment. By so doing I gave myself a small sense of independence from this pervasive and I felt wanton control. She was always aware of my behavior but she never mentioned it to me.

We were all waiting for the press reviews the next morning. We did not expect rave reviews but we were not prepared for the three-inch headlines on the front page: TALIESIN DANCES, STIFF AND GRIM. In the text there was a mention of a dancer with a large moustache in the front row (that was I) who was counting his one, two, three, and four loudly. More devastating comments followed. While all this did not please Olgivanna, it destroyed Iovanna and promptly put her on the warpath to get revenge on everyone.

We continued to have demonstrations in our pavilion theater at Taliesin West. But that was our home turf, and the critics were kinder there than in Chicago. Then in 1961 we prepared for another big demonstration

event in Dallas, Texas. The place was the innovative Kalita Humphreys Theater designed by Mr. Wright in 1955. That event was a landmark of sorts. During the preceding ten years the thrust of the dances had changed. The Gurdjieff movements were gradually deleted from the program and were replaced by dances representing epics choreographed by Iovanna. Some of those epics had a religious content, some had an artistic base. In one, called "Prima Vera" after Botticelli's painting, the women go through a lyrical sequence, ending in a pose depicting that of the painting. By that time I was doing some choreography for my own solo dances. Olgivanna was composing all the music. Olgivanna explained the reason for the change one day. "Gurdjieff's exercises were like the alphabet in a language. We will use it as basis for our work," she said.

The Dallas demonstration was reviewed in the *Dallas Morning News* by the notable theater critic John Rosenfeld. His balanced review recognized the serious effort that went into the work. He said that Iovanna did not make dancers out of all the student architects but that she taught them how to dance. He wrote about her gifts in choreography and of her mother's more-than-assistant role. He also wrote, "Kamal Amin danced some choreographic intricacies with a notable kinetic charge."

CHAPTER 11

GOVERNMENT AFFAIRS

> *Bureaucrats: They are dead at thirty and buried at*
> *sixty. They are like custard pies; you can't nail them to*
> *a wall.*
>
> —*Frank Lloyd Wright*

A YEAR AFTER MY ARRIVAL AT TALIESIN, I had to deal with unresolved immigration problems. We were in Wisconsin. I took the bus from Spring Green to Milwaukee in order to meet with Immigration officials. I was apprehensive about this face-off with the government, but I had no choice. Will they deport me, I wondered, or will they put me in prison? In the bleak Kafka-like environment of the Immigration office, a quick look at my papers was sufficient for the Immigration officer to wonder out loud what I was doing in Wisconsin on a visa that indicated New York as my place of alien residence.

"I changed my mind after landing in America," I said, "and decided to spend some time with Frank Lloyd Wright before I went to Rensselaer." I was lying, but I did not give my conscience enough time to talk back. During the discussion that ensued, the officer decided to withdraw my student visa and issue me a three-month visitor visa with no possibility for extension. It was a qualified relief.

I was grateful that I was not deported on the spot but three months were not time enough even to turn around. I had no viable options that would affect the meeting in Milwaukee. So I decided to do nothing and

let fate decide the next move. I continued my life as a member in good standing at Taliesin, which meant spending the summers in Wisconsin and the winters in Arizona at Taliesin West. Eventually the constant moving proved to be an advantage. A moving target is harder to hit. I blinked twice and the three months ended. I did not try to renew the visa, so I did not have to appear before an Immigration officer. My legal stay had ended. I would be vulnerable without any recourse.

I had gone to Taliesin with the idea of staying a year, then going to Switzerland to get a Ph.D. in hospital design, return to Cairo, and have a specialized architectural practice in that field. But meeting Mr. Wright had completely changed my plans, and I had decided to stay with him as long as I could.

From the spring of 1953 when my visa expired until the spring of 1955 when I left America on a trip to Egypt, I was an illegal alien. I hope that the statute of limitations has run out on my breaches of any applicable laws. Being illegal did not feel any different from being legal. My busy and involved life at Taliesin left me no time to think about the issue as long as I avoided confrontations with Immigration.

One inadvertent event, however, almost upset the apple cart. I was traveling from Wisconsin to Arizona with my then-current girlfriend. I was driving a Chrysler Imperial that belonged to a friend. My friend had to fly. Outside of Santa Fe, New Mexico, two highway patrol officers stopped us. I was not speeding, but apparently the appearance of a foreign young man with a large black moustache and a blonde young woman driving along in an obviously expensive car aroused suspicion. I felt decidedly in a weak position as my thoughts went to my passport with an expired visa.

But I asked them why we were being stopped, and my girlfriend asked the officers for their names and received them. One of the officers seemed to know who Frank Lloyd Wright was and referred to him as Mr. Wright. That was comforting. In anticipation of being asked about identification, I took the risk of preempting the whole scene by thrusting my passport in the officer's face, banking on the probability that a high-

REFLECTIONS FROM THE SHINING BROW

way patrolman in New Mexico would not know what to look for in a passport written in Arabic and French. The crisis passed and we were on our way. By the time I returned from Egypt that fall, Taliesin was recognized as an educational institution for GIs. This gave it the legitimacy that allowed me to obtain a new student visa.

I have been legal since.

I had, for eight years, seen America through the eyes of a great American: Frank Lloyd Wright. As a young man from Egypt I had begun to see the uniqueness that made America what it is. President Kennedy's inaugural address in January 1961 was a floodlight that illuminated for me a mysteriously exciting past. I read his book *Profiles in Courage*. I had never heard the names of the personalities he profiled, but I was excited by the tone and thrust of the message. Very quickly, America became home, and for the first time I had patriotic feelings for a geographic location on the planet.

I began to understand the institutions that maintained the balance of powers in the government and the innate respect by the American people for these institutions. When the dimensions of the body of abuses referred to collectively as Watergate became clear, I surprised myself by the intensity of rage I felt toward President Nixon and the group of thugs he had surrounded himself with, and I made my feelings known loud and clear.

Probably the first time I really felt like an American was as the Watergate saga dominated the airwaves, six years after I had become a citizen. In 1974, during the height of that crisis, Olgivanna called me in for a talk. As I sat down with her that afternoon, she said to me in her distinctive East European accent, "What is this I hear about you? People tell me that you have gone mad with anger at Nixon."

"I am angry, Mrs. Wright," I said. "He is abusing the institutions of this country—the FBI, the CIA, the IRS, and others."

"But," she said, "have you looked at all sides of the issue? Are you completely sure about your information? Can you find any mitigating circumstances?"

She had written a piece in the local paper, which had been reviewed on the radio that day. It was kind to President Nixon, presenting a human face to an issue where the media were having a field day in judgment and condemnation. I believe Olgivanna was hoping that the president would become aware of it and perhaps respond in some way. It did not happen.

I said excitedly, "There is absolutely no excuse for using the CIA or the FBI to spy on or harass law-abiding citizens who simply go about doing their work. I love this country and he is destroying it."

After thirty minutes of this discussion, we agreed to disagree. Later on that evening at home, I was having a drink. As I thought about our meeting, it became quite clear to me that the purpose of that encounter was not to have a political discussion; rather, it was to test my conviction and my ability to articulate my passion. She wanted to be sure that my feelings were truly my own, rather than those transferred from a mass sentiment. I must have passed the test because I noticed a faint smile on her face as I stood up to leave.

For the first eight years that I lived in the United States, I had intended to return eventually to Europe and Egypt. After Mr. Wright died in 1959, a strong sense of mission suddenly caused me to revise my plans and think about staying to carry on his work.

My father had been writing me, pressuring me to return to Egypt, citing family responsibilities. Nothing he wrote made any sense to me or had any effect. One day Olgivanna, who had known about my plans, called me in and said to me in the softest voice, "Why don't you stay? There is nothing to go back to in Egypt and there is much you can do here." It did not take much persuading. Then she said, "Just go ahead and begin your citizenship papers." That was in 1960.

I did apply, and in November 1968, I was sworn in by Justice Tom Clark at Grady Gammage Auditorium at Arizona State University in Tempe, Arizona, along with 102 other new citizens. I had done the structural engineering on the roof of that auditorium, which was origi-

nally designed by Mr. Wright for Baghdad in 1957, then modified by Taliesin for Arizona State University.

While we were waiting for Justice Clark to arrive, someone asked me if I had anything to do with that building. I said that I had done the structural engineering on the roof. This person related that piece of information to the one next to him, who in turn did the same to the person next to him. Soon, a number of those present were looking in my direction. By the time this information came back to me from the other side, it was magnified to the tune of making me out as the one who had designed the whole building. No amount of effort could make a dent in the rumor.

Sometime during the weeks preceding the swearing in, I had been summoned to the Immigration and Naturalization office to take my history examination. That was shortly after the 1967 six-day war between Israel and its Arab neighbors. The examiner's last name, as I found out later, was Israel. I am sure that he was bending over backwards in order not to give me any reason to doubt his fairness. His only question to me was, "Who is the President of the United States now?"

"Lyndon Johnson," I said.

"Very good," he said. "You pass."

I wished he had asked me some real questions. By that time I had developed an affinity for American history and was making a serious study of it. I wanted to show off to the examiner.

CHAPTER 12
BERLIN

> *The human mind is like an umbrella; it functions best when open.*
>
> —*Walter Gropius*

IN THE SUMMER OF 1955, I HAD BEEN WITH Mr. Wright almost four years. I had been an illegal alien for nearly two years, and I decided to spend the summer in Egypt, then re-enter the States now that Taliesin was being recognized as an educational institution suitable for GIs. I had lost my student visa as a result of absence of that recognition. But I could re-enter legally with the change of status.

I stayed in Egypt a little longer than expected. One day I received a telegram from Mr. and Mrs. Wright telling me how much they missed me and inquiring as to my time of return. I was ecstatic at getting that message. My father told me later, "As soon as that telegram arrived we could not hold you down." I saved that telegram for years. But in a fire at Taliesin West in 1964 I lost it along with everything I owned.

On my way back to the States toward the end of the summer, I made a stop in Berlin where I had a friend from my school days in Cairo. A competition had been announced for a large office complex to be constructed in Cologne across the Rhine River from the great cathedral. With the help of my friend I would try to associate with a local German firm and see if we could cooperate on entering the competition. We did that and I was to design the building after I returned to the States.

My visit to Berlin lasted about a month. I stayed in Ich Kamp. During that visit I had the good fortune to spend some time with the illustrious architect Hans Sharoun. Mr. Sharoun's career had been wide-ranging. At sixty-two, he was a gracious, portly gentleman, chairman of the architectural department at the University of Berlin. A few years after our meeting, he designed the home of the Berlin Philharmonic, an innovative and widely publicized building.

During some of our talks he left me with the distinct impression that my four years with Frank Lloyd Wright could qualify me to write a dissertation on the great architect, which could earn me a Ph.D. in architecture from the University of Berlin. I was a member in good standing in the office of Frank Lloyd Wright, on my way back to work. But the prestige of a Ph.D. from the University of Berlin was a cause for much soul searching.

For the first time I was forced to view from a fresh perspective the popular notion that obtaining additional certification is a more desirable option for the willing and able. I was already working with the greatest architect of all time, partaking in an inexhaustible well of creative energy. To obtain the degree I would have to give all that up and spend a number of years writing and polishing a dissertation about what I could be and preferred to be doing. Then what have I got at the end? It was not a difficult decision to make, and I never regretted returning to the office of Frank Lloyd Wright to continue my work with him.

During that same trip I met Walter Gropius, who had founded the Bauhaus in 1919 and who was on a visit to Berlin from the States to give a lecture. It was the first of two occasions when I met him. The second was about 1963 at Taliesin West. Mr. Gropius and his wife had arrived unannounced to take the regular guided tour. Someone recognized him and informed Olgivanna about his presence on the premises. She came out to greet him and invited him and his wife for cocktails and dinner. On both occasions he told me that his mother had given him as a present Mr. Wright's 1911 Berlin portfolio *The Ausgeführte Bauten,* which

represented Wright's work from 1902 through 1910. He spoke of the influence this work had had on him. The work of the Bauhaus had been greatly influenced by Mr. Wright's work during the period illustrated in that portfolio.

As soon as I arrived at Taliesin in Wisconsin, I had a delightful lunch with Mr. Wright, during which we discussed a radio interview I had been invited to give in Berlin. Then I went to work on the design of the office building for the Cologne competition. I wish the episode that followed had never happened in quite the way it did.

I had been absolutely fascinated with Mr. Wright's design called Crystal Heights for the corner of Connecticut and Florida Avenues in Washington, D.C. Every time I started to sketch something, my mind became overwhelmed with that design. Some time elapsed before I thought that I had gotten that design out of my system. I drew the project. Subconsciously, I must have incorporated much of Crystal Heights into my drawing without realizing I had done that.

I told Mr. Wright what I was doing and asked him if he would like to critique my work. He was very kind and walked with me to my desk. He sat on my chair. After he had looked at my drawing, he stood up and said, angrily, "This has been done before."

Then he walked away. It was not my proudest moment.

CHAPTER 13
TRANSITIONS

> *Why, I just shake the buildings out of my sleeves.*
> *—Frank Lloyd Wright*

THE YEAR 1956 WAS SOMEWHAT OF A WATERSHED in the development of Olgivanna's work at Taliesin. Mr. Wright was a youthful eighty-nine years old and he was at the top of his form. He was working every day and he was at the height of his creative powers. According to his doctor he had the vital signs of a forty-five-year-old. He looked as though he could go on forever. A visiting history professor from Brighton, England, asked me one day, "What will you do after Mr. Wright dies?"

I said without hesitation, "Mr. Wright will never die." It was almost a conviction.

In 1956, a number of exciting projects were on the boards and many others were coming in regularly. Those projects included the Guggenheim Museum in New York City, the Price Tower in Oklahoma, the Beth Shalom Synagogue in Philadelphia, and many private residences.

One morning during that summer, I was working at my desk at the Hillside drafting room in Wisconsin when I heard Mr. Wright walking in, dragging his cane across the flagstone floor, humming a tune as he sometimes did when he had an idea working in his mind. He said as he approached his desk in the front of the room by the fireplace, "Well, boys, today I am going to design a Greek Orthodox Church and a mile-high skyscraper."

It was 9 A.M. He sat at his desk and started to work. I could see from where I was sitting at my desk the quick and sure movements of his hands as he moved the T-square and triangles about his paper. It reminded me of the times he had sat in my seat at my desk to work over my drawings. Magic sprang from his hands.

By noon he had drawn the Greek Orthodox Church, which looked exactly like the final building in Milwaukee completed in 1961. He had also drawn the mile-high skyscraper, which has acquired much celebrity since.

The following year, Mr. Wright, at age ninety, flew to Iraq for meetings with officials about designing an opera house for Baghdad. He studied the maps of the properties offered by the government for the project and quickly declared that they were not suitable. In flying around the city scouting for another property, Mr. Wright pointed at an island on the outskirts of the city and said, "This is the place."

"But, Mr. Wright, this island belongs to the king."

"I would like to see the king," said the passionate architect.

The next day he swept into the king's court in his famous cape. In his grand and persuasive manner he made the case for the island as the most suitable location for the opera house. King Faisal said without hesitation, "The island is yours, Mr. Wright."

After Baghdad, my father hosted the Wrights and Wesley Peters, who had accompanied them for a sightseeing and lecture tour in Cairo. In a letter kept in the Frank Lloyd Wright archives of June 11, 1957, Olgivanna wrote, in part, to her brother Vlado about the trip to Baghdad and Cairo:

> We met Kamal's father, mother, and sister. He has a fine
> family, extremely kind and very intelligent, who gave us
> tremendous honor wherever we were. We had formal in-
> troductions and receptions, and we went on a marvelous

boat trip down the Nile with a sumptuous lunch with the wine and delicacies all very beautifully served. Kamal took care of us by calling and writing instructions to his parents about what hotel to put us in, and that the rooms should face the pyramid. It was a wonderful sensation to wake up in the morning, go out on the balcony, and see the pyramid within the throw of a stone. These were our experiences, very rich. Never have I had as fruitful and as powerful a trip as the one to Baghdad and Cairo.

On the Sunday morning after Mr. Wright returned from this trip, during the weekly Sunday morning talk, this great American stretched his mercurial logic, extolling the virtues of the monarchy as the ideal way to govern. We all knew just as he himself did that what he said was true only while he was the king. The following year, King Faisal was assassinated during the revolution that forever changed the complexion of that part of the world and ended the opera project.

↶

This unusual energy at his age did not obscure the statistical odds on Mr. Wright's life expectancy. Olgivanna was thirty years younger than he was, and it was highly probable that she would be at the helm sometime in the future. From the time I first knew her I could observe the subtle and steady manipulations of the organization's values and its structure in preparation for that inevitable occurrence.

Olgivanna was beginning to consolidate her long-time efforts into a structured course. She had established her bearings within the community. Her devoted followers were approximately positioned to assume their roles when the time arrived. Her deliberate and personal management style began to show as it contrasted with the easy, democratic style of Mr. Wright's. She, however, showed uncompromising deference to his wishes and demands.

Her teaching that had for many years been kept on the periphery of the architectural activity began to emerge as a legitimate segment of the

educational spectrum. The sacred dances were the most visible aspect of the Work. The movements were musical and rhythmical, and they were performed in a group. As a result they impacted the way of life overtly. A point had to come when they would emerge from the shadows, where they were kept away from Mr. Wright's path, into the light where Olgivanna thought she could deal with his resistance. On some occasions, members of the group had to be pulled away from the mainstream activities in order to be thrust into a rehearsal. Some of those who were not serious about Gurdjieff's Work experienced a low-grade resentment not unlike a low-grade fever with a seemingly obscure origin. It never got cured but eventually affected their general behavior.

Another aspect of the Work revealed itself because of an inadvertent happening. One of my delightful colleagues was the Japanese architect Taro Amano, who would later be recognized in his own right in Japan. His knowledge of the English language was so slight that I felt he did violence to the language every time he attempted to speak it.

During the first winter he was at Taliesin, Taro, in a chance meeting with Olgivanna, said to her in his heavily accented language, "Mrs. Wright, I do not understand your mind." His poor English alone could have accounted for his lack of understanding. But Olgivanna was sensitive about her message being obscure to some who might want to learn about it, so she took him seriously. In the same week she initiated a series of Tuesday afternoon talks open to whoever wanted to attend, always taking notice of those who did not attend. Those talks took place at the Sun Trap during Mr. Wright's nap because Olgivanna was always keen on avoiding the appearance that she was in competition with him. In these talks she spoke about the Work. She elaborated on being honest with oneself. She spoke about looking inward and making a serious effort, observing one's actions and motives. She often pointed out the long-practiced phenomenon of lying to oneself and the justifications one manufactures as excuses for lack of character. The talks lasted for that winter season.

REFLECTIONS FROM THE SHINING BROW

Taro and I were joined in many of the construction activities at Taliesin. We helped build a silo to store grain from our farm. Chickens laid eggs everywhere around the buildings. Taro was fond of cracking an egg once in a while and eating it raw.

I had bought a new Jeepster that summer, and I took Taro with me on the semi-annual trip to Arizona. With us was the third musketeer, the German apprentice Reinhold. It was an adventure not all of which was easy. One late night we ended up in a ditch in a snowstorm outside of Amarillo, Texas. A day or two earlier we had been lost in another snowstorm in Cheyenne, Wyoming.

Somewhere in eastern Oklahoma I picked up a hitchhiker. He was less than clean and was carrying a sack even less clean than he was. He did not seem to know where he was going. When I said that we were going south, he said that he was, too. When I said that we were going west, that seemed to be his destination. We could not get rid of him without simply telling him to leave. We stayed in a hotel in Tulsa, Oklahoma, and planned to leave very early in the morning, hoping he would not be ready that early. But as we walked out of the hotel, there he was sitting on his sack on the curb. Then I mustered all my courage and simply told him he needed to find another way.

When I was in Japan in 1975, I saw Taro, who by then was suffering from advanced Parkinson's disease. It was very difficult to see him that way. But we had a rich time together, and when I left him, we both knew it was goodbye.

The most constant, uninterrupted, significant aspect of the Work was the everyday on every occasion one-on-one talks with the various individuals whose paths, character, or attitudes brought them into confrontation with Olgivanna. Those confrontations were almost always challenging. They were never intended to be a medium for praise. If you came up short in your performance, you were told that in no uncertain terms. If you had done an admirable job, your performance was dismissed as history and you were challenged to face the next higher step.

While we were working on building the movements pavilion, I was on construction every day from 5 A.M. until 6 P.M., with brief moments for meals. Then I was at the movements practice after dinner from 8:30 P.M. until 10:00 P.M. Olgivanna called me one day to go down to see her. When I sat on the chair in front of her, she said, "I asked you to come here today because I want to urge you to make some super effort."

She knew as well as I did that there were no more hours left in the day. But I understood from that encounter that if I had developed any vanity about my usefulness in the scheme of things, I had better modify it to an acceptable level.

The same thing happened much later, about 1970, when I was doing single-handedly the structural engineering and structural drawings of the First Christian Church that was built in Phoenix in 1972. In 1950, Mr. Wright had designed that church for a congregation. It was not built at that time. He had done only a few sketches showing the aesthetics. These sketches would need a great deal of further study to turn them into a building. In the late sixties, another congregation was going to build that church. It became my task to provide the necessary engineering to transpose those sketches into a viable building.

It was an awesome task. Had Mr. Wright been living, he would have made the necessary changes in the process of study to make the building work. But in his absence it was impossible to make obvious changes that would alter the aesthetics and still call it a Frank Lloyd Wright building. I was getting up at 4 A.M. every morning, going to the drafting room, and staying there well into the night. It was for me most enjoyable work.

After a few months of this intensely focused effort Olgivanna called me to see her; then, after a few minutes of talking about me and my character, she said, "Now I want you to develop some concentration."

Clearly someone had reported to her my sustained concentration and she wanted to make sure that I had not developed a swelled head.

Olgivanna must have thought that vanity was my favorite sin. She certainly pointed it out to me on a regular basis. Heloise, the talented

sculptress who eventually did the famous bust of Mr. Wright, had decided to do one of me because she said that she was interested in my bone structure. It took many sittings, and I savored the special attention I received from that lovely woman as I was singled out for this high-profile experience. Since Olgivanna was routinely made aware of the details of everything that went on in the community, she knew that I was posing for the sculpture.

One day when the bust was completed but still in clay, Olgivanna called Heloise at an odd hour. One of her valuable Buddha statues had met a mishap, which damaged his head. Olgivanna wanted Heloise to fashion a new head to replace the damaged one. But for some reason, she wanted it right then and there. Heloise was not sure how to produce the head on such short notice.

"Do you have a clay bust you can quickly transform today?" Olgivanna asked.

Heloise said, "I have only the bust I did of Kamal."

"Bring it quickly and change it into a Buddha," said Olgivanna.

Heloise did just that. When I learned about that episode, my disappointment was crushing, although I tried hard to appear casually disinterested. I suppose that was good for my character.

Once, Olgivanna asked me to come down to her room to see her and startled me by saying as soon as I sat down, "I do not think that a building needs to belong to its surroundings."

The statement flew in the face of everything on which the work with Mr. Wright was predicated. By that time I had become accustomed to Olgivanna's convoluted statements, outrageous as they might be, realizing that there was always a follow up which made sense of them. I did not know how to answer but she hastened to say, "Would it not be good to have a house that can be built anywhere?" Her manner lent credence to the idea.

Then she said, "I will give you a task. I would like you to design for me some houses that can be built on any site."

Giving tasks targeted to specific objectives in an unfamiliar venue was a not infrequent method of Olgivanna's, aimed at teaching flexibility. I accepted the challenge and a few weeks later I had sketched a dozen designs. When I showed her those designs, she said, "It can be endless, can't it?"

Some time later I came to realize what I thought to be the significance of this exercise. She wanted to remove any possibility of dogmatic tendencies I might have developed about Mr. Wright's work due to the absolute devotion I had for him.

It is difficult to find language that can transmit a process in which language was the least reliable means of communication. When Olgivanna spoke with me, intending to impart knowledge, she did so on two levels. One was simple matter-of-fact indisputable information on the order of "the sun rises in the east and sets in the west" or "if you take enough poison you will die." Statements of this kind were intended to cut through unproductive circular arguments to which pseudo intellectuals are addicted. The other level of communication dealt with intangible concepts where language became inadequate.

At all times, the core of the message was conscious evolution of the human being as represented in the work of one individual—myself at that particular moment. Inner suffering resulting from life difficulties promotes awareness. It opens one to realizing and accepting dimensions of life one would normally miss during routine existence.

Olgivanna was always there providing that lesson. Within the hot house she had created where she had total control, she could provide ample opportunity for suffering. Manipulating the many activities she had at her disposal and the people engaged in those activities provided maximum equal opportunity unpleasantness for everyone. That way she offended a number of the participants. In the process she often breached some of the values conventionally regarded as sacred. Sometimes she would not keep a promise about an issue one considered vital, thus giving one a chance to examine the true value of the issue. Or she

might reveal what one considered a secret, not knowing that so many had the same experience that it was never really a secret. This obviously did not endear her to many. Indeed there developed a small industry of Olgivanna haters who maintained communication even after they left the community.

By the mid-fifties, she had complete control over the entire operation at Taliesin, except for the architectural work. She had from the beginning endeavored to have her own school. She almost had it now. She had emerged as an unchallenged force at Taliesin and she wanted to expand her influence. She also wanted to separate herself from Gurdjieff. Her book *The Struggle Within,* which outlines the Work, does not once mention Gurdjieff. She sought to recruit a whole new class of pupils who would come to Taliesin to be her pupils and to receive her teaching. She delegated some of the old apprentices, who had left and started lives of their own in various parts of the country, to persuade their friends and acquaintances to come to Spring Green. The recruits would hear Olgivanna speak, partake in the movements practice, inhale the atmosphere at Taliesin, and, of course, be close to Frank Lloyd Wright for a brief time. Many of the new recruits were not clear about what their new adventure really meant. Most of them had the impression that they would receive instructions on Gurdjieff's teachings. But, in one of Olgivanna's first talks one Sunday morning when Mr. Wright was in New York working on the Guggenheim Museum, she said sternly, in no uncertain terms: "This is not a Gurdjieff group. What you will receive here will be my instructions to show you how to lead a worthy life." By then I had become an instructor for the movements practice and I conducted two or three classes during the weekend. The guests would pay for room and board.

For a number of years these guests arrived every Friday afternoon in Spring Green from various cities. Mr. Wright had acquired a number of farms around Taliesin in order to be assured of keeping the pristine beauty of the southern Wisconsin hills. He had torn down what was less than authentic and restored the rest. We had several farmhouses, some

of which were quite charming. Olgivanna had traveled to Madison to buy furniture items from Goodwill stores in order to furnish those houses. Guests were accommodated at the various farmhouses, the farthest of which was within a fifteen-minute drive from the main buildings at Taliesin. The guests came to be named after the cities they came from: the Chicago group, the Pittsburgh group, the Indianapolis group, and so on. They were a motley assortment of groupings and individuals that I generally welcomed as their presence provided a change from our routine activities. From Chicago came a woman who had known Gurdjieff in Paris, an elderly couple who were at the time of life when they were searching for meaning, a well-to-do recovering alcoholic couple who eventually divorced. Later, the wife remarried into the Wrigley family; then mysteriously her mutilated body was found in a trashcan. There were also a young aspiring playwright and poet who was teetering on the edge of emotional balance and a number of single women whose search for enlightenment was equaled only by their search for husbands. Some of them, including the one who became my first wife, eventually found husbands and joined the Fellowship.

From Indianapolis we had a heart surgeon, who became a very close friend of mine, and his family of wife and three children, and a dentist and his wife. From Pittsburgh came a medical doctor and his very interesting wife and their daughter of seven. Eventually he became Olgivanna's personal physician. A delightful percussionist who played in a jazz band in Louisville came from Kentucky with his wife. Once or twice he brought some of his instruments. He played and sang a catchy tune that I adopted for many years:

> *You can't shake it like my sister Kate.*
> *She shakes it like jelly on a plate.*
> *It must be jelly 'cause*
> *jam don't shake like that.*

There were others.

Some participants were simply curious. One or two couples thought they might receive some counseling. The single women represented for me an attractive potential, as I am sure they did for other young men in the Fellowship.

The presence of these faces, raw from urban America, was a stimulus of sorts. They came with the preset notions prevailing in the market place where the rat race is the criterion: emotional values, behavioral patterns, and thought processes were predicated on securing survival, safety, and prosperity, often bending ethical values to facilitate those objectives. As the visitors became exposed to the atmosphere at Taliesin, questions that had existed in their minds for years probably acquired centrality and added importance. What constitutes a worthy life?

The goals outlined by urban Americans were not different from the goals we all had. Certainly Olgivanna had not taken a vow of poverty. Indeed, all the years I knew her she was keen on surrounding herself with moneyed people who, with everything equal, had easier access to her than most. What it all meant was that she wanted to reach all those goals without being a part of the rat race. She expected to be given money by the well-to-do who joined her groups in return for the assistance and guidance she imparted to them. A side issue to the presence of those individuals was the inevitable human involvements between the different individuals. Most of these involvements were sexual, which provided the ideal medium for Olgivanna to educate them when they were vulnerable.

Olgivanna had asked Mr. Wright to design a space that could be used for the movements practice and demonstrations, among other theater activities such as music and other arts. It was clearly intended for the movements. To Mr. Wright, that was not a priority. For one thing the entire effort made on behalf of the Gurdjieff teachings was an activity outside of his sphere of interest, and it had occasionally appeared to compete with him.

On one occasion when we presented our own designs to Mr. Wright for his critique, I had designed a movements pavilion for Egypt. Over

the years he had been consistently and without fail complimentary about my designs. He had enjoyed the first one I ever did for him in 1952, so much so that he had it placed on a shelf in his room for the whole summer. But when I presented the pavilion for Egypt, he said, "Give that to Iovanna." And he did not offer a critique.

That was the first time I sensed his feeling about movements. But Olgivanna had expressed to me often, "I am trying to give the 'young people' something they can call their own where they can witness the results of their own direct effort."

Olgivanna was usually able to persuade Mr. Wright to do what she thought was necessary. She had become such an indispensable and integrated force in his life that it was difficult to discern where her decision ended and his began. Eventually he sketched what came to be called "the pavilion," to be built at Taliesin West in Arizona. A small theater with a large stage and an equal area for seating about 120 people were integrated in one space, separated by an orchestra pit. The entire space was placed under one pitched roof of redwood rafters spanned with panels of colored two-layer panels of plastic material with insulation between. The stage had two sets of curtains, one set behind the other in order to change the size of the stage according to demonstration demands. They swung open with the push of a steel arm welded to the post carrying the curtain. When we began building the pavilion, Olgivanna announced that we would have a demonstration in April 1956.

The months of building were exciting, enjoyable, and productive. Day extended into night as we built concrete forms, carried heavy rocks from the mountain to place in the walls, welded the seats, and so on. Mr. Wright was always there with his cane pointing out what should be done everywhere.

A colleague of mine and I decided to surprise him. We went one afternoon in a large truck to the Indian reservation near Chandler. We drove in and, with mighty midget and chains, stole two Indian rocks with hieroglyphic writings on them. We intended to place them in the

REFLECTIONS FROM THE SHINING BROW

lower part of the fireplace so they would be exposed when the fireplace was completed. The next day Mr. Wright walked in and without looking at the two precious rocks, he made a change in the design of the fireplace so the new shape would completely cover those two rocks. My colleague and I made the change without saying anything.

As performance time approached, our work took on a more furious pitch. Not only were we trying to finish the building but also we, the builders, were also the dancers and the makers of the costumes, besides being the architects who had projects to produce for clients. More people were pulled away from the architectural work in order to participate in the demonstration effort. This made for the rising of tensions and the inevitable conflict between priorities.

During the last week or two before the event, Mr. Wright's visits to the construction site became slightly more agitated. One afternoon I was on stage kneeling on the floor having just welded the arm on the curtain post when I heard Mr. Wright's angry voice approaching. Before I knew it he was hitting the steel pipe arm, which I had just welded, with his cane about an inch from my head. The arm acted as a shield between his cane and my head.

I believe that Mr. Wright was confronted with the inevitability of the upcoming event and was struck by the fact that he had nothing to do with it. It was happening without his participation or direction. He decided that he wanted some of his drawings to be placed for exhibition at the back of the seating area in the pavilion so the members of the audience would see them as they arrived to attend the performance. Iovanna strenuously objected to the idea, and she got her way. I can only imagine the exchange between Mr. Wright and Olgivanna that afternoon and evening. But about dinnertime, an hour and a half before curtain time, I was standing by the dining room when I heard them. Mr. Wright was walking in a fast pace away from the residence, past the dining room toward the parking lot, saying that he was going to leave. He was followed closely by Olgivanna, who finally caught up with him about

where I was standing. He was burning with anger and she was hanging onto his shoulders crying and saying, "I don't want you to go. No, Frank, please, I don't want you to go."

It was an astounding scene. I do not know how long it lasted. But she eventually calmed him down and walked back with him to the residence. Later on that evening he came to the pavilion just before curtain time, after he forced a change in the program by eliminating one dance that was performed on what he considered crude rhythm. The next day I saw a relaxed Olgivanna after a late breakfast and she said, "I am like a ship in the sea. What a storm can do for me is to fill my sails so I can go faster."

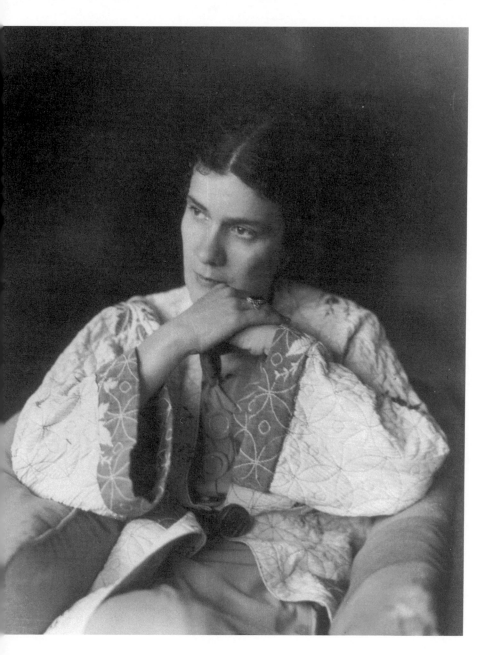

Olgivanna

*The author with Ken Lockhart surveying to build a restaurant
and a road to lead to it in Wisconsin*

Above: The author welding
Below: The author operating a front-end loader in Wisconsin

Left: The author with Eve, Olgivanna's granddaughter

Below: Mr. Wright and the author saddling Johnny Walker, Mr. Wright's horse, for daughter Iovanna

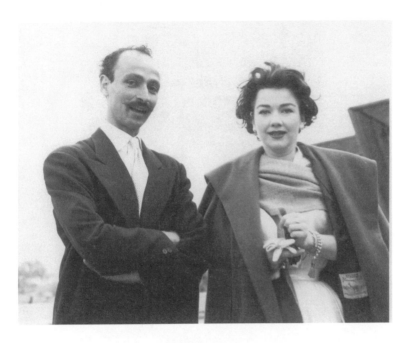

Above: The author with Ann Baxter
Below: The author's father Dr. Amin, Mr. Wright, Olgivanna,
the author's mother and sister in Cairo, 1957

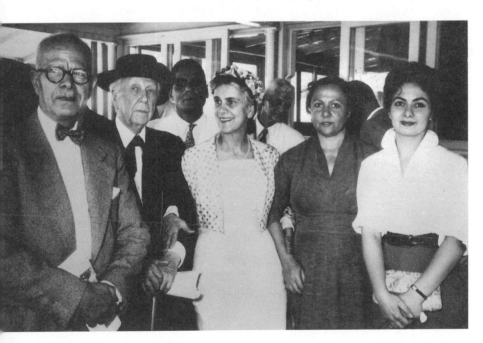

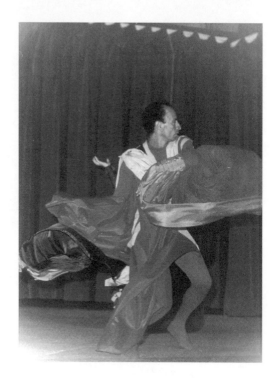

Above: The author rehearsing a dance he choreographed for a performance in Dallas
Below: The author with Olgivanna on a picnic

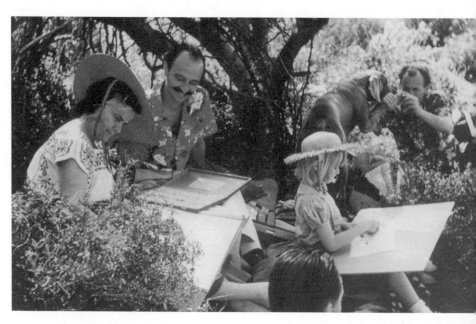

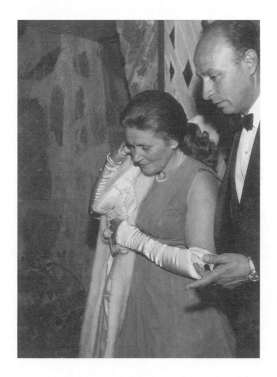

Above: Svetlana Stalin and the author at a formal dance
Below: Prince Giovanni del Drago, Maggie Savoy of the L.A. Times,
Dr. Amin, and Olgivanna in Switzerland

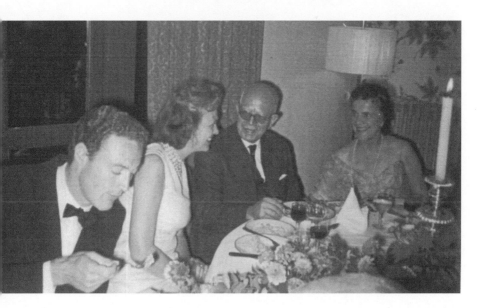

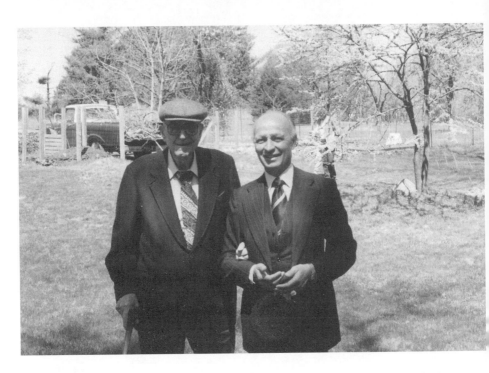

Above: The author with Dr. Karl Menninger at the doctor's birthplace in Topeka
Below: Olgivanna with the author at a formal dinner at Taliesin West

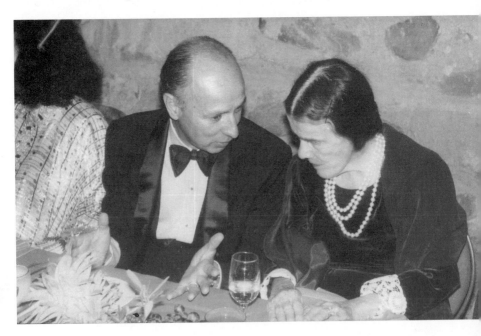

Above: Madame Jehan Sadat with the author at his home in Arizona
Below: The author, Maureen O'Sullivan, and Jim Cushing
at an exhibit of the author's work at the Arizona state capital in Phoenix

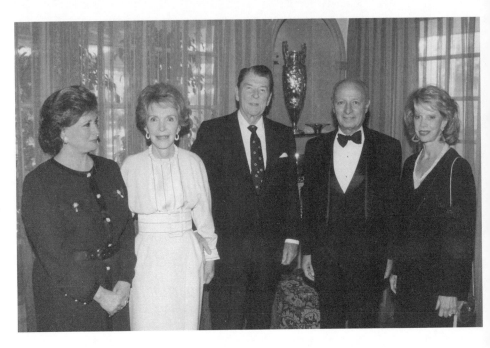

Madame Sadat, Nancy Reagan, President Reagan, the author,
and friend Martha Mako in Beverly Hills
Below: The author with President Carter at the University of Maryland

CHAPTER 14

DAILY LIFE

> *Organic architecture seeks a superior sense of us and a finer sense of comfort, expressed in organic simplicity.*
> —*Frank Lloyd Wright*

W<small>HEN</small> I <small>ARRIVED AT</small> T<small>ALIESIN</small>, I had a sense of some realities about life. But that did not at first impression indicate to me what was expected. I certainly could not fare well alongside young American boys, some of whom had tinkered with their cars since they were twelve years old. Nor was I able to compete with others who had helped their fathers add to the house or work on the farm. In the culture where I grew up, these activities were relegated to another class of people who were paid to perform them.

Nothing in my life in Egypt prepared me for a practical experience in using tools or for that matter dealing with outdoor activities. I lived in the city, read a great deal, discussed "weighty" political matters with my friends in coffee houses, and partook in a rich social life in the exciting and sometimes shadowy quarters of Cairo, where layers of 5,000 years of cultures met happily with the twentieth century.

At first, for a time, I was timid about using my hands for fear of embarrassing myself. I did not know the proper use of the different tools. One time a senior apprentice caught me using the sharp edge of a wood chisel to pick a nail that had penetrated the inside of my shoe. It was not pretty. But soon through a number of mistakes and mishaps I was handling tools, including the electric saw and rotary blades. Indeed, in a

year or two I was making ivory and ironwood jewelry for my girlfriends with some of these tools. Through Mr. Wright's generosity, that experience was rendered so accessible. He would buy truckloads of plywood and allow us to experiment with our personal projects without restricting our flights of fancy. It, however, had to be your own initiative that would get you started and get him interested.

When I first joined the Fellowship, I was given, like everyone else, a canvas sheepherder's tent, nine feet by nine feet at the base with a peak height of seven feet. The tent frame rested on the floor of the desert. A small canvas army cot on one side constituted the furniture provided with the tent. One could choose to live in this tent for the duration of the stay at Taliesin. But we were encouraged to expand or improve this circumstance or even find another location and build something new. That was my first entry into the art of building a shelter to keep me warm and dry.

In 1953, I designed a little tent. I called it a tent although it had a partial desert masonry wall, a masonry fireplace, and a sheet metal roof. But what made it a tent was that it did not have electricity or plumbing. I used a Coleman lamp for light and walked a quarter mile to the shower. I stored water in Mexican *ollas*, low-fired porous clay pots that kept the water cool as it evaporated through the pores. I drew a 500-square-foot tent design and showed it to Mr. Wright to obtain his approval. He examined it carefully and asked me a number of questions. Then he said, "It is very good. Go ahead and charge all the materials on my account at Entz White [a building material store in Phoenix]." It was at once a thrilling and a scary moment. It had always been thrilling for me to have Mr. Wright's enthusiastic support for my designs. He was always generous with his compliments. But the scary part was that I had to build the structure while still inexperienced in construction. But that was the idea. Living at Taliesin in those days was like living in an ongoing experiment. Much was being tried for the first time. Sometimes materials or methods did not work and we learned a great deal as we remedied the problems.

Building my first tent meant carrying five-gallon milk cans filled

with water across the desert to use for mixing concrete by hand in a wheelbarrow. We had only had one truck to serve everyone. It meant borrowing that truck whenever I could, driving it to a wash in the mountains where sand had accumulated, and shoveling some of that sand into the truck's bed. Then I drove to Phoenix to charge cement on Mr. Wright's account. It meant carrying rocks from the desert, placing them in wood forms, then pouring the hand-mixed concrete around them. I built a tall fireplace using the same method. Rock sizes became smaller and smaller as they were placed higher in the fireplace wall. I erected a steel frame made of thin-gauge steel channel and used sheet-metal screws to attach an aluminum-sheet roof, so thin it could not keep away the heat or cold.

It took me two winter seasons to complete enough of the tent so I could live in it while I finished it. I could work on my tent only in the time I could spare from my regular duties. Its sides were made of vertical canvas sheets that hung from the roof and were loosely attached to the floor without quite reaching it. I had regular visits from rattlesnakes, Gila monsters, ringtail cats, an occasional javalina or desert fox. My large rat trap once caught a young skunk. The trap must have damaged the gland that releases his fetid odor because there was no such odor when I carried him out to get rid of him.

A family of screech owls got in the habit of taking residence in my tent during the summers while we were at Taliesin in Wisconsin. Shortly after I returned to the desert one fall, I was awakened in the middle of the night. I felt something land on my head and hover, flapping its wings, as I got up. I was able to catch it. I turned a basket over it and went back to sleep. In the morning I discovered what it was and took it to Brandoch, Wesley Peters' son, who had a menagerie of eagles, hawks, barn owls, and the like. Unfortunately, for some reason, the screech owl died. After that, I took every one I caught ten miles away and let it go.

Some months later, Olgivanna, now at Taliesin's helm, called me in and asked me, "Can you get me a screech owl?"

Surprised by the question, I said, "I don't know, Mrs. Wright. I have not seen any at my tent recently, but we can look for one."

"Brandoch's birthday is coming up soon, and I want to give it to him as a present to replace the one that died."

"Well, Mrs. Wright," I said, "screech owls make their nests in holes they dig near the top of saguaros. Maybe we can search around for one there."

The idea excited her and she said, "I will go with you."

The next day I asked my friend Ken to help me. We carried a step-ladder across the desert and leaned it against a saguaro where we could see holes near the top. Then we looked on the ground for castings, balls of fur wrapped around rat bones, which the owl casts away after consuming the rat's flesh. An owl would likely be found in the hole above the castings.

Meanwhile, Olgivanna drove out in her little Karman Ghia to where we were. She brought a case of beer. We spent the better part of the afternoon in the most pleasant hunt while I climbed the precarious ladder, cautiously sticking my hand into the unknown space of a hole on top of a saguaro. We never found an owl.

By the time I had completed the building of my tent, I had gained precious experience in understanding the nature of materials that I discovered could be transposed in other building projects. Indeed, I had developed a passion for hands-on site construction. I built tents for other members of the community, including my girlfriend. My favorite construction media were welding, concrete, and carpentry. I was never able to perfect a miter.

At Taliesin in Wisconsin, the buildings were older and more substantial. The main house and environs, built in 1910, were wrapped high around one of southern Wisconsin's rolling hills. The living room that was twice burned down and rebuilt was a space that Mr. Wright lovingly tinkered with, changing it and perfecting it for fifty years. It was often called the most beautiful room in the world.

When I first joined the Fellowship, I was given a room in what was known as the tower, one of the original buildings. It was right across a green lawn from Mr. Wright's room. I could look from my room directly into his, where he would be writing at his desk, reading, or simply lounging naked. This was the original Taliesin.

Over the years of changing, expanding, and functional alterations, it had become like a castle; you could live in one part and never discover the rest. There was a court for horse-drawn carriages, some of which were still there when I arrived in 1951.

Living quarters were placed discretely around every corner. Around another nearby hill across a small valley, Mr. Wright had built a residence for his sister Jane. She had died shortly before I arrived. The house was a large three-story structure that demonstrated some of Mr. Wright's early concepts of space. Later, it accommodated a number of Fellowship members during the summers. Nearby was the chicken coop, later transformed into a residence where I lived with my wife for several summers. At a lower location on the same hill there was a tool shed, which, during my second year in the community, I had transformed into a small cottage with a fireplace and a stone terrace. Soon after I finished I invited Olgivanna, Mr. Wright, and his sister Maginel Barney for a house-warming steak dinner, which I cooked in a charcoal pit I had dug that afternoon.

Soon after Mr. Wright died, Olgivanna decided to have a stone wall built on one side of the Taliesin hill to contain an area between that wall and another wall built into the hill. The area was large enough to accommodate a private garden for her. The project went against the grain of the puritans who never appreciated changes in the master's work. But we built the wall, which was promptly torn down after her passing in 1985, some time after I had left the Fellowship.

We laid sod over the newly smoothed ground and built a small, round pool with a fountain at one end. When we were finished, we had a grassy rectangular space confined within four stone walls accessible

through two round moon gates at two distant locations on the perimeter. Olgivanna had the task of arranging the furniture in that space so as to create an appealing environment.

For all the complexity in Olgivanna's makeup, her sense of design was simplistic to the point of banality. After much thinking she placed a row of small round tables in a line parallel to the rear wall with four chairs around each table. She did the same thing along the opposite wall. When she had finished, she had a most sterile, awkward arrangement where one could not feel comfortable sitting anywhere.

A week or two later as I was serving her a drink in that garden at cocktail hour one evening, she asked me, "What would you do with this garden to give it some interest?"

I had already been thinking about that. But from my experience with Olgivanna I had learned not to make a suggestion until I was asked a specific question. I said, "I would plant a clump of horizontal junipers here." And I pointed to a location near the fountain. "Then," I said, "I would plant another clump there," and I pointed to a spot opposite and diagonal to the first one. "I would make two basic seating arrangements related to those two locations with secondary seating at a few other places around the space."

From the look she gave me I gathered she must have thought that I had taken leave of my senses. She rejected my suggestion completely and ended the conversation. That was when I decided to carve a little garden in the woods.

Across the tiny path from my cottage, I carved a discrete garden within a woods thicket in which I had a lawn, a fountain, a lowered dance floor and, for light, I arranged kerosene torches I had found in storage in a circle around the perimeter of the clearing. You could not tell that this space existed unless you accidentally came upon it as you wandered in the woods. On that hill in 1889 Mr. Wright had placed the windmill structure famously known as Romeo and Juliet.

Romeo and Juliet was the name Mr. Wright gave to the sixty-foot-

high windmill built over a reservoir dug up on the hill to feed the Hill-side Home School. The avant garde school for boys and girls was built in 1887, at the request of Aunt Nell and Aunt Jane, two matriarchal maiden sisters of Wright's mother.

Aunt Nell decided, "Why not have a pretty windmill in keeping with our school building instead of an ugly steel tower? I am going to ask Frank for a design."

Strong and sustained objections from every quarter, including family and the local contractor, could not sway Aunt Nell from involving Wright, who was then twenty-two years old and working as an architect in Chicago.

His tower plan comprised an octagon partially wrapped around a diamond-shaped form. The two geometrical forms—Romeo and Juliet—looked as though they were in an eternal embrace.

One Sunday afternoon during a picnic with the Fellowship on the hill near my cottage, I asked Olgivanna to go with me for a short walk down the hill. It was not more than fifty yards to my garden. It was late afternoon. The golden sun rays filtered gently through the thick protective woods and mysteriously illuminated the clearing I had carved. The little fountain made a friendly, inviting sound. The chairs were arranged in a circle and directly behind them were the kerosene luminaries, which I had found in storage the day before and lit for the occasion.

Olgivanna was stunned at the serene beauty of the scene. She made her feelings known. She was generous with her compliments and solicitous about making me feel her joy of discovery. Underlying her enthusiasm, however, was a familiar grudging tone, which I had come to detect oftentimes when she felt she had taken a wrong turn. By that time I had known her for twelve years, and I could easily detect the different shades of her voice.

It was Sunday, the musical evening at Taliesin. She decided to have the music in my garden to further honor my effort. My good friend John Amarantides directed the chorus to sing a number of Brahms songs and

made sure that one of those songs was "Secret Nook in a Shady Spot." In those days Olgivanna was writing a column for the *Capital Times* in Madison. The event of my garden's discovery found its way into that week's column.

It was a love fest. Knowing Olgivanna, I was waiting for the other shoe to drop. As I had dealt with Olgivanna over the years, she had emerged as the most jealous human being I have ever known. The most casual remark about anyone could trigger the sharpest of responses. Sometimes when I complimented an actress in a movie for her charm, I would receive an immediate counterstatement about the charming actor. She had worked diligently at diffusing this aspect of herself over the years.

On Monday, the day after our unusually pleasant evening in my garden, I walked into that garden again to savor the events of the night before. To my devastating disappointment, I found that all of the kerosene luminaries had disappeared. I later found out that Olgivanna had sent someone to pull them out and take them to where she had suddenly decided to have a garden similar to mine in the woods near her residence. She had asked a member of her close inner circle to go with her to look for a clearing in the woods. They found the most meager spot, large enough for one chair and a table located on a path frequented by everyone. It was patently weird.

This overt demonstration of jealousy was in clear contrast to other occasions when she rose above it in a spectacular way. During the time of Mr. Wright's burial, Olgivanna asked us to locate the grave of Mamah Cheney, Mr. Wright's first true love, and place a headstone on it. She asked us to inquire of the old-timers in Spring Green about the location of Mamah's grave. We were told that it was near a small pine tree. But forty-five years later, there were no small pine trees. Eventually, we found the grave and Olgivanna had us engrave Mamah's name on the headstone. This was, considering her own nature, performing a heroic act. It dawned on me later that her gesture was a monumental personal triumph.

Farther down the road from my cottage and the little garden, wrapped around another hill, was Hillside. It was a complex of buildings containing the main studio, a handsome living room with a balcony looking down on the dining room, the theater where we had dinner and a movie every Saturday evening, and a large kitchen. Around the studio were two rows of rooms for some of the members of the Fellowship. In May 1952, while Mr. Wright was burning brush at Hillside too close to the building, the roof caught on fire, razing the theater and dining room. Over the next few summers we rebuilt all of it.

Slightly to the east around another hill was Midway, called by that name because it was located roughly midway between the main house at Taliesin and Hillside. That was where the complex of farm buildings was situated, with silos, a barn, and some living quarters. I lived with two others in an apartment over the barn for a summer. The cows often made their presence known as they exchanged moos directly below my bed.

These clusters of buildings were arranged within a manicured 700-acre estate in the heart of the beautiful hilly farmland of southern Wisconsin. Before I joined, Mr. Wright had had a little stream dammed to form a small lake and a waterfall that spilled into a lower lake, which, in turn, had a dam at its end that spilled into the stream's original bed. In the seventies the two lakes were joined into one large lake to accommodate a boat that Olgivanna had received as a gift. She shared boat rides with some of us, and I built a wooden bridge connecting the mainland to an island we had formed to dock the boat.

Walking on the road from Taliesin to Hillside at 5 A.M. to cook breakfast was almost a spiritual experience. The golden sunrise illuminated the mist as it hovered over the mirror-like surface of the lake. White pines and spruce partially showed their tips through the soft fog, and willows discretely reached for the water with long, delicate branches. It was like walking into a Japanese print.

Sometime in the fifties, my maintenance assignment was road grading. That meant standing on a steel platform over a steel blade

furnished with two wheels and a lever with which I could change the tilt, direction, and elevation of the blade in order to re-form the gravel on the road after a rain or simply after a period of use. A Caterpillar called a "Bobcat" pulled this seemingly reptilian contraption. I absolutely loved road grading. It looked so dangerous and manly and the equipment made so much noise.

Road grading was one of Mr. Wright's favorite pastimes. He would occasionally jump on the grader and spend the better part of a morning working the blade, sculpting the gravel. Once when he was in his seventies he fell off the grader and injured himself. That was the end of his road-grading days. Olgivanna would not let him get on the grader again. But his fondness for earth-moving equipment never left him. I watched as he developed long-term camaraderie with bulldozer operators who were occasionally hired to work on the property.

By the sixties, my love for construction and fieldwork had nearly dominated my activities. I had learned from Mr. Wright that ideas never come to you as you sit staring at a blank sheet of paper. They invade your imagination as you are engaged in other activities. Only then would be the proper time to go to the sheet of paper and register your idea. The estate was interconnected with a net of gravel roads that ran over and around the hills. Two or three cattle guards crossed some of them to keep in check the brown-and-white cows that roamed decoratively on the grass.

One day, I was grading a steep stretch of road at the entry of the Taliesin hill. I was on the grader with my hands furiously turning the wheels, adjusting the blade's angle and tilt. Another apprentice was driving the Cat. Suddenly Mr. Wright appeared on top of the hill all dressed up in his three-piece suit and tie. He was walking down toward where I was working. He motioned to me, lifting both of his arms in the air, waving his cane. He looked like a symphony conductor as he was trying to direct my movement of the blade.

There was no way I could hear his voice. The machinery was too

loud and the movement of his arms did not clearly convey what he meant. So I did what I thought he wanted. But I was wrong. He tried again and I tried again, and I was wrong again. There was a time lag between my intent to move and the actual movement of the blade that did not seem to be taken into account. I could see his frustration beginning to show. My anxiety to do the right thing to please him made matters worse. After a few more failed attempts, his anger got the best of the situation and he stomped furiously up the hill.

He must have gone to the residence and told Olgivanna about this stupid Egyptian who could not understand his instructions. I am sure he did, because Olgivanna was particularly kind to me for a few days after that incident.

After a year, my maintenance assignment had developed into what was termed "estate maintenance," a catchall phrase that included everything within the estate. Taliesin had expanded to 4000 acres after Mr. Wright bought a number of farms surrounding the Taliesin property. As it developed, estate maintenance included but was not limited to road grading, laying sod, cutting grass, pulling out or installing fencing, cutting trees, planting trees, moving dirt, dredging the lake, dynamiting stumps or old masonry, building features such as bridges or gates to connect or separate areas, and another multitude of activities.

Fortunately for me, I had a mentor who had the experience and interest to introduce me to the initial stages of these activities—Ken. He was an all-round earthy, intuitive man, all knowing about everything. He knew about building, farming, cooking, cattle raising, milk producing, road building, machinery, and all the areas of life with which I needed to familiarize myself. Although he was twelve years my senior, we became fast and close companions who continued to be good friends until his death forty-five years later. Each of us seemed to have just what the other needed.

For all the years—probably five—that I worked on estate maintenance, Ken and I worked six-day weeks and a minimum of twelve-hour

days all summer long. If there were one word to describe that experience it would be "joy." Wild horses could not have dragged me into the design studio to draw anything. We were in the field all day long with tractors, chain saws, trucks, a sod-cutting knife, a sickle bar, a road grader, dynamite and caps, a detonator, and much more. We had a Volkswagen truck in which to carry the materials, along with a case of beer.

Working on the estate was an open-ended proposition. Everywhere I looked, something needed urgent attention. Since we usually started work at 5 A.M., by the time 10 o'clock came around we were ready for a break. Two miles away, at the intersection of Highways 14 and 23 at the heart of the farm country, two brothers, Charlie and Jack White, had established a tavern. They were an amiable, plump pair whose widths were about the same dimensions as their heights. They were as natural to the landscape as a pair of cabbage heads. In the fall, they went coon hunting. Through the sweltering hot and humid Wisconsin summers, they served a glass of Wisconsin beer for a dime and an enormous salami sandwich for thirty-five cents. Farmers from the surrounding farms congregated at White's tavern at 8:30 or 9 A.M., after they were finished with their chores, to drink beer and gossip all day. As the day progressed, Charlie received requests to serve grain alcohol sweetened with some syrupy pop. But most popular was a boilermaker—a shot of whisky with a beer chaser.

Everything seemed to happen at Charlie's. The farmers or farmhands who frequented the tavern had names like Rip Vandron, Clarence Carmedy, Hank Larson, Tom Wench, Hoppy Pronel, Rolf Nowatny, and others. The place was a metaphor for a cultural center. Everything that went on within a five-mile radius was currency for social exchange.

One summer we built a swimming pool on the hill at Taliesin. The vicious attacks of Wisconsin mosquitoes in the summer are legendary. More than anyone, Olgivanna was not only especially sensitive to mosquito bites, but she seemed to be a preferred target. On one of the

REFLECTIONS FROM THE SHINING BROW

frequent picnics we made, I was chatting with her and she was complaining about the mosquitoes as she was drenching her bare limbs with some mosquito repellent. She said, "I don't know why mosquitoes single me out for their bites. When Mr. Wright and I go for walks, they never bother him, they only bite me."

To that I answered, "Well, Mrs. Wright, if I were a mosquito I would want to take a bite out of you also." She laughed approvingly.

We had decided that in order to keep mosquitoes out of the pool we would cover the whole area with a Quonset hut frame and drape a net over it. In the early sixties, Quonset huts were relics of the war. Ken and I telephoned Chicago, Milwaukee, Madison, Cleveland, and other cities looking for a Quonset hut. We could not find one. A few days into the search, Ken said, "Let's go to Charlie White's." We walked through the door and ordered our beer and salami sandwiches. Within fifteen minutes Charlie had located a Quonset hut for sale three miles away in a community called Arena.

There was something endearing about a small farm community of 900 inhabitants, three blocks in any direction, with half a dozen taverns tucked away within two streets of the business area. The Dutch Kitchen, a five-room hotel, rested on a small restaurant, which made the most heavenly Dutch apple pie imaginable. The general store sold building materials. Cobby Cosper owned a haberdashery. Cobby was a pleasant, mild-mannered man who had just married Old Stuffy's widow. Old Stuffy had owned a tavern on the river across State Highway 23 from one of the hills Mr. Wright had purchased in the process of restoring the pristine complexion of the environment around Taliesin. The tavern, which was a part of the purchase, was no longer in operation. But its presence polluted the environment. The tavern had to go and in a "Nero burning Rome" fashion, Mr. Wright decided to make a ceremony out of burning it down.

We had a picnic on top of the hill across the highway. Mr. Wright had my good friend John Amarantides, a world-class violinist, play the

violin during the picnic. When the time came, Mr. Wright started descending the steep hill. A lovely blonde young woman named Mary Joy and I ran toward him. She held him under one arm and I held him under the other. When we reached the bottom of the hill, a fire, which was started at one end, quickly engulfed the tavern in flames. The fire department, which rushed to the scene after seeing the flames from Spring Green, was not amused. Olgivanna left the scene and went home after the picnic. She later told me, "Mr. Wright suffered so much from fires throughout his life. I think it was wrong to start one deliberately."

I continued for some years after I lived in California to purchase my knee-high rubber boots at Cobby's haberdashery for $7.89.

⌒

A door or two from the Dutch Kitchen was the barbershop where I had my hair cut for thirty-five cents. The quasi car agency was owned by a gentleman who seemed to own a piece of everything in town. During my first year in Wisconsin, I impulsively bought a car from him. It was a red Jeepster with canvas top and canvas sides. I paid $900 for it. I had one problem. I did not know how to drive. Before I concluded the deal I explained my situation to him and said, "I don't know if I can buy a car if I do not have a driver's license."

He thought briefly, then went with me to the sheriff's home where the sheriff handed me a driver's license. I did not expect any of that but I was relieved and gave the man the $900.

When I first joined Taliesin our telephone in Wisconsin was on a party line, which we shared with a number of the surrounding farms. The instrument had a handle that one would have to crank until the operator got on the line to take instructions. Often one would lift the receiver only to hear one of the farmwomen leisurely talking to another woman with interminable pauses between ahs and grunts about what never seemed to be very important. Eventually, one would get the operator. The operator's office was located in Spring Green, perched on top of Stacey's Drug Store, with visual command of what went on in the street below. Stacy was a bulky man probably in his 50s, with a consider-

able belly. He did not look like it, but it was general knowledge that he had his way with the ladies.

I remember sometimes calling the operator as I would be looking for someone. "Mabel, I am looking for Tom Wench. Do you know where he is?"

She would say, "Yes, I just saw him going to the Dutch Kitchen. Let me get him for you there."

Occasionally, I used my wife's gold Cadillac for transportation as I tended to some of my duties on the estate. I kept a box of dynamite in the trunk as a matter of course, never thinking it was important enough to tell my wife about it. Little local cheese factories sprang up on the sides of gravel county roads surrounding Taliesin and Spring Green where one could buy fresh young cheese. My wife was in the habit of buying cheese from these little factories to send as gifts to friends in Oakland or Phoenix. One day in the early seventies, an enormous bomb was exploded at the University of Wisconsin in Madison. It destroyed a large portion of the science building and killed a man. The perpetrator was believed to have fled north. A wide-scale manhunt ensued.

One day my wife took her car to one of the cheese factories to buy cheese. After she made her purchase, the factory owner carried the cheese to the car. She opened the trunk for him to place the load inside. In the emotionally charged atmosphere of the massive, news-media-amplified search for the dynamite killer, an awkward silence fell as my surprised wife and the shocked merchant fixed on the dynamite box. Both recoiled, uneasy. Recovering, Barbara did her best to ease his suspicion. Apparently she succeeded because she came home without having been incarcerated.

CHANGING VIEWS

> *Remember you come here having already understood the necessity of struggling with yourself—only with yourself. Therefore thank everyone who gives you the opportunity.*
>
> *—G.I. Gurdjieff*

WHEN I FIRST JOINED THE FELLOWSHIP, Olgivanna and Mr. Wright had, in the camp in Arizona, two adjacent bedrooms looking out on an interior garden, bounded on one side by the back glass wall of the living room. It was a serene environment where the two rooms were joined with a common, terrace-like exterior passageway with several wide steps leading down to the garden. The rooms were enclosed but they had an outdoor aspect about them. To have more privacy, Olgivanna wanted to build another room adjacent to hers on the side opposite to Mr. Wright's room. It would be several steps down, about the same level as the garden.

After much debate, she received reluctant approval from Mr. Wright. He was not fond of the idea but she had her way of persuading him. At the same time, she did not want to make it out to be a major construction project that he would have to deal with everywhere he turned. She asked a few of us to do the construction at night, after Mr. Wright had retired. We started after dinner at about 8:30 and worked until midnight or later. Activities like building forms, mixing concrete,

carpentry, plastering, laying tile, and other tasks all took place under electric light, which was wired to illuminate the exterior as well as the interior of the space.

Mr. Wright sometimes visited the construction in the morning. He found that much had been done since he had seen it last. Some of what had been done did not coincide with his wishes. He once pointed to a concrete corner I had poured the night before and said, in obvious rage, "Who the hell did this?"

"I did, Mr. Wright," I said sheepishly.

"Get it out of here," he said.

We worked every night for about eight weeks. Olgivanna used that room extensively for many years.

In the mid-seventies, twenty years later, she asked me to come for a talk with her. When I sat on the chair across from her, she said, "I am buried here. This room has no view whatever. Could you design and build me a room elevated enough so I can look out on the valley?"

I said, "Sure, Mrs. Wright."

Across a small court from her lower room was a storage room. We thought I could perch a room on top of that space. I designed a staircase that led to that level. It took me two months to complete a small, private space, which she used until her departure. That construction project, in the summer of 1977, was the last I undertook at Taliesin. I left in November of that year.

↩

Mr. Wright's passing caused a number of difficulties for Taliesin. A central question was, "How can we keep Taliesin at the heart of controversy and hence the focus of attention?"

Mr. Wright's polarizing personality inspired either unmitigated hatred or unqualified love. His fountainhead of genius flowed uninterrupted for his seventy years of practice until a few days before he died. Clearly, it was impossible to replace the energy he had generated. In spite of her intelligence and personal strength, Olgivanna did not excite

the public, although she did evoke strong feelings of both devotion and hatred on a personal scale. The specter arose that Taliesin might be relegated to obscurity.

Olgivanna took stock of the celebrities who had been attracted to Mr. Wright and had moved into his orbit over the years, strengthened those relationships and initiated a social life at Taliesin. She included people such as Henry and Clare Luce, Senator William and Helen Benton of Benton and Ball, Ray and Bettina Rubicam of Young and Rubicam. They were encouraged to bring friends and acquaintances. We rubbed shoulders with Allen Dulles, Margaret Truman, John Kenneth Galbraith, and Walter Cronkite, who had a daughter who was an apprentice.

We had our regulars such as Buckminster Fuller, Adlai Stevenson, Charles Laughton, and countless others. Olgivanna was writing a column in the Madison *Capital Times* and those names found their way into that column. It was unclear whether young apprentices would continue to be interested in joining the Taliesin community in the absence of the source of its energy. New young people were the lifeblood of the Gurdjieff-like society Olgivanna had dedicated her life to from the beginning. Her imagination had always served her well. In 1964 she initiated a tradition that lasted for three years and singled Taliesin out as a unique educational institution. The idea was to spend the better part of the summer in Europe instead of going to Wisconsin as had been done since 1932.

The first trip was an exploratory one. We flew to Paris and bought a fleet of Citroën cars. The deal was that we would buy them and sell them back as we left. We were told that was a less expensive way to secure transportation. We traveled across Europe to Venice, Trieste, Split in northern Yugoslavia, and then along a mountain trail barely wide enough for one car. (It has since been improved into a regular highway). By nighttime we reached Dubrovnik.

The next morning we pressed on to Budva and Svete Staphan, where we spent two unusually beautiful weeks. Svete Stephan is a fishing village built on a rocky causeway into the Adriatic Sea. The

Yugoslavian government had transformed the simple stone cottages to create a unique hotel out of that complex. They added the proper number of bathrooms to ensure modern comfort. They created little nooks and discrete places for taverns, shops, or just private areas. Everything was joined by narrow rocky trails, which meandered up and around the rock, ending in a small stone chapel at the top. I found a few fig trees (my favorite) richly laden with their copious crop. The water in the Adriatic was unusually clear. When I swam in thirty-foot deep water I could see every rock and pebble on the floor of the sea.

We took side trips to Belgrade and more significantly to Citinje, the capital of Montenegro where Olgivanna had been born. She took us to see the house where she had lived with her father. Her experience was familiar to me. Going back to a childhood location that I had fantasized over the years, I would have embellished and enlarged it as it receded in distance and time. Returning to view it out of sentimentality, I would find that it did not look at all like what I had come to expect. That was what happened in Citinje.

Another aspect of life in a native land that one forgets is the attitude of old acquaintances preoccupied with their own lives, who are not aware nor do they really care about the achievements you have made in your new home. At a lunch Olgivanna had arranged in a restaurant, she sat at the head of a long table. To her right and left were two local gentlemen. I sat next to the one to her right. In the manner she had been accustomed to for many years, she presided over the occasion—or so she thought. She began to speak with the expectation that everyone was hanging onto her every last word, only to observe that whatever she had said simply dissipated in the air without reaching anyone. The two gentlemen to her right and left carried on a conversation in Serbian across the table, totally oblivious to what she was doing or saying. Two or three more failed attempts at controlling the situation threw her into desperation. She looked at me and said, "This is turning into a disaster."

She had hoped to leave the impression of a "little local girl done

good." But there was no chance for that. She had tried that in other ways. She had written to Marshal Tito after he had imprisoned his old friend Milovan Djilas. Tito and Djilas had had a long camaraderie in their struggle through the communist party. But Djilas became disillusioned about communism and was vocal about it. Then he wrote his book *The New Class,* published in the United States in 1957. The book discusses the inherent dysfunction in applying the lofty principles of equality touted by communism, which paved the way for the emergence of a new class of bureaucrats in which power was vested. Tito had Djilas arrested and imprisoned.

Olgivanna wrote to Tito scolding him for breaching his friendship with Djilas, invoking the name of her hero grandfather, Duke Marco Milanov. The duke had fought the Ottoman Empire with great distinction. She had perfected a way to secure the attention of an important personality by pointing out a glaring mistake. It did not work with Tito. But it did work with President Kennedy. Kennedy had visited Phoenix during the 1960 campaign. In order to mend his fences with the Republicans, he made a visit to Goldwater's department store. Olgivanna wrote to Kennedy scolding him for visiting "the ugly Goldwater department store" instead of visiting the beautiful Taliesin. This time she got the president's attention and was invited for dinner at the White House.

The two other European trips were different. We rented the buildings of the American School in Switzerland for two-and-a-half months. The school was located in Montaniola near Lugano, in the Italian region of Switzerland. We landed in Milano and drove across the border to Lugano. The idea was simply to move the entire architectural operation from Wisconsin to Switzerland and attend to the architectural commissions as though we had never left Taliesin. These plans belonged to the category of famous last words. The radical change of the environment demanded radical changes in style and behavior. But it was all in a day's work. We took excursions to lakes, mountains, small villages, and the like. Ev-

eryone enjoyed the change that for many was the first and probably the last time they would have that experience.

My parents came to visit. I got them a room in a hotel in Lugano and my brother Ismail, who lives in Zurich, came down also. Olgivanna was exceptionally gracious to my father, especially during the last dinner we all had together before everyone returned to where they belonged. Because of my loner nature, I have a particular prejudice against collective activities. I had been to Europe many times, so I did not enjoy the summer as much as everyone else did. Besides I was into my first marriage. It was a non-experience, lacking in character, devoid of stimulation and excitement. This probably contributed to my indifference.

I am not sure how many young people joined Taliesin because of these European summers. But the expense was justified by the benefit derived from the assertion that Taliesin was still a thriving enterprise. We were told that we had saved money by spending the summer in Switzerland rather than Wisconsin. I am sure that some creative accounting was provided to support that notion.

Besides these focused projects aimed at creating an atmosphere of activity around the life at Taliesin, a sustained outreach to the immediate community in Scottsdale, Phoenix, or, for that matter, Spring Green, needed to be established. Mr. Wright never saw a need to be a part of any community. All his life he had stepped off the beaten path and marched to the beat of his own drum. His life was well rounded and self-contained. During the years I knew him, we seldom had many guests. Socializing as an end in itself was never a part of our lives. Mr. Wright and Olgivanna usually had dinner alone in their private residence on the property. I served Mr. Wright a cocktail, one ounce of Old Bushmill Irish whisky with water and no ice; I served Olgivanna a Four Roses old-fashioned on the rocks.

〜

After Mr. Wright's passing, Olgivanna initiated a few programs with Arizona State University. Some of the students came to experience the art

of Eugene Masselink and to hear him talk. She began to invite guests to the traditional Saturday dinner and chamber music evenings. It was my task to organize a cocktail hour to precede the evening. But since a cocktail hour had never been a part of life at Taliesin, I had to start from scratch. At first, Olgivanna had me serve the same drink to everyone—a Four Roses old-fashioned. That drink was made of blended bourbon whisky, orange bitters, a slice of orange, and a maraschino cherry. I was embarrassed as I pushed that drink under the nose of all the guests, many of whom had not asked for it. Certainly, not many guests wanted the sweetness of an old-fashioned cocktail. A long-time friend who liked her bourbon whispered in my ear one evening, "Just give me the bourbon, never mind the garbage."

In time, I brought in a bottle of Seagram's gin. The next cocktail evening I dashed to all the guests. Before they had a chance to say anything, I said, "Good evening. Would you like a bourbon or a gin?" Soon after that I persuaded the money people that I should buy a bottle of Scotch whisky. I was serving this from a makeshift bar—a small counter in the corner of the kitchen, where everyone was on top of everyone else trying to serve dinner. I had to do something.

An old abandoned bathroom had become a catchall, messy storage room where every orphan project was thrown until someone decided what to do with it. It was located in a more-or-less central position near both the kitchen and the dining room. In my moments of frustration, I had toyed with the idea of transforming it into a bar. The idea became more pressing as our social life became more prominent.

Early one morning I knocked on Olgivanna's bedroom door. When she let me in, I asked her if I could build a bar in the location of the old bathroom. As always, we had the usual dance to which I had become accustomed. She placed all possible obstacles in the way of the project, citing expense, time constraints, and others. I said, "Mrs. Wright, I bet you that I can serve you a drink this evening from the new bar."

"You will?" she said, feigning excitement.

"Yes," I said without hesitation.

"All right," she said. "I will bet you ten dollars."

It took several hours to empty the bathroom of its contents, and it took me the rest of the day to cut and fit enough plywood to build a counter and a few shelves. By 6:30 P.M. I had a surface on which to place a bottle of Seagram's gin, a six-pack of tonic water, a lime, and a bowl of ice. I made a gin and tonic, her favorite drink at the time, and knocked on the door of her sitting room, where she usually took her cocktail. That evening I became ten dollars richer.

It took me several weeks to finish the construction and detailing of the bar. Within six months, the bar became an institution where a certain few would gather around at cocktail hour to discuss the world. By that time I had stocked it with every conceivable drink.

⌣

One source of pride that Mr. Wright instilled in us was that we managed every aspect of our life without the aid of hired labor. We worked on the farm, raised our food, maintained the grounds, milked the cows, and produced the highest quality milk in the county. Besides providing the apprentices with a well-rounded knowledge about life, presumably the work was cost effective because it saved the expense of hired labor. However, since we had no proper experience as professionals, we often made the wrong moves and learned by correcting those moves. In the process we wasted much time and material.

One summer we started an operation for raising chickens. We gave them feed, collected the eggs, and asked the advice of a neighbor farmer. After breakfast one morning, I asked Mr. Wright, "How did you like your egg, Mr. Wright?"

He said through his characteristic amused chuckle, "Well, for a two-dollar egg I guess it is all right."

Money was always scarce at Taliesin. The nature of the work did not invite mass housing or faddish affectations. The buildings that were realized were not many, although every one was a masterpiece. Clearly, making money did not motivate Mr. Wright. Money came as a result of

his doing his work in pursuit of his architectural ideas. Income was unpredictable, capricious, and undependable. In his life he had turned down some lucrative work because the constraints were such that the result would not have been up to his standards.

During lean periods, we had beans three times a week. Cooks were encouraged to be creative in making something new out of a pot of beans. Once we had what was termed "lamb stew." As I dipped the spoon in the stew bowl, I encountered a couple of pieces of potatoes at the bottom and observed a few peas floating on top of the liquid. Arthur, the young man sitting next to me, wondered out loud, "Who got the piece of meat today?" But somehow that was never an issue. Being around Mr. Wright, listening to him, talking with him, observing him work, and beholding his creations seemed to feed one's whole being.

One evening while we were at the theater a Steinway piano Mr. Wright must just have bought arrived. Mr. Wright directed that it go to the theater orchestra pit. The configuration of the orchestra pit was such that all three piano legs could not be accommodated at the same level. Mr. Wright said, "Joe, get a saw."

Joe Fabris, a favorite of everyone, brought a saw.

"Cut it off here," said Mr. Wright, pointing at a place about halfway up the piano leg.

To the horror of the driver and some of the guests Joe commenced to saw off the leg of a brand new $10,000 Steinway. When the piano was finally located properly, it belonged as though the space had been designed just for it. It is probably still there.

⌒

After Mr. Wright's passing, an atmosphere of desperation set in to the culture at Taliesin. It became evident in constant anxiety about money. The change of complexion of the administration concentrated the power in Olgivanna's hands. She might or might not discuss her plans with the handful of her close, loyal, "yes" individuals. Everything was conducted in secret. No one knew the status of any issue or indeed if

there were an issue. No information was ever shared about our financial status. The party line was, "We don't have any money."

That pronouncement put a damper on any initiative that did not issue directly from Olgivanna. One time I saw in a commercial outlet some very handsome dinnerware of bone china. The cost was about $20 for sixty plates, which would have been enough for the group. We had been eating from plastic. When I suggested to the treasurer that we buy them, he simply said, "We don't have any money."

I thought, even if you do not have money, how can you pass up such a deal which would in the long run save a great deal of money?

Taliesin West, placed on the lower slope of the hill, was always in the way of torrential floods that came rushing down the mountain, and it was often drenched. One time I used a back hoe to dig a ditch around the northeast side of the buildings to direct the water flow around the property. We were supposed to build a bridge for those who lived north of the ditch and needed to go across it to their residences. But *we didn't have any money.* So, we placed a temporary strip of pre-cast concrete two feet wide across a twelve-foot ditch. Everyone who needed to, had to walk across that precarious makeshift structure either in the daytime or in the dark after having had a drink. A whole year went by without being able to extract some money to build a safer method of crossing.

One night my friend architect Charles Montooth, while walking to his residence in the dark, fell in the ditch and injured himself. When I heard about it the next morning I became furious. Without asking anyone, I telephoned a steel company and ordered a three-foot-diameter culvert thirty feet long to be placed in the ditch and then covered over. I sent a message to Olgivanna to inform her about what I had just done. She telephoned me and asked me to come to see her. As I sat down she said, "I like someone who takes matters into his own hands and gets things done."

Then she became remorseful and told me how sorry she was about not attending to that problem while she was lavishing so much money

on her own quarters. That statement was meant to invite me to indicate to her how I had felt about the seemingly extravagant way she had been changing and remodeling her quarters. Her manner had appeared self-indulgent, wasteful, and uncaring about the rest of the community. But I had not felt that way, and she could sense that from my attitude.

My intuitive perception of this incident and others like it was that the backbone of Olgivanna's work was the creation of conflict in every venue in which she found herself. The appearance of self-indulgence and lack of caring for others was intentional on some level. I know she possessed enough inner strength to exist in the harshest of conditions if she needed to. But the apparent disparity she created was intended to engender feelings of anger, envy, and resentment—the human qualities she was interested in exposing so she could bring them to everyone's attention.

One time my first wife was in the Scottsdale hospital near death after extensive surgery. One morning, while trying not to alarm me, Olgivanna's concern was obvious. She advised me to call my wife's family to inform them about the seriousness of the situation. That evening while chatting with her after I had served her a drink, she repeatedly complained about some cut she had in her finger. She never asked me about my wife's condition. She only spoke about her own cut. I could not even see the cut. In view of my wife's extensive cuts, which might never have healed, I was offended to the point of anger, but soon I began to realize the purpose behind that seemingly weird behavior. The message was: You have done all you can; the matter is in God's hand. So go on living because worry is a waste of energy.

Olgivanna did not have a passion for architecture as an art. She appreciated good architecture, especially having lived for thirty-five years with the greatest. After Mr. Wright's passing, architecture was viewed in the context of being the only source of income. She did not appreciate what all the fuss was about when the concept of integrity became associated with a certain look, proportion, or dimension in a building. She had made changes in her quarters, usually in good taste. To some these

changes in the work of the master were heresy. Except in rare instances, the change in details did not disturb the spatial concept. I thought that since she was living in those spaces, she had every right to make alterations that coincided with her sensibilities. After she died, everything was restored to its original state.

The currency in conversation or debate about architecture remained lofty but became increasingly empty. Understandably, the work was not that of genius. But inspired by Olgivanna's perceptions, a lower standard of design was acceptable. Indeed commissions that did not promise much in the way of cutting-edge design were welcomed as long as they represented a lucrative fee.

My good friend Vern, an intelligent, ambitious young man, is more than ten years my junior. He joined Taliesin when I had been a member for six years. His feelings about me were plainly expressed recently as we shared the head table with Madame Jehan Sadat during a dinner I had organized for her which was hosted by my close friends, Leila and Reggie Winssinger, at their home in Paradise Valley, Arizona. He said to all present, "When I joined Taliesin, I hated three things: buttermilk, brown bread, and Kamal."

Coming as he did from a conservative, white, highly religious Protestant background, he must have had some feelings of insecurity engendered by my demeanor, my long moustache, and my general manner. They dissipated over time. He had made that remark many times over the years, and I took it as a statement of affection, meaning that the opposite is now true—at least about me if not about buttermilk.

Vern and I spent many hours together just talking. One day in 1965 when the Fellowship spent the summer in Switzerland, the group was to meet at a small town outside Lugano. Everyone drove, but Vern and I decided to walk along the country roads. It took five hours, and we arrived conspicuously late. Olgivanna, who was always threatened when any two people developed some closeness, asked us the next day, "What could you possibly have been talking about for five hours?"

From then on until today, we dub every walk we take regardless of how long it takes a "five-hour walk."

In 1972 Vern attracted the attention of the National Homes Corporation, a large home-building company headquartered in Lafayette, Indiana. They had seen a pamphlet about mobile homes he had written and distributed nationwide to homebuilders. He traveled to Indiana. With his persuasive, almost evangelical salesmanship, he returned with a contract for the office to design some of National Homes' housing units. What this project caused, more than anything else, was a great deal of soul searching. The product provided by National Homes was decidedly inferior. The budgetary restraints were severe and there was no real hope for meaningful changes or retooling in a well-established massive operation that had been humming along making money for years as it was.

Olgivanna held a staff meeting to discuss the matter. In all the years I had known her, she had never called such meetings without being assured of the outcome beforehand. She wanted the half-million-dollar fee. That was a given. But in view of the radical departure from Wright sensibilities, she needed to be able to say that she did not single-handedly foist this work onto the organization. During the meeting she asked for the comments of just the right individuals who happened to be mainly from the loyal group with whom she had discussed the matter beforehand. They would have agreed on anything she said anyway. She solicited token responses from one or two she knew would have opposing views but no real force. A long-time Chinese member who was an artist to the bone and an aesthete of highly refined taste left the meeting and walked alone in the desert for hours, probably to cleanse his aura of the "contamination" of the meeting. He vowed never to touch the project. This only served to add color to the preconceived bleakness of the prospect. But the die had been cast and most of the office got busy working.

National Homes arranged for a public relations blitz in New York,

where Olgivanna and Vern met with the press and managed exposure for the project.

On our "five-hour walk" following the New York event, Vern said, "She blew it."

"What do you mean she blew it? Blew what?" I asked.

He told me that Dick Cavett had been interested in having Olgivanna on his show. During the initial interview with one of Cavett's assistants, in a familiar attempt to control the outcome of the interview, she placed too many conditions on the questions she wanted to be asked. Cavett lost interest.

CHAPTER 16

MY SHINING BROW

> *The truth is more important than the facts.*
> —*Frank Lloyd Wright*

SHORTLY BEFORE I LEFT EGYPT FOR THE United States in 1951, I had
been writing in Arabic for a popular magazine in Cairo. Probably the
only thing I missed about Egypt a year or so later was that experience.
There was something to the process of composing a narrative that de-
scribes an event or a sentiment, then seeing it in print being shared with
others whom one does not even know. My desire to write was very much
alive when, ten months after I arrived in America, I heard that the
Egyptian revolution, which had been raging during my last years in
Cairo, had succeeded in ousting King Farouk and laying the foundation
for the republic. I wrote a commentary in Arabic that was published in
a magazine called *Rose Al Yousef*, the most effective, colorful publication
in the city.

The magazine had the name of its founder, a woman of great con-
sequence who in 1925 had left her profession as a prominent stage per-
sonality and thrown her hat into the political ring of publishing. In 1952
she was still living but her son Ihsan Kuddous, a passionate writer, was
publisher and editor. He kept the magazine always at the cutting edge
of opposition to the government, with its contributing writers never
quite going to prison but always just a few steps from being there.

In 1971, when I traveled to Egypt with my then wife to attend the funeral of my father, *Sabah El Khair*, a sister publication to *Rose Al Yousef*, had in its issue of February 11 a long feature article about me and my wife titled "The Greatest of Egyptian Expatriates." My commentary to the publication after expressing my delight at the ousting of the king urged the new regime not to succumb to the temptations of superficially imitating the infatuating vestiges of "advanced civilizations" without first getting grounded in Egypt's own culture.

In 1952 at Taliesin, I thought of publishing a small magazine, perhaps a monthly or quarterly, in which I could gather the thoughts of my colleagues in a story or a sentiment. Not knowing where to begin, I started by asking Olgivanna. She did not object. Indeed she encouraged me, which was a boost to the project. Eugene Masselink, the influential secretary to Mr. Wright, was adamant that I not precede. I found out later that Eugene would have had to carry the burden of tying up the loose ends generated by the process.

But I had Olgivanna on my side, and I went ahead requesting literary contributions from my colleagues for the publication, which I had called *The Shining Brow*, a name that Olgivanna used to title one of her books some years later. I worked nights organizing the project while one of my colleagues, Louis Wiehle, called Alvin at the time, typed the material as it was received. I designed a cover page and in about two months we were ready to go to print. Of course, Olgivanna had to read the material. I left it with her and went to Madison seeking a printer to engage in the project while she read it.

Two or three days later she asked me to come in to see her. I walked in expecting a compliment on my effort, which was always a mistake. She had the stack of paper I had given her on the table in front of her.

Her first comment as she pointed at the papers was, "This is not good. It is dull and boring."

She singled out as "pretty good" an article I had written about being at Taliesin and a story written by one of the women about a mouse

that ventures out into the world only to be eaten by an eagle. The rest she said was dreary. More interesting were the comments she made about the writings of some of the individuals whose sentiments ran against the grain. Over the following half hour, she took apart what they had written and selectively isolated statements that reinforced her conviction that they did not belong. By the time that encounter was concluded I knew exactly why she had encouraged me to produce that material. She never had any intention of allowing it to be printed. She simply wanted everyone's sentiments in writing so she could use them as a club to beat them with it, if she needed to.

For some reason this obvious trickery did not offend me. The individuals whose sentiment ran against the grain were as disturbing to me as they were to her. She did not need my project to identify them. But their writing confirmed her instincts. What always bothered me about those people was their blatant hypocrisy. They all verbalized their loyalty to Mr. Wright, conveniently forgetting that without Olgivanna none of them would have had a chance to be close to him.

Most of them had a simplistic notion that you could only be loyal to either Olgivanna or Mr. Wright, not both.

She was not competing in a popularity contest. They did not like her. That stunted their judgment.

So, I picked the manuscript for my periodical and went out looking for other projects to initiate.

CHAPTER 17

CHANGING OF THE GUARD

> What is needed most in architecture today is the very
> thing that is needed most in life—integrity.
> —*Frank Lloyd Wright*

Mr. Wright's departure on April 9, 1959, created a vacuum that was never filled. His last crowning decade was a spectacular period for him, for us, for the many clients with whom he was working, and for the many others who were waiting for the proper time to retain his services at age ninety-two. This made his sudden absence even more deeply felt.

Olgivanna did not hide her wrenching grief and she became more accessible as she welcomed expressions of sympathy. There was a period of confusion as the community looked for leadership. It was natural to look to her for that. Clearly, she was Mr. Wright's partner. Together they were co-founders of the organization.

Directly behind her overwhelming expression of grief, she was hard at work from the first day setting up the new organization. She was sixty-one—strong, intelligent, and manipulative. For years, she had had the total command of the heart and logistics of the environment in which we all lived.

With the benefit of many years of planning she had also had her choice of people placed where she wanted them to be in order to be of most benefit to her agenda. A few peripheral members defected and went to work with other architects such as Bruce Goff. But, largely, the

155

group seemed to line up behind her with a sense of solidarity in facing a common hardship. There was no telling how long that period of solidarity would last. But it prevailed for a time while the hair cracks in the structure, which had appeared a few years earlier, began to develop into separations.

The separations brought again to the surface some nagging questions: What is Taliesin? Is it the office of the world's greatest architect where young people go to learn about architecture? Or is it a community modeled after Gurdjieff's vision where they go to learn about themselves and make the best of what they find?

I had traveled nearly 10,000 miles for the sole purpose of being with Mr. Wright, never having heard of Gurdjieff or of Olgivanna. Being with him was the most thrilling experience I could ever conceive of having. I needed no more than that to feel that my life was fulfilled. The exposure to Gurdjieff's work, however, was fascinating, interesting, and even at times exciting. I could see no contradiction between the two activities. I plunged into that work with the same zest I had plunged into the other.

It never ceased to surprise me to find so much almost violent opposition to Olgivanna and her Work. Not long after I met her, I came to recognize the polarizing effect of her personality. She was always in control and she readily emanated that disposition in every look and gesture. She would nearly decide to allow you to like her or she might choose to cause you not to. Olgivanna knew exactly what her goal was and she went directly to it. She had an ability to read a person instantaneously at a first meeting and immediately decide to invite that person into her space or build a separation wall. The strong feelings people had for or against her were not entirely of their own making. She was a participant in the outcome. She had been grooming herself in preparation for stepping into the space vacated by Mr. Wright's departure, and she walked into it trying all the time never to appear as though she had intended to replace him.

The nagging questions about the nature of Taliesin were never

REFLECTIONS FROM THE SHINING BROW

answered verbally. Taliesin was what it was. One had to carve out a space that would accommodate one's sensibilities and where one could function effectively. That space was Taliesin. The answers to the questions were defined by the extreme positions taken by some of the group.

During Mr. Wright's life, there was not much fear of Gurdjieff encroaching on the architectural practice. Olgivanna saw to it that the Work was kept as far from Mr. Wright's path as possible. But after Mr. Wright's death, with the proponent of Gurdjieff's theses at the helm, there was an unspoken discomfort as some anticipated a measure of structural changes. The architectural office was temporarily safe from major overhauling. It was the only source of income and it needed to function as it had always done under the direction of Wesley Peters, who for twenty-seven years had been the pillar upon which the production of the office rested.

↜

William Wesley Peters, affectionately called Wes by everyone, was a student at Massachusetts Institute of Technology when in 1932 he learned that Frank Lloyd Wright had started accepting interested young people to apprentice in his office in Spring Green, Wisconsin. He immediately left MIT without completing his courses and traveled to Taliesin. Wes was intense and dedicated, a hard-working youth who threw himself with abandon into every activity that went into maintaining the life of the community. He worked on the farm, built roads, worked in the drafting room and on the construction of the buildings. Later when some projects began to find their way to Wright's office after ten years of drought, the engineering skills that Wes had acquired at MIT became useful to the office. He was called upon to do the structural engineering. As more apprentices joined the community, his loyalty, hard work, and engineering skills kept him first among equals but closest to the Wright family.

Wes had come from a wealthy family in Evansville, Indiana, where his father was the editor of the *Evansville Press*. Unlike anyone else in the group, including the Wrights, he had access to money and he was gener-

ous in helping the community in general and some of his apprentice friends in particular with sizable infusions of funds. This loyalty held him that much closer to the hearts of the institution as well as to the Wrights. Those were the lean years. Money was scarce. The group lived off the land and in some way charged the necessities at local stores in Dodgeville and Spring Green.

After Mr. Wright's death, there was a standing and not wholly un-justified apprehension that the office would be dominated by someone who was not an architect, whose priorities could be at variance with the strict workings of the architectural practice model, and who had the personal will, as well as the legal authority, to implement her agenda.

In a patronizing, Big Brother manner Wes took on the cause of the drafting room as an untouchable entity not to be molested by other con-siderations. But to ask Olgivanna not to dominate anyone or anything that she came across was naïve. She had the distinct conviction that she could make better anything or anyone she touched, and she was not shy about proceeding to do so at all times.

Following Wes in his quest was the band of individuals most pro-ductive in the office. That group was also the group most opposed to Olgivanna and the Gurdjieffian phenomena. As big brother, Wes want-ed to appear large in the eyes of his colleagues. A substantial part of his battle was to secure for himself an autonomous leadership role that would function parallel to Olgivanna's and might even encroach on her domain as demands of the office warranted. But again it was naïve to think that Olgivanna would forgo any part of her control.

↪

Wes was a large man, at six feet, four inches. He was strong as a bear and nearly as awkward. He wanted to force the issue. He was family to Olgivanna and his closeness was ensured during the devastating tragedy that had struck them both at the same time.

Svetlana, Olgivanna's daughter from her previous, short-lived mar-riage to Vladimir Hinzenberg in Russia, was beautiful, kind, and univer-

sally loved and looked up to by everyone. She and Wes fell in love and with characteristic passion they wanted to get married. The request was met with disapproval by the family. I was not at Taliesin, but I have little doubt that the disapproval originated with Olgivanna, who wanted to create a hurdle for the young couple. By overcoming it, they could strengthen their own characters as well as their marriage.

Wes and Svetlana eloped and married. They traveled to Evansville, Indiana, where Wes started an architectural practice. Eventually, the relationship between them and the family was mended and the young couple returned to Taliesin. By 1946 they had two young boys and Svetlana was pregnant with a third. She had become an icon of love and caring that many went to for comfort and friendship. Wes had become the undisputed leader of the apprentices and a tower of strength on which Mr. Wright depended in his work, and Taliesin depended on for getting much done in all its endeavors.

Then tragedy struck. As Svetlana was driving with her children across the Spring Green Bridge returning to Taliesin after a shopping outing, her cat, which was in the car, acted in a way that distracted her. The car veered to one side, struck the bridge railing, and fell a long way into the riverbed. Everyone died except eight-year-old Brandoch, who ran up to Taliesin screaming, "They are all dead…they are all dead."

The sudden disproportionate tragedy was beyond what anyone could bear, especially Olgivanna, who was both mother and grandmother of the victims. Wes further buried himself in work and became even closer to the family and to Olgivanna, who was inconsolable. Much later when she spoke with me about that period she said that she called upon every conceivable fiber of her inner strength to protect her against self-pity that would have destroyed her life. Being an aristocratic European in origin, she was comfortable only in a soft and protected environment. When she retired to sleep at night she had to have a well-made bed with all the bedroom windows closed. That was the exact opposite of Mr. Wright, whose affinity for things natural favored his living totally in the open. When it looked that it might rain as they started on

their daily afternoon walk, she would shrink from the impending experience and he would say, "Come on, Mother, you are not made of sugar or salt. You won't melt."

After this tragedy, among many other inner exercises, she made herself sleep in a sleeping bag outside in the cold so that the physical discomfort would help her to be aware of the possibility of slipping into a condition where it would be convenient, even attractive, to wallow in self-pity.

Gurdjieff's principle of "intentional suffering" was at work. In his book *The Harmonious Circle*, James Webb quotes Katherine Mansfield as she wrote to her husband from the Gurdjieff Institute where she died in 1923:

> One suffers terribly. It takes very severe measures to put one right. But the point is there is hope. One can and does believe that one will escape from living in circles and will live a conscious life. One can through work escape from falsity and be true to one's own self, not to anyone else on earth....

When I joined the Fellowship in 1951, Wes was a phenomenon unto himself. From where I was standing he was the first lieutenant to Frank Lloyd Wright, working with him on all projects, taking the lead in implementing Wright's ideas but always deferring to him in the details. Wes was exempt from all maintenance duties, although one would sometimes see him knee deep in the sewer plant trying to correct what was wrong. He did not cook, wash dishes, or participate in general cleaning or serving. He often flew across the country on trouble-shooting trips. He appeared to be the only possible person to carry on the architectural work after Frank Lloyd Wright.

Wes was larger than life in many ways. He lacked a sense of proportion in his actions. Instead of giving a gift, he would give two or three. His designs were larger than they needed to be, with more embellish-

ment than is consistent with good sense. When we showed our designs to Mr. Wright in order to receive his critique, his comment on Wes's designs would often be "Wes is more" after "Less is more."

But one could not imagine the office without him. As close as he was to Olgivanna, he was never a participant in her private world of inner Work. Certainly he never joined in the Gurdjieff dances or exercises. Indeed, he was never really sympathetic to the Work Olgivanna was doing on the periphery of the pure architectural practice. He was sometimes impatient when that Work encroached on the logistics of the office, but he never obstructed or hindered her considered wishes. She counted on him to facilitate much of what she needed and he always obliged. As a notorious practical joker, he was very fond of puns. He had extravagant, creative ideas for skit parties and fun occasions. Wes was liked and respected by everyone.

When Mr. Wright passed away, Wes thought, in his bravado style, that he could fill the shoes of the master, and he behaved as though he expected to receive the kind of hero status only Mr. Wright had commanded. He never said words to that effect. Surprisingly, Olgivanna seemed to support his picture. She walked with him to the formal Saturday evening events, seating him where Mr. Wright used to sit. She ordered his choice of movie for the weekend. She made the group stage a performance of the opera *Patience* by Gilbert and Sullivan because Wes suggested it. This picture looked strange to me, as I am sure it did to others as well.

As well as I knew Olgivanna, I would say that she had a plan. With Wes singled out for this honored position, his exposure would exaggerate his faults. Already some of us were offended as he began to regard the office as a one-man enterprise the way Mr. Wright had, not taking other architects into account. He changed the standard "owner-architect" contract form to read that he was the only architect who did any designing in the firm, and he insisted upon signing all contracts. This practice excluded all of us who were capable, licensed, qualified architects. The issue was important, and many of us were offended by the crudeness of his position.

One day a message reached me from Olgivanna asking me to state in writing my objections to the new contract. I wrote:

> All of us individually and collectively are equally committed to the principles of Organic Architecture. As to who signs the contract, it is not an issue for me. Many corporations hire someone to perform that function. But articles 18 and 19 of the new contract state that Wes is the only architect who does any designing in the firm. This is a discrepancy that borders on misrepresentation. This document must reflect without ambiguity who is to be credited with the work.

I was not sure at the time why I was asked to write that statement. Later, I realized that it was a part of the ammunition Olgivanna was gathering with which to confront Wes when the time came.

Away from the public appearances, a struggle over policy and style was always at work. Olgivanna needed Wes as we all did. She did not want to destroy him. She wanted only to cut him down to a manageable size so he would line up behind her. She was president of the organization that included the architectural office, and she had intended to annex that venue into her domain. Wes was doing a good job of squandering his standing with his actions. Like a martial arts master, Olgivanna was not about to interfere with her opponent while he was in the process of destroying himself.

She wanted to break up the clique in the drafting room that had solidified into a pocket of resistance that got its support from Wes. She had control of every other venue in the life at Taliesin. She made life difficult for that clique and, one at a time, they all left and were replaced by new young blood trained on the job. Sacred cows were not a feature of her perception of life.

We had a plumber in Wisconsin by the name of Joe Crogman. He had

been the only plumber in the universe who knew all the ins and outs of the plumbing system (if one can call it that) at Taliesin in Wisconsin: the labyrinth of pipes installed in 1910 and worked on and improved through the years. Besides, he had been employed by Mr. Wright, which gave him a sacred status. By the 1960s, fifty years of constant additions and omissions had rendered that feature of the buildings impossible to fathom. Being secure in the notion that he was indispensable because of his special knowledge, Joe Crogman became careless as he delivered incompetent service, to the exasperation of everyone.

One day Olgivanna called him in and had a delightful time firing him as she observed the stunned expression on his face. Then she asked one of the Fellowship members who had a special knowledge about plumbing simply to study the system and take it over.

~

While Olgivanna maintained the appearance of having Wes as the single most important individual, she endeavored to diminish his stature with his colleagues. There was nothing she would not do in order to achieve her objective. She asked a disagreeable and ambitious little man who would later become an obnoxious presence in the office to spy on Wes and regularly report to her about everything he said or did. In return she would groom that little man for an enlarged role in the office. He obliged, and she had a wealth of material that she could throw at Wes either seriously or humorously at all times. Wes did not help himself by trying to force his way through situations by making decisions, only to find out later that her handpicked administration office personnel would not acknowledge his decisions.

I remember in my own work the drastic difference between Mr. Wright's open, decentralized style—as road builder, for instance, I would exercise my own judgment, order loads of gravel, hire an asphalt operator, and go to work—and, on the other hand, the highly centralized system Olgivanna implemented. A deadly bureaucracy stifled all work because every single decision had to travel through the multilayered structure directly from her. At times I experienced her rejection,

as Wes did, when my requests for funding a certain project of my initiation were refused only to force on everyone the concept of the hierarchy she had put in place. I felt also, as I am sure Wes did, that Olgivanna wanted to force everyone to accept the power she had conferred on her people, whose only virtue as far as anyone could tell was their uncompromising loyalty to her.

Her drop-by-drop manipulative style of reducing Wes's influence was very effective in neutralizing his attempts at maintaining his credibility. I remember many casual gatherings with Olgivanna and a number of us where Wes's name was mentioned in some connection. Olgivanna would immediately find an avenue in the conversation where she would place Wes in a less-than-flattering light with reason to mock his deeds or words. It offended me because I could see beyond the immediate entertainment value into the steady erosion of Wes's standing.

Later on in the seventies, Wes and I became even closer. In some of our one-on-one outings he would say, "I never thought it would turn out this way."

With his group of supporters in the drafting room gone and his space slowly but surely crowded with others whom Olgivanna had thrust into it, Wes began to look like an architect emeritus. He still retained the title of chief architect. Indeed he designed buildings. But the power was vested elsewhere.

During the time Olgivanna was working hard to dominate the architectural office, she was systematically and consistently dropping remarks about the influence she had had on Mr. Wright's designs. It was absurd to hear her recounting incidents and conversations during which she had given him the idea for some of the building designs. It struck me as a crude attempt at creating the credibility that would guarantee for her the acceptance as a qualified architectural critic. She had told me at times, "You measure your competence as architects by the number of

years you spent with Mr. Wright. Well, I spent with him more time than any of you."

Olgivanna once said to me: "After the commission for the Unitarian Church in Madison was secured, Mr. Wright came into the room one evening and said, 'Oh, Mother, I have this church in Madison and I do not know what to do with it.' And I said, 'Frank, just think of the posture of two hands joined in prayer.'"

She had cupped her hands at her chest under her chin in a prayer pose. The spectacular roof of the Unitarian Church does look something like two hands joined in prayer. But in the context of the dynamics that I observed over the years, I found Olgivanna's account farfetched.

John Howe was the draftsman architect who produced all of Mr. Wright's drawings for thirty years. He was present with Mr. Wright at the drafting room at all times. He told me when I brought the issue up to him one day, "Well, once or twice she came to the drafting room and as she would start to make a comment, Mr. Wright would say, 'Alright now, Mother, never mind.'"

But she was able technically to force herself on the process by demanding that everything was to receive her approval before it left the office. As it developed, it was a procedural matter established mainly to demonstrate her control over every aspect of life in the Foundation. I had a few brief, uneventful sessions with her where I showed her my designs and received complimentary comments.

That is not to say that Olgivanna was without influence on Mr. Wright's work. It was not a direct influence on specific designs but rather an intangible dimension that became subconsciously a part of his approach. To understand this, one has to refer to her sensuality. For the years I knew her, she regarded sensuality as one of the most valuable attributes of human nature, a sign of active, conscious living. She always tried to open one's eyes to make one aware of one's true sensuality, which springs directly out of one's senses. She differentiated sensory awareness

from mental images calibrated to accepted or faddish notions. She herself was a very sensuous woman.

She often remembered the halva she used to buy as a little girl in Montenegro from an old man pushing a cart down the street. Her description of the halva as it hung from a gadget on the cart and the way it looked, smelled, and tasted was so vivid it was almost like lovemaking. Her mouth watered every time, recalling an experience sixty-five years old.

I was walking with Olgivanna one morning through the vegetable garden in Wisconsin. Suddenly she asked me to stand with my bare feet in the recently watered soil. "Is it not wonderful to feel the mud coming through your toes?"

I believe that a few years into their marriage Mr. Wright's work acquired a sensuality that was not obvious in his early work. I am thinking of Falling Water, the Guggenheim Museum, and other buildings in which forms and materials beckon one to touch them. Olgivanna's sensuality was perhaps her greatest influence on Mr. Wright's work.

The true influence Olgivanna had on Mr. Wright was through the creation of this unusual community environment which she populated with a group of young individuals dedicated to him and his work. They generated an energy which inspired him to continue to create.

She was a balm who introduced serenity in what was a turbulent life. Outside of his work she became the only reference point on which he could count.

I could observe from where I was standing that in her relationship with Mr. Wright, she maintained a brilliant balance between unconditional love and a dynamic of conflict which I am certain prolonged his youth.

CHAPTER 18
GUESTS

> *I'm an idealist. I don't know where I'm going but I'm*
> *on my way.*
>
> —*Carl Sandburg*

ONE YEAR IN THE MID-FIFTIES, Charles Laughton, Charles Boyer, Sir Cedric Hardwicke, and Agnes Moorhead came to Phoenix as part of a national tour reading Bernard Shaw's *Don Juan in Hell*. Mr. Laughton, who was a friend and admirer of Mr. Wright, came to visit several times shortly before the performance. One evening we had the unusual good fortune of hearing him read to us in our little theater at Taliesin West. He was a magnificent performer with a remarkable flexibility of voice and body. He read from Genesis 11, among other things. His voice meandered from the lowest to the highest registers as language flowed from him like a lyrical melody. He raised his arms, which gave the appearance of his whole head sinking into his chest. Then he straightened up, looking for all the world like a stocking turned inside out. Mr. Laughton was a delightful gentleman with whom I had a very pleasant time every time we talked. He was accessible, with a great deal of charm and an easy sense of humor. He was always on stage. I took him for a walk one time to show him the buildings and he moved readily from ecstatic delight to near tears at the sight of the various architectural features and dramatic spaces.

During one of those visits Mr. Wright, Mr. Laughton, and the

whole Fellowship went to Oak Creek Canyon to a spot called Shnebly Hill, outside Sedona, a bit more than 100 miles north of Phoenix. We had dinner—a whole lamb cooked on a spit—and spent the evening in an exciting conversation about art and life in these United States. We turned in, into our sleeping bags, while Mr. Wright and Mr. Laughton went to a nearby motel. I will always remember the look on Mr. Laughton's face when Mr. Wright told him facetiously, "Well, Charles, you stay here with the boys. I am going down to a motel to sleep." Mr. Laughton's objections were drowned out by Mr. Wright's chuckle. In the morning they came up for a breakfast of bacon and eggs.

Olgivanna told me once that Mr. Wright, in his seventies, had been nearly at death's door with severe pneumonia. It looked to Carl Sandburg, who was a good friend visiting from Chicago, that the end was near. Being the showman he was, he prepared a poem. He was ready to read it at the foot of the bed as Mr. Wright slipped into his final moments, thus creating a deathbed scene worthy of note. Olgivanna, who routinely panicked every time Mr. Wright showed the slightest sign of discomfort, was aghast at Sandburg's suggestion. She firmly dismissed it, citing the fact that Mr. Wright needed every ounce of energy he could muster for recovery.

Mr. Sandburg's showmanship was evident to me one time at the Hillside little theater in Wisconsin, which we had just finished rebuilding after the fire of 1952. During a Sunday afternoon with Olgivanna, Mr. Wright and William T. Evjue, the editor of Madison's *Capital Times*, present, Mr. Sandburg, who was again visiting, walked to the center of the stage and began reading from his *Rutabaga Stories*. The stories take place and are narrated in the idiom and language of the American Midwest. They are populated with characters such as the Five Rusty Rats, the Rag Doll and the Broom Handle, the White Horse Girl and the Blue Wind Boy, and the Potato Face Blind Man. He stood ramrod straight with his feet touching, his hair combed characteristically flat over his Swedish head. He read a story titled "Bozo the Button Buster"

about a man with a tight vest who busts a button every time he takes a deep breath.

Apropos of Bozo, he ventured a story about two maggots that hung precariously at the end of a shovel resting on the shoulder of a WPA worker. As the worker moved about, he inadvertently shook the shovel and the two maggots lost their grip and fell. One fell between the dried boards of an old floor and nearly starved to death without nourishment. The other fell on a recently dead cat and ate to its heart's content. When the two maggots met later, the lean and hungry one asked the other, "How did you manage to become so prosperous?"

"Brains and personality," said the fat maggot.

↜

For all the years I knew Mr. Wright, we celebrated his birthday on June 8. Olgivanna had invented a birthday cake containing within its layers many of the ingredients Mr. Wright enjoyed most—strawberry jam, nuts, and other sweets. It was covered with whipped cream and chocolate syrup. She just called it the "Birthday Cake." It was my favorite, too, although I never had a sweet tooth.

While in Berlin in 1955, I had had probably the most delicious white wine I had tasted until then. It was one of the Liebfraumilch varieties. When I returned to the States I gave a bottle to Mr. Wright, who liked it enough that it became the ideal gift to give him on his birthday.

It was one of the two occasions during the year when he would critique our designs and in the process impart his architectural wisdom to our sensibilities. It was always a most valuable lesson. The other occasion for such a critique was Christmas.

His ninety-second birthday came two months after he had died on April 9, 1959. On June 8 of that year we had a memorial celebration at Hillside in Wisconsin. There were many local and national personalities present. Buckminster Fuller delivered a long, emotional speech in which he spoke in part of the first time he had met Mr. Wright, in 1930, during a symposium on modern architecture in New York, at the Women's

University Club. New York's landmark buildings, such as the Empire State Building and the Chrysler Building, were starting to be constructed or about to open their doors. Architects of those buildings were the speakers at the symposium. Fuller said, "I could not understand how it happened that I was invited to speak.... I had never built a building. I was just a researcher. I was simply a punctuation mark between these other speakers.... And when I sat down, Mr. Wright stood up and said, 'My young friend Buckminster is as bad a speaker as he is as good a designer.' And from that time on he befriended me. Nothing gave me as much courage or pride."

Adlai Stevenson gave an eloquent speech, mostly about continuity. He quoted from Psalm 27: "I had fainted unless I had believed to see the goodness of the Lord in the land of the living." He continued to say that there was something in the scripture about the grace of continuity.

The elegant Alicia Patterson Guggenheim, publisher of *Newsday*, said, after speaking of Mr. Wright, the architect: "But somehow it is not as a great architect that I remember him, it is as a great man who fought all his long and useful life against sham and hypocrisy, who refused to bow to the great god Organization. And who felt that the individual was more important than the mass."

Hal Price, founder and CEO of the Price Pipe Company of Bartlesville, Oklahoma, who had retained Mr. Wright's services to design an office building, gave a most affectionate speech. He said, "When we thought about building an administration office for our company, we were thinking of building a three-story complex. We approached Mr. Wright. During the early discussions he was thinking of a nine-story building. After many debates, we compromised and built a nineteen-story tower."

Ann Baxter was there, looking as lovely as ever. Ann was Mr. Wright's granddaughter; her mother, Katherine, was Mr. Wright's daughter with his first wife, Katherine Tobin. Katherine had married Ken Baxter, a Taylor wine representative. Ann's presence was always an enlightening experience. Her grandfather certainly liked her and she

was attached to him. That connection added a dimension to her life beyond simply being a prominent actress. But by being at Taliesin, she evoked latent jealousies and envies in Olgivanna and Iovanna. Clearly, Ann had arrived at her place of recognition on her own initiative, savvy, and competence. Those qualities were proclaimed by Olgivanna as ones you achieved by being a follower of her teaching—except there was no one on hand who could demonstrate those qualities. Certainly her daughter Iovanna's potential was unclear and was not tested in the arenas Ann's was.

The message at Taliesin was that achievement in the "outside world" was inferior to being within the fold. This was a concept Olgivanna had initiated from the beginning in order to keep her flock together. But also it provided a tool to justify an unrealistic superior attitude that members of Taliesin have always and still do have about their worth.

Olgivanna was a self-appointed judge on the quality of other people's lives. Ann came to visit one time during the filming of a western movie in the Superstition Mountains east of Phoenix. Twice she asked me to accompany her to the lot and watch the operation. Back at dinner one of those evenings, she quizzed me about some mythological stories she had heard in Egypt while filming *The Ten Commandments*. The stories did not ring any bells with me. The conversation was strained due to the presence of all three women together at the same table. But Olgivanna in a familiar superior fashion conferred on Ann the grudging compliment of having reached her level of success without having sold out her principle (which meant her virtue) to the movie industry.

The sight of Anthony Quinn sitting on the floor at Mr. Wright's feet was always touching. In his 1972 autobiography, Quinn told the story of his attempts in the early thirties to become a student of Mr. Wright. When he first applied and came to meet Mr. Wright, Mr. Wright noticed a defect in Quinn's speech. He brought it to Quinn's attention, encouraging him to have an operation under his tongue to repair the condition

before he attempted to be an architect. The operation and the speech therapy that followed led to Quinn's first stage role. He was making seventy-five dollars a day when he went back to see Mr. Wright about being his student. Mr. Wright said, "My dear boy, you take the $75 a day. You won't make that as an architect for years."

Then he told Quinn that if he still wanted to come back to study with him, he would take him any time.

While I was in the kitchen slicing prosciutto one evening in preparation for the cocktail hour, a breezy, gregarious Mike Todd walked in, preceded by an infectious laugh, and started to help himself to the freshly sliced prosciutto. Within moments we were engaged in the most delightful and sometimes interesting conversation. That was in 1957. I had not known much about Mike Todd except his name, as it was associated with a flamboyant lifestyle. I also knew that he had produced the Oscar-winning *Around the World in Eighty Days*. Soon after that I learned that he had developed a three-dimensional film technique called Todd-A-O. His new method of projection required special lenses and a wide screen. By definition, it also required a theater design different from the normal one. Todd came to Mr. Wright to discuss that prospect.

Todd arrived in a private plane that landed in the tiny Scottsdale airport with his new wife, Elizabeth Taylor, her children, and her ex-husband Michael Wilding—an arrangement that Mr. Wright thought rather bizarre. The group stayed around for a day or so during which I took another look at Elizabeth Taylor. I had heard, as I am sure everyone else had, about her extraordinary beauty, her violet eyes, and her other assets. Over the years I had never seen that. I did not think she was a particularly talented actress (except when I later saw her in *Who's Afraid of Virginia Woolf,* the only performance in which I thought she had excelled). Her appearance brought to mind the questions "What is beauty in the context of a human being?" and "Can you ever separate beauty from charm?"

One appreciates the standards of static grace in statues like Aphro-

dite. If one ever fantasized about spending an evening with Aphrodite, one would have had to fill in the blanks with the appropriate charm in order to enhance the fantasy.

Baltasar Gracian, the Spanish Jesuit monk, wrote about charm in the manual he authored in 1653. He wrote in part, "A charm is everything. It is the life of the talents, the flower of speech, the soul of action, the halo of splendor itself.... Without it all beauty is dead and all grace graceless, for it transcends courage, wisdom, prudence, majesty itself."

Such exquisite quality was not the lot of Elizabeth Taylor. I would not have picked her out as anything special had I seen her walking down the street in Scottsdale, dressed in blue jeans and a shirt.

The talks about the theater between Mr. Wright and Mike Todd were to be continued a few months later. But Mike Todd's plane crashed near Grants, New Mexico, on March 22, 1958.

⌐

Margaret Sanger visited in the early sixties. At the time, she was living in Tucson, a mere 100 miles southeast of Phoenix. Talking with this small, soft-spoken, fragile-looking woman, it was difficult to associate her with the intense battles she found herself engaged in as she challenged the status of women around the turn of the twentieth century. Anthony Comstock, a powerful fundamentalist "reformer," lobbied successfully in 1873 for the enactment of severe federal statutes known as the Comstock Law. The statutes opposed the transportation of obscene material in the mail—including contraceptive material He strenuously fought Margaret Sanger.

I asked her, "Mrs. Sanger, which was a more formidable foe to you, Comstock or the public sentiment which usually has a way of inducing resistance to change?"

She said, "Our cause was just and it quickly made sense to the public. But Comstock himself was an undeterred kind of a bully. At age seventy, one year before he died, he personally came after my newspaper, which I had initiated in 1914, demanding that the postmaster outlaw its distribution through the mail. Soon after that I was indicted for violating

the Comstock Law. But the case was eventually dropped. This signaled the general positive change of attitude toward our effort."

All she was doing was attempting to secure the right of privacy to the lives of women. The marathon struggle in the courts, in the streets, and in the press besides a brief imprisonment paid off as the court of appeals in 1936 allowed doctors to administer contraceptives to save lives of women. Then there was the Supreme Court Griswald decision in 1965, then the Roe v. Wade decision of 1973. Both were decided based on the right of privacy—a word that does not appear anywhere in the Constitution but is a concept that emanates from every article thereof.

CHAPTER 19

CLARE BOOTHE LUCE

> *They say that women talk too much. If you have worked in Congress, you know that the filibuster was invented by men.*
>
> —*Clare Boothe Luce*

Henry and Clare Boothe Luce were frequent dinner guests at Taliesin. The exchanges between Mr. Wright and Mr. Luce were probably the most exciting occurrences I ever witnessed. Mr. Wright had an expansively philosophic overview of the human condition that always focused on the root of the problem, seeking to change the dynamic by altering the ground rules. His ability for synthesis was disarming. His agile and mercurial mind in concert with his strong convictions and sense of humor made it pure pleasure to watch what he could do with an idea or just a thought.

Mr. Luce, on the other hand, had a flood of interesting ideas, which he came by easily and instantaneously and delivered with rapid fire. He dealt with things as they were, seeking solutions within the prevailing system. The two approaches could not have been more different. But their convergence within the same space was inordinately stimulating.

I was there once when Mr. Wright was developing his Utopian view of society, which often reminded me of Sir Thomas More, where he believed that an organic quality in the human makeup could self-regulate and eventually find the right path. Mr. Luce said, "Do you mean that we do not use traffic lights?"

I had a running discussion with a constant theme with Mr. Luce every time I saw him. He believed strongly that Orientals are completely different from Occidentals, to the point of almost being a separate species of the human race. He was born in China and lived there through his pre-teens. So, maybe he had an insight to which I had no access. The first time this subject came up, I said, "But Mr. Luce, you are a Christian and your faith comes from the East."

"That is true," he said, "but I meant the Far East."

I said, "Don't you think that simply being human brings with it a basic set of sensibilities, desires, fears, and aspirations? Everyone needs to survive, work, love, be loved, procreate, and so on. It is just that some do it in English and some do it in Chinese."

"No," he said. "There is a qualitative distinction between the fundamental make-up of Orientals and the rest of the world. This distinction completely alters their response mechanism and renders them totally unpredictable."

The first time I met Clare Boothe Luce she recalled to me an event that took place in Rome during her tenure as U.S. ambassador to Italy. She told the story.

One evening after the embassy work was done, I had dinner with the first secretary and a small number of other embassy officials. About 10 P.M., I went upstairs to my quarters to retire for the night. Not long after that the embassy street doorbell rang. It was a surprise to me and to everyone present. No one was expecting anyone that evening.

After a pause, I asked the first secretary to see who was at the door. He did, and then he came up to tell me that King Farouk was downstairs requesting an audience with me. I could not for the life of me imagine what the recently deposed King of Egypt could possibly want from me, and at this hour. Like anyone else, I had heard of his unsavory reputation. I took my time to think; then I said to the first

secretary, "Please let him in and join us in the reception room to see what he wants."

The king came in. We shook hands and exchanged smiles. I asked him to take a seat between the secretary and me. Some awkward moments, which felt much longer than they were, passed by as I was waiting for him to divulge the reasons for his unusual visit. Nothing was forthcoming except a series of non-consequential pleasantries. After about half an hour of this, he stood up ready to leave. We shook hands again and I turned around heading upstairs to my quarters.

As I looked back I noticed that just before the king exited the exterior door he took the first secretary aside and whispered something in his ear. After he left, the secretary came up. He was seized by uncontrollable laughter, which scarcely permitted him to speak. "Do you know what he wanted?" he asked. "No, what?" I said. The secretary said between his breathless chuckles, "He wanted some American toilet paper because he said it was the best in the world."

The relationship between Clare and Olgivanna originated at different points on the human spectrum and developed along lines consistent with their widely divergent characters. During the many years I observed them together, I always saw competitiveness and jealousy lurking below but not far from the surface. Clare Luce was attractive and engaging, a talented woman who was comfortable around power and the powerful. She knew her way around the social and cultural scene, and she climbed the celebrity ladder with ease and speed. She participated with vigor in the political and social life around her and exacted high critical acclaim on all fronts.

Clare Boothe Luce was born in 1902 and died in 1987. She was regarded as one of the most brilliant, accomplished women of the

twentieth century. President Ronald Reagan presented her with the Presidential Medal of Freedom in 1983. For nearly sixty years she held positions of distinction in many venues in both the political and literary life in America. In 1930, she was associate editor of *Vogue* magazine, after which she became managing editor of *Vanity Fair.* Clare was an award-winning playwright who wrote three successful plays, all of which were adapted as motion pictures.

She was elected to the House of Representatives from Connecticut, where she served from 1943 to 1947. President Dwight D. Eisenhower appointed her ambassador to Italy in 1953.

In 1979, she received the Sylvester Thayer Award from the West Point Alumni for a life of distinguished civil service—the first woman to be so honored.

She was a force in the conservative movement as well as a feminist in the original definition of the word, where chivalry was one of life's graces.

When I first met Clare, I knew none of this. But, strangely, I was sexually attracted to this woman who was then more than twice my age. As I look back, I believe it was her intelligence that came like fire through her eyes. She had a self-confident, superior attitude that excited me and motivated me to challenge her.

Clare was not particularly introspective. But she was forceful and articulate in an argument or a discussion; she had a tendency to dismiss the opponent's response and often his presence by drowning it in a monologue-like speaking style. Her support system came from outside, from people who may or may not have been intimate with her but whose presence around her depended on her remaining the force that had attracted them in the first place. Essentially, she was alone in the midst of a crowd.

I saw Clare Luce around Taliesin for many years. We had a number of one-on-one encounters—some would say confrontations. She was generally distant and impersonal, almost impervious. I often thought it would be a most rewarding experience to penetrate the vacuum-like

space in which she enveloped herself, in order to reach the substance, which appeared to reside in her frame. Besides, she remained a sexy woman even into her seventies, when I last saw her. Her behavior was unpredictable and often socially offensive.

Olgivanna, on the other hand, was intensely private. She was self-contained and introspective. She operated within a small circle of devoted admirers. Her vast and deep knowledge of human nature enabled her to penetrate and manipulate their defenses, so they became emotionally and spiritually dependent on their relationship with her. This small group was the foundation for a strong personal power base, which she was able to leverage to achieve a social presence equal and sometimes superior to that occupied by others who had devoted all their lives to becoming socially prominent. Olgivanna was cited at one time in *Life* magazine as the most sought-after hostess in Arizona.

As we were walking in the desert one winter afternoon Olgivanna said to me as she was talking about an evening when the Luces and others were her guests for dinner, "On the way from cocktails at the living room to dinner at the cabaret theater, the guests were walking in a one-group formation when I inadvertently found myself more or less paired with Harry. I looked from the corner of my eye and there was Clare glaring at me as though I were running away with her prize. I said to myself, 'Oh God, no, it is nothing like that.' I backed off and gave her the space."

During one of the opulent black-tie festivities we occasionally had, I was dancing with Clare and enjoying it. I started to say something complimentary to her. She unceremoniously disengaged her arms from mine, turned around, and slowly walked away from me, leaving my arms half stretched in mid-air, as I looked at her shapely behind. The ensuing awkward moment seemed like a lifetime. All I could do was quickly dance with another woman who happened to be standing nearby, hoping that many had not seen this incident.

This incident pales beside what Clare did once during a dinner at

the home of Eleanor Cudahay of the meat packing corporation. Olgivanna, who was present at the dinner, related to me the story, which was later confirmed by Mae Sue Talley, who was also present. Clare was seated next to Ray Rubicam. The discussion between them did not progress in a manner that was to Clare's liking. So, she picked up her purse which had a metal border around it, and struck Ray over the head with it, stood up, and left the room as blood ran down Ray's face. Ray was taken to hospital emergency to receive some stitches on his forehead. When Mae asked Clare the next day if she had telephoned Eleanor to apologize, Clare wondered, apologize about what.

The most memorable encounter I had with Clare was at a dinner hosted by Olgivanna in the dining cove. There were ten guests, including my wife Barbara and me, several of the seniors on the Taliesin staff, and Clare, who was visiting from Hawaii where she had been living since Henry Luce's death. I was sitting across the table from her, affording enough distance so that she could not hurt me.

The People's Republic of China had been admitted to the United Nations and Clare was angry about it and making her feelings abundantly clear. For years I had had a desire to have an open discussion with her just to see how far we could go. I said, "But, Mrs. Luce, we share the planet with these people. Would it not be prudent to have a forum where we can speak with each other?"

"We know they are there. We do not need to formalize their presence and show support for their political system, which is predicated on unholy ideas," she said forcefully.

I retorted, "But ideas have nothing to do with it. Ideas are something you write in books and place on shelves. When nations deal with each other they deal in a business mode stemming from an instinct of survival regardless of their internal political system. The East camp and the West camp are like two large real estate corporations, each trying to gain influence over the most prized real estate property on the planet."

"This is absolutely wrong. History is driven by ideas," she said.

"Like when? Give me an example," I shot back. "The Crusades?"

She paused for a moment without an answer. I glanced at Olgivanna at the head of the table. She was looking at me with a discreet smile, imperceptibly nodding her head in my direction as though she were saying, "I like what you are doing. Continue." She was approving of what I had inadvertently undertaken with Clare. It was a chance for Olgivanna to show Clare put on the defensive by one of her group. This conversation, if you can call it that, lasted for the entire dinner without anyone else saying a word. I am showing only the highlights.

After a few moments of silence Clare started again by glorifying the capital system in the West and the perceived personal freedoms associated with it. I said, "That is well and good, but we seem to mix the free enterprise system with the form it takes as it degenerates into capitalism. Free enterprise is an expression of individual initiative. Capitalism is an oppressive umbrella of collective power and it has a dampening effect on individual freedoms."

"Not true," she said, heated again as she felt cornered. "Capitalism is the ultimate freedom. Look at what we have accomplished by letting the capital system work."

Trying to cool things down a little, I said, "I do not think so, Mrs. Luce. We cannot accomplish anything of value for ourselves or for society if we do not have an ethical compass to guide us. What can you buy for 200 million that you cannot buy for 100 million? You sleep in one bed at a time; you eat one meal at a time, and you drive one car at a time. So if you have 100 million, why would you try for 200 million? It is only power."

She suddenly banged both her hands on the table, half got up from her chair, then sat back down. "Absolutely not. This is absolutely untrue." She half shouted. I was slightly startled by her reaction, as were others at the dinner table.

The next day I was chatting with Olgivanna about the evening and she said, "When you brought up that point about power, she thought you were speaking of her husband Harry. That is what made her angry."

I was certainly not speaking of Henry Luce, nor was he anywhere near my thoughts.

After dinner, Clare stood, came towards me, hugged me, and with her hands still on my waist said, "I enjoyed our discussion tonight. But we should continue discussing this thing about power."

I said, "Mrs. Luce, I loved talking with you and by all means I look forward to discussing anything with you."

She was staying at the guest quarters perhaps 300 yards from the dining cove. I wanted to walk her up to where she was going. But my wife's glaring looks stopped that train. I will never know how that night would have developed had I not had a wife so painfully close.

One Sunday afternoon Olgivanna and a group of guests, Clare among them, were walking leisurely toward the theater. I happened to be along as I was finishing a conversation with Olgivanna. As we walked by the dining room one of the women pointed to the dining room chairs and exclaimed with admiration at their attractiveness. They were simple-looking chairs made of thin round steel rods with a round cushion for the back and another round cushion for the seat. We had painted the frame Cherokee red, a favorite color at Taliesin, which most everything was painted. We had made the seats out of blue material. The chairs had been designed by Mr. Wright in 1913 and used in Midway Gardens, a Chicago beer and pleasure establishment. When prohibition caused the demolition of those buildings in 1929, everything disappeared, and the chairs could be found only in the drawings in the archives.

About 1963, my good friend Ken Lockhart brought out the drawings and we set out to build enough of those chairs to use everywhere in our winter camp. We made a jig and I welded 120 of the chairs. They were handsome and elegant by any standard. As soon as the woman made her complimentary remark, and before Olgivanna even smiled, Clare cut in with a dismissive remark in an acerbic tone. "They make them here," thus stunting whatever pleasure Olgivanna was to derive from the compliment.

Often Clare viewed the efforts made at Taliesin with ridicule, springing from jealousy. She envied the way Olgivanna, without the vestiges of power with which Clare was so familiar, could have established a devoted community that she could consistently play like a Stradivarius. Clare had difficulty showing admiration for the uniqueness of the enterprise. Olgivanna understood that side of Clare and made allowances for it because she was keen on preserving the relationship.

When Olgivanna died in March 1985, Mae Sue Talley, a friend of both Olgivanna and Clare, told me that she telephoned Clare at the Watergate Apartments in Washington. She said, "Clare, Olgivanna died yesterday." Clare responded, with a distant voice, "Oooo?"

CHAPTER 20
IT BACKFIRED!

> *The energy spent on active inner work is then and there transformed into a fresh supply, but that spent on passive work is lost forever.*
>
> —*G.I. Gurdjieff*

ONE WARM WINTER AFTERNOON, I was walking with Olgivanna on a road that leads into the Arizona desert to a picnic ground we had prepared a few years earlier about half a mile from the main buildings. I had personally and single-handedly graded that road with a rake and a shovel over a period of several weeks. The work was part of the intentional hardship tasks that Olgivanna always recommended and I was responsive to. Walking on that road that warm afternoon was a kind of celebration.

We were having one of those infrequent relaxed conversations that was not laden with stress or urgency. We talked about my family, whom she and Mr. Wright had seen in Cairo a few months earlier. She spoke of her father, the gentle and loving chief justice. Then she spoke of her mother, the imperious and distant entity in her life, and her legendary grandfather, General Duke Marco Milianov.

She spoke of her daughter Iovanna, who was beginning to show signs of imbalance. We had walked for maybe twenty minutes when she stopped and abruptly changed the subject. In her distinct accent, she

said, "Mr. Wright has a great desire for sex. He wants to have sex once or twice a day. It is too much. I cannot do it."

I was at once startled and flattered to have her speak with me so openly about her sex life with Mr. Wright. Although her words sounded like complaining, I could hear a note of pride as she was taking credit for keeping her husband sexually active at age ninety. I had no response to this interesting piece of information. I just kept walking, looking at the ground, observing our shoes as we took slow, deliberate steps.

For all the years I knew Olgivanna and from the endless talks I had with her over thirty-four years, it was clear to me that sexuality was a central theme in her thesis about the human condition. I often heard her say, "To try to confine sex is like sweeping the ocean with a broom."

She saw sex as a monumental force that can be of immense benefit to anyone who has the knowledge to use it well. To her, it was an energy that acquired its ethical value from the manner it was used, much like atomic energy—not inherently evil but vulnerable enough so that ignorance and greed can render it so.

The potent force of sexuality and its inordinate influence has caused society at large to regard sexual behavior with reverence, suspicion, disgust, and shame—all at the same time. It has always, at one time or another, been placed in a box that one has to approach with anxiety and apprehension, or at least caution. In that box it is removed from circulation as a normal, natural, desirable mode of interaction. It is relegated to a shadowy, musty section of the psyche without enough oxygen for free breathing. Over time, it accumulates a labyrinth of taboos that cause much social distortion and individual psychosis.

Olgivanna thought—and opened my eyes to seeing—that sexuality located in the psyche in the proper perspective, free from addiction, excess, or deprivation, can become a source of education. This knowledge enhances and even deepens one's understanding of life. The pervasive influence of sexuality on virtually every life endeavor renders it a rich medium in which all human emotions are expressed. For Olgivanna,

that was an important venue in which her teaching took place. In my case, I had frequent love interests over the years, and I felt comfortable speaking with her about them.

The intensity associated with sexuality and the uneven and often unreasonable demands and distorted feelings made for an ideal place for her to impart her wisdom. With the participants distressed, vulnerable, and desperate, they are in a good place to receive and accept realities about themselves they would not otherwise be capable of considering.

She felt that the dynamics of a homosexual union are the same as those of a heterosexual one. I never heard her express one negative remark about homosexuality. Indeed, she was protective of homosexuals and had a number of them among her closest assistants. Knowing that I am a complete heterosexual, once or twice she endeavored to preempt any negative or superior attitudes I might have developed about homosexuality. She called it a natural response. "Even animals engage in it," she told me once.

She frequently praised those she had brought so close to her. While talking with her once, I casually described homosexuality as perversion. She snapped, "No perversion."

"There is a sexual component to every relationship," she told me once.

I had the feeling that she did not necessarily think that sexuality was gender specific. I believe she thought that as a life force, sexuality resided in a deeper region of the human psyche. By the time it found its way to the surface to be expressed socially, it would probably have been through so many twists and turns that it would likely take any one of a variety of different forms. Therefore, to place a moral value on whatever shape it assumes is narrow-minded demagoguery.

Olgivanna once told me, "A man should be sexually attracted to every woman." It was an outrageous statement on the face of it. It ignored the social habits developed over the centuries among the human species

where "attraction," "love" or mutual interest brings together individuals within socially recognized institutions. It also ignored the moral standards ingrained in a culture intended to inhibit natural expression on behalf of the security of mass sentiment.

Olgivanna's statement, however, was rooted in the truth we share with all other species. At mating time, the most significant moment in the process of continuity, no value stands in the way of procreation. In humans, this behavior is rightly regulated by a structure suitable for social interaction in the complex society we have devised for ourselves. The tragedy, however, is that this regulation takes on a life of its own as it denies the presence of the original impulse without which none of us would be here. Many individuals advertise their superiority by shouting the virtues of adherence to regulations. Many institutions have built their earning capability on peddling a threatening fire and brimstone criteria to a helpless public seeking approval.

The result is a tyranny, which forced sexuality in the musty back alleys of pornography. Many mental institutions are filled with sensitive women conflicted between strong natural impulses on one hand, and paralyzing restrictions on the other.

I saw Olgivanna once utilize sexuality to save a marriage. In that case, the woman was what one calls in popular culture "needy." She had focused all her psychological needs on her husband. She had the unreasonable expectation that if he loved her he would provide her with all her needs: emotional, sexual, and mental. In time it became a burden that he had difficulty dealing with. Besides having his work as an outlet, he was socially adequate, and he received stimulation by associating with other men as well as women. The marriage faltered under the weight of the emotional demands the husband could not meet and eventually was reluctant to try. His wife came desperately to Olgivanna, looking for guidance. Olgivanna's advice was for her to invite male energy into her life by associating with other men in work situations or on a one-on-one relationship. After all, sexuality is an exchange of male

and female energies, and it does not necessarily include sexual intimacy. She often told me that it all came from the same barrel: a cupful or the whole barrel.

Needy as she was, the woman was thoughtful and introspective. She recognized the value of the advice and went about following it, at first cautiously, then with considerable ease.

A few months later as the burden of expectations became lighter and was eventually removed, her husband seemed to miss the pressure. The resulting vacuum perked his attention and revived his interest in wooing his wife again. The marriage was taken off the respirator.

I do not know whether or not the woman ever had an intimate relationship with any of the men she had associated with. But it did not seem to matter.

Olgivanna always stressed the innate power of the female principle and the pervasive influence women have on society in spite of appearances. Knowing that I came from Egypt, an apparently male-dominated society, she felt I needed more education on that subject than most. She said to me on several occasions, "Even in the case of a Turkish sultan within the harem of one hundred women, there is one woman who has the sultan's ear. She is the one who will influence his sensibilities and impact his life." She also thought that in spite of the forms of society, women led.

In her own life Olgivanna was driven by that conviction. She lived by it and did well with it. She also tried to instill it in the hearts of the women at Taliesin, with average success. In her manipulation of the lives of the people she had access to, she was able to save some marriages, and cause some to take place. She was able to facilitate the marriage of homosexual men to straight women. One of those marriages lasted a lifetime; two ended in agreeable divorces but with lasting friendships.

Not all of her efforts were successful. Indeed some of them turned into unmitigated disasters. One in particular took several years to be

resolved, and Olgivanna commented at the end by saying to me, "It backfired."

After Mr. Wright's death, Olgivanna kept alive a traditional Sunday morning event where Mr. Wright joined the Fellowship for a late leisurely breakfast and talked spontaneously about one or several of a variety of subjects that happened to be on his mind. Subjects ranged from the condition of the Union, abstract ideas, architecture, or even household matters. Occasionally houseguests were present at breakfast and often joined in the discussion. I remember Charles Laughton, Buckminster Fuller, Edward Teller, and many other notables.

One morning during a discussion about technology and creativity Fuller declared, "Mr. Wright, you are a great composer, but I construct pianos."

I could hear Mr. Wright's approving chuckle.

⌐

Internationally famed architect Arthur Buchannan was included in one or two of these breakfasts around 1960 or 1961 after Mr. Wright's death. He charmed everyone by his stories and witty comments. One time he looked at his wife. "Joanne, take a look at these beautiful people," he said, pointing in the direction of members of the Taliesin Fellowship who were all dressed up for the formal breakfast. "Why do our people always look so miscellaneous?"

Buchannan was an architect of note. For a number of years during the fifties and through the seventies he was a force in the architectural profession, receiving commissions and designing buildings across America and abroad. His work was elegant, comfortable, and usually expensive, although less than distinguished. He was educated at Ivy League institutions where he became a professor before launching his architectural practice in New York. I met him during his visits to Taliesin in the early sixties. He was a true southern gentleman, gracious in manner, with a ready smile and easy wit, and he was an engaging storyteller.

He spoke well of Frank Lloyd Wright in public events. It did not

hurt him to be graceful to the controversial giant since Mr. Wright responded in kind. They had developed a relationship of sorts based on this exchange of public pleasantries. Unlike Mr. Wright, Buchannan was a society architect who had considerable ease in making his architectural practice a part of his social life. His pleasant relationship with Wright, however, never inspired him (even when it looked reasonable and desirable) to facilitate Mr. Wright's receiving a commission, even when it was clearly to everyone's advantage that Wright be the architect.

One of the great advantages (some would say the greatest advantage) to Buchannan was his wife Joanne. He had named some of his designs after her. American-born and of Slavic origins, Joanne had a dark complexion with beautiful roving eyes and long curved eyelashes. She arranged her thick black hair in a tall formation so as to make up for her small stature. The strong bond between Arthur and Joanne was apparent. She told me that when she had first met him, he was experiencing some personal hard times. The relationship that ensued was a source of comfort that had helped him straighten out his life and had eventually made her queen of his professional empire.

During the first years after Mr. Wright died we had no new commissions. The office was finishing up some large projects that had been on the boards at the time of his death: Grady Gammage Auditorium in Arizona, Marin County Civic Center in California, the Greek Orthodox Church in Milwaukee, and others. But there did not appear to be anything new on the horizon. It was a time of professional uncertainty. The public would be looking for Frank Lloyd Wright and all it would see would be a motley crew of unknowns who could never fill his shoes.

Wesley Peters, who had now emerged as a serious contender for leadership, was pursuing the age-old methods aimed at attracting work: telephoning, traveling, meeting with potential clients and moneyed people, and so on. But in the final analysis the survival of the enterprise was the life-giving substance of Olgivanna.

Ever since she had set foot in the United States she had had the

singular purpose of creating the community she now headed. Thirty-five years of single-minded planning and consistent brick-by-brick building were in the balance, and the only objective was survival. The demise of this project would mean the total collapse of her life work. The only source of income was essentially the architectural practice. She had to devise a means to bring work into the office.

Her fertile imagination, which had served her well all her life, began to weave a yarn rooted in survival. It included Arthur Buchannan as a player. If he in some way became close to the Taliesin community, perhaps some of his professional prosperity would rub off on the Taliesin practice.

⤵

When I came from Egypt in 1951, Olgivanna had quickly recognized from talking with me, from her knowledge of Middle East culture, and from information transmitted to her by a loyal squad of reporters that I was culturally preconditioned to a social structure based on definite gender roles. Men were supposed to possess qualities superior to those of women. Corresponding attitudes must have prevailed. I had an overtly respectful and flattering manner toward women, but I am sure she could sense subtle behavior patterns that indicated my cultural bias.

Olgivanna, who was truly a liberated woman, set out to straighten out my thinking. One morning at breakfast when I first knew her, she made a big point of ancient Egypt having revered women to the point of having them become queens in their own right. Over the following years she invested much time and effort toward expanding my understanding of the female role. In the process, I began to learn through her constant prodding and my own experience the major leadership role women play in society, both publicly and privately.

I thought back on the society I had come from, where it appeared as though men were the initiators of all activities. I began to recognize, through her eyes, that women in my own family had in reality made all the decisions upon which our lives revolved. I realized how the women in my own life were influential in pointing out the directions I often

took. Indeed, I appreciated the female energy in my space and began to seek the counsel of women. Olgivanna had emphasized to me repeatedly that on some substantial level, wherever women go, men would follow. Therefore, if she wanted Buchannan to be close to Taliesin, one way of accomplishing that would be to find a way to attract Joanne.

Olgivanna had a most winning way with women as she invited them to share with her "girl talk," an exchange of private feminine experiences, sensations, and intimate thoughts. Her natural sympathetic manner and deep understanding of human nature had always enabled her to draw the women into a world of her design where reality, even if it were radically different from the accepted norms, would be the proper way to see the world. While giving Caesar that which is Caesar's by dealing in society according to its norms, she reserved for herself the right to live an inner life, even a secret life, that conformed more to a true, almost pagan vision of the universe. She was able to communicate that to women and men alike. But it was easier with women because of the natural and special language that women have that men do not share. She was able to make reasonable, and even attractive, to the minds of these women the most foreign concepts.

Women with whom I had been intimate who had such talks with Olgivanna told me about the Pied Piper character of her persuasive rhetoric, which always pointed to a direction without overtly making a specific suggestion.

When she came to Taliesin in response to Olgivanna's invitations, Joanne spent a great deal of time with her at meals or in private talks in her quarters or walking in the desert. Sometime later Joanne expressed to me her delight with the level of intimacy the two women enjoyed.

Culturally, Olgivanna had always worked seriously at freeing God-given human energies from the shackles of transient social mores. She taught everyone she could reach to have direct access to his or her own potential, without stunting the process with the "shoulds" or "shouldn'ts" that invariably come from an outside source. Every time

she talked with people who were truly listening, she tried to make them aware of their own imagination as separate from the accumulated information that circled their minds.

One weekend in the summer of 1957, Dr. Henry Franklin, a brilliant, highly regarded cardiovascular surgeon in Indianapolis, joined one of the groups and came with his family to visit Taliesin. He and his wife Heather and their three children made a perfect picture of a happy, functioning, well-adjusted Middle American family. The weekend they arrived, they were placed front row center with the Wrights at dinner and the after-dinner musical entertainment.

The Taliesin community traditionally looked with skepticism on outsiders. Henry's position as a surgeon who probably made a great deal of money and who, we later found out, owned his own airplane, gave him and his family a special entree with Olgivanna. Life seemed to smile on this union for a time.

Gurdjieff's movements, which had always been an integral part of the subculture at Taliesin, were at the center of the activities in which the visiting groups participated. I was teaching these movements regularly, which gave me the opportunity to know those visiting personalities, especially some of the single women who joined each for her own reasons. Like the rest of the groups that came to Spring Green every summer from Chicago, Pittsburgh, Kentucky, and other cities, the Indiana group participated in the regular chores and activities such as cleaning, serving, or working in the vegetable garden.

The constant contact with the community had a way of exposing the aspects of human characteristics that could be protected during a brief social encounter. By the third or fourth visit of the Franklins to Taliesin, cracks seemed to appear in this tower of stability. I and probably others saw the evidence of deep-rooted dissension, which had apparently been present for some time before the Franklins appeared on the scene.

It became obvious that Henry's oppressive male dominance over

Heather had stunted her potential and contributed a measure of misery to her existence. The marriage had been in trouble for some time and the less-than-perfect picture made it ideal for Olgivanna to come in for the rescue.

Heather's experience at Taliesin began to expand as she became more and more involved in the dance. In the dance classes I was conducting I noticed that she moved rather well and had a good attitude and a desire for learning. This involvement was certainly a relief from her marriage experience. There was the usual "girl talk" from which Olgivanna sized up this new pupil and gave her permission to feel her feelings and let down her phony guard. By the fall of that year Olgivanna found it reasonable that Heather stay for a week or two at a time so she could have an uninterrupted period of practice while Henry went to Indianapolis with the children to attend to his practice.

When a confined dog barks long enough in protest of its confinement, the barking becomes an end in itself. When the gate is suddenly opened to let it out, it charges through but soon stops, not quite knowing where it is going. When Heather was let out of the confinement of her family life, it took her a moment or two to recognize the many open possibilities she could partake in. Activities of all sorts were available, as were sympathetic people to talk with. Certainly a number of young, attractive men were hungry for the friendship of a briefly unattached attractive woman whose own natural feelings, thoughts, and sensations were beginning to surface. It was not inevitable that Henry's absence for extended periods triggered extramarital affairs for his wife. But it did. Was that another attempt at reviving her relationship with her husband to breathe life into the marriage? I am sure that was a large part of it. It was also a stand Olgivanna was taking on behalf of the liberation of women.

When Henry came to visit on weekends, it was clear that his wife had interests elsewhere, including intense preoccupation with the dance

practice. For a time, my relationship with her, as I instructed her about the Gurdjieff exercises and other aspects of his teachings, developed into an intimacy that enhanced both our lives.

Olgivanna sent me once to Indianapolis, where I was a guest at the Franklins' while instructing the group about movements and discussing Gurdjieff. Henry and I had a natural liking for each other, and we became almost constant companions during his weekend visits to Spring Green. He had a good mind, though not particularly an agile one. He was emotionally dependent, so it was a perfect arrangement for him to have Olgivanna to lean on. He could lay the burden of his sins at her feet and let her worry about redemption. That feature of his character was the eventual undoing of his relationship with her. The last thing Olgivanna wanted to do was to worry about other people's sins. The core of her Work was to point out people's sins, then try to help them pay.

Henry and I had together the best of intellectual discourse. He was intensely self-centered. In all the years I knew him the bulk of our conversations was focused on his emotional concerns including his now-tenuous relationship with his wife. Her preoccupation with her activities had left him very much alone and quite lost. It was quite a change from life in Indianapolis, where by virtue of his position he was waited on and catered to by his family. Now the roles were reversed. His wife expected to be waited on and cared for as she attended to her tasks, which were central to their presence at Taliesin.

The Arthur Buchannan project, which had been on the back burner waiting for the right circumstance to emerge, was moved to the front burner. Olgivanna invited Joanne for a visit. She arrived in an environment where everyone was busy and deeply involved in the many venues of work that constituted life at Taliesin, including the movement practice. Heather had been chosen for a central role in the upcoming perfor-

mance. Most of her time was taken by intense training. The only loose items on the premises were Henry and Joanne. The law of averages would surely bring them together in some fashion. It did, and they started an affair.

Was that inadvertent or was it planned? It could have been either. I would favor the latter. Many were not watching and did not care. Of those who were close and aware, a few mouthed the party line. They said that Olgivanna was completely unaware of this new union, an ironic thing to say about a woman whose work in life was to be—and show others how to be—aware.

Now Joanne had a good reason to make frequent visits to Taliesin. Since I was close to both of them, they confided to me their most intimate feelings and often the details of their relationship. To Henry, I remained the constant fixture where he could safely hang his feelings. Their relationship was aesthetically attractive regardless of its morality. Throughout my life I could never find a meaningful space for morality to occupy among the ethical values that constitute truth.

Things could have continued for some time the way they had started. Both lovers could have had a pleasurable respite from their respective marriages and gone back to those marriages richer and refreshed. I believe that Olgivanna had that in mind. Years later, when this saga came up in conversation and she said, "It backfired," I noticed that the colloquial expression was uncharacteristic of her use of the language.

What happened next was awkward, unpredicted, and most undesirable. Henry and Joanne thought they had fallen in love. How much of that was a result of the dispositions of their existing marriage at the time? There is no way of telling. But this love changed beyond recall the chemical composition as well as the parameters of the game as they began to plan their exits from their marriages. No amount of talk by Olgivanna could persuade either of them to give up their plans. Olgivanna was in an untenable position, and she felt imposed upon by two prominent adults lacking in sophistication and behaving like starry-eyed teen-

agers. She felt that there had been an unspoken understanding that the main rule of the game was to go as far as they wanted without upsetting the apple cart. The paramount consideration for Olgivanna was to protect herself and Taliesin from the ravages of impending scandal.

Olgivanna had known of the affair all along. Indeed, she had provided the environment that made it possible. She had given the impression to both of them that they had permission to carry on. But when they changed the rules of the game without regard to the unspoken understanding, she reverted to her street fighter mode and unceremoniously kicked them both out of the community. She announced that their affair was brought to her attention by some of the people who had observed their suspicious behavior. She said that when she questioned them they were forced to admit it and that she was not going to have such breach of morality within the community of Taliesin.

The two stunned lovers felt betrayed and walked out angry and bent on revenge. I was close to both of them so I was informed about the developments as they happened. The dynamics of these dramatic happenings were not felt outside the inner circle that was personally involved with the characters.

In spite of Olgivanna's affinity for intrigue, this had pushed the envelope beyond tolerable limits. The situation was out of her hands and she was not in control, a position she had studiously avoided all the years I knew her. She was clearly disturbed and she saw demons everywhere she looked. She did not specifically talk to me about it at the time, but she betrayed her state of mind when she directed the office to buy me a car, a surprising gesture I was not sure how to respond to. The Foundation gave a very few of its long-standing seniors whose work required extensive travel a company car for their use on official business. I was not one of those members. I soon realized that Olgivanna's growing suspicion and mistrust of everyone had led her to cover my base. She was giving me a bribe just in case I had thought of taking the other side, given my obvious and historical closeness to it. The Foundation had bought me a charming little white Ford. But I was hurt by the insin-

uation that I might sell out, and I never used it. I was never sure what she thought I would sell out for.

Over the twelve years I had known her up to that point, Olgivanna and I had reached a reasonable, unspoken accommodation. It went without saying that she controlled all the circumstances under which I lived and worked. But she could not arbitrarily cause me to do anything that I found unreasonable.

I had always understood and appreciated the notion of the master–pupil concept as the means of becoming one with the universe. In that setting, pupils completely give away their power and who they are and obediently follow the master's instructions without question. In time, the pupils' perceptions would be illuminated by the wisdom that had been inherent in those years of obedience.

Olgivanna's small circle of devotees had literally given up their personal lives in exchange for feeding on her energy. From where I stood, this scene did not constitute master and pupils. They were getting their sense of power by staying close to the source of power.

The dynamic inherent in this relationship from my perspective did not contribute to the enlightenment of anyone of that group since enlightenment was not the primary purpose in the first place. It did, however, provide for Olgivanna a base from which she could manipulate the rest of the community. When the party line required collective change in the disposition of the thoughts or emotional process of the group, she never called the group together to make a public announcement of an impending change. Rather, she sent that little core of individuals to spread about among the group to talk about the new procedure in firm though hushed tones, making it sound as though the ideas came from the messenger. This method of delivery had two consequences. First, it angered many, providing a level of conflict that was the ideal environment in which Olgivanna wanted to work. Second, it ensured the distance she liked to keep between herself and the rest of the community, thus maintaining her mystique: everyone was always kept wondering as

to what she might decide next. That way she had no trouble keeping everyone's attention.

Whatever closeness I had with her, which was often considerable, sprang from her belief that I believed in her ideas and that I was seriously working on having them become a part of my experience. She also believed in my undivided loyalty. Her gift of the Ford provided for me an insight into the inordinate insecurity of such a commanding, controlling individual. The fact that I maintained an identity separate from hers and a thought process where I acted independently left room for her to assume the possibility of the worst in spite of my longtime loyalty. So, the car incident was a source of anger and hurt feelings on my part. I had thought that Olgivanna's unparalleled knowledge of human nature allowed her to be more discerning in dealing with the wide variety of relationships she had access to, instead of placing a uniform threshold beyond which she would not play.

After Henry and Joanne were banished, the saga developed a life of its own outside of Taliesin. Their relationship continued. They had a kind of blood pact that each would write a book about the total event, each from his or her perspective with the objective being to bring Taliesin down.

Three years later I too left Taliesin for reasons totally unrelated to these events. One morning in April 1966, Olgivanna called me in and ordered me to leave the community. I left that afternoon and headed for Los Angeles.

This event was the culmination of a six-year struggle we had had over her then six-year-old granddaughter Eve. I had known Eve since she was one day old. The way her eyes looked that day brought Mr. Wright back alive again; he had died eighteen months earlier. And I loved her dearly. I had taken upon myself the task of protecting her in a turbulent environment. The result was a very close relationship between Eve and me. That relationship unintentionally but decidedly excluded everyone else including her grandmother. Olgivanna experienced a less than un-

fettered access to the child because of Eve's feeling of safety with me. At that time Eve had something of a personality conflict with her grandmother which did not readily lend itself to ease of communication.

It was a complex situation where I felt committed to protect the child. Olgivanna felt that I loved Eve unconditionally. She also knew that the energy I brought to her life was beneficial to her development. Eve's father, who was a talented Canadian architect, had gone back to Canada before Eve was born. He would eventually be committed to a Canadian mental facility.

The intolerable thing about this situation, however, was that it was all out of Olgivanna's control. Nothing could be worse.

She had to break it up. Her intense and often sordid and hurtful campaign to accomplish that end was met with angry rejection from me and naïve disregard by Eve. The only solution was to remove me from the physical environment.

When I went to see her that day, she feigned intense anger about some issue of which I had no recognition or recall and concluded that I had to leave.

I would return to Taliesen two years later in response to Olgivanna's encouragement which bordered on pressure.

During those two years, she maintained a good relationship with me and I continued a very good relationship with Eve. For that Christmas, I authored a children's story for Eve which she read to her class at school.

Until her death, my relationship with Olgivanna was subjected to a measure of social tension regarding this issue. But there was an unspoken connection rooted in the unconditional love we both had for that child. This unusual connection was clearly demonstrated one day.

When Eve was eleven years old and her relationship with her mother had worsened considerably, I collected funds, designed and built for Eve a little apartment outside of her mother's residence, but connected with one door. It helped the situation a little but only postponed the break. Two years later, Eve was forced to transfer from her school in

REFLECTIONS FROM THE SHINING BROW

Scottsdale to another in Champaign/Urbana. Clouds of sadness which dominated me on one side and Olgivanna on the other made for our unspoken closeness without exchange of words.

On the day Eve was to depart for Illinois, about the time the car was to leave for the airport, Olgivanna telephoned me to come and see her. I walked into her bedroom. She was sitting on a chair facing the door. She motioned me to sit down. She only glanced at me with her brilliant eyes that seemed to be inlaid in a death mask.

As soon as I sat down a flood of tears gushed out of her eyes, as anguished cries emanated from her whole being. She was weeping as I had seen her weep only once before, fifteen years earlier, when I had said something to bring to the fore her daughter Svetlana, killed in the prime of life in 1946.

She put her face in her hands; then she removed her hands.

In a few moments, I could not hold back my own tears. It was a spear in the heart to have to uproot that lovely young girl from her home and send her away because her own mother could not handle her role as a mother.

It soon became evident to me why I was there. Olgivanna wanted to completely feel her emotional vulnerability. But she needed to do so in the presence of someone who experienced the same quality and intensity of her feelings. I do not remember how long this went on. But when she had shed as many tears as she needed to, she looked at me. I received the message and stood up to leave.

Not one word was exchanged.

During my two years in California, I was working as a structural engineer with Los Angeles Architect John Launter. Only John and I were in the office. During the time we worked together, we produced two houses, which would be widely published: The El Rod house in Palm Springs and the Stevens house in Malibu Colony. I did the structural engineering on both.

One afternoon, I received a telephone call. On the other end was

Henry. I had not seen him or Joanne for three years. He was calling from Coronado. He had started a new medical practice after a few failed business ventures with Joanne, where he had lost all of his money. He operated at a large hospital, where he would eventually become chief of surgery. He asked me to spend the weekend with him in Coronado. It was good to hear from him and I looked forward to seeing him. I had not thought very much about the events of three years before. But the anticipation of seeing him brought to the fore many of the feelings and sensations that were so vivid at the time.

The first few hours were spent reminiscing. Then he expressed without reservation his raw feelings of anger and hurt at Olgivanna's sudden, and to him completely unjustified, reversal of position. He felt that she had sanctioned his relationship with Joanne and suddenly vilified it for no reason he could understand. Throughout our relationship, he always took seriously what I had to say, but this time he was not really willing to listen to my argument that her acute instinct for survival was at the heart of her actions. He was going through a period of intense emotional torture but ironically he seemed to need Olgivanna more than ever. His previous emotional dependence on her had never left him, and she emerged as the only person who could relieve his anguish.

For the fifteen years that followed, he never stopped asking, then begging, to see her. She had shut that door until one day she allowed him in for a few minutes. By then, so much had happened that it rendered the encounter meaningless.

That evening at his house, he went into his bedroom and came back with a stack of paper. He had finished his book about his experience at Taliesin and he asked me to read it. When by the next day I had read through it, my task became clear. I had to stop him from publishing it. I felt protective toward Taliesin and I did not relish the idea that a book was about to tarnish its image. My complete devotion to Mr. Wright and loyalty to his legacy took over. I was also thinking about Eve. I did not want her to grow up surrounded by this rubbish.

The book was a one-sided, one-dimensional statement describing his six-year experience at Taliesin. In it, he accused Olgivanna and the Taliesin Fellowship of breaking up his marriage, causing his wife to become an alcoholic, encouraging her to engage in extramarital affairs, and generally have a devastating effect on his life. Nowhere did he have anything to say about his own contribution to the state of affairs. He had changed the names of the main characters to Kerr instead of Wright and placed the story in a farm community very much like Spring Green, but with a different name.

I was not impressed with the book. He gave himself a passive role as he watched his family disintegrate before his eyes. In the end, he did not make his case, and the book seemed without center. His obvious dependence on Olgivanna added a note of ambivalence to the narrative. But that did not change my view of my task. I was determined to stop it.

As we were having dinner that evening, the telephone rang. He went to answer it and I noticed that before he lifted the receiver, he pushed the button on a tape recorder connected to the telephone. When I asked him later about the reason for the tape recorder, he went through a lengthy subtext on the ongoing saga. He said that Arthur Buchannan, who by then knew everything about the two-year affair, was painfully stung by what he perceived as the collusion between Olgivanna and his wife in arranging it. He had tapped everyone's telephone and had placed detectives on everyone's trail.

Not too many days after that conversation, I myself became the recipient of the same favors. I had telephoned Joanne in New York from my house in Hollywood Hills. The next day I stepped out on Vasanta Way, my very narrow street. On a five-foot concrete fence across the street, a man was looking intently into my window. I waved at him as I drove away in my car. By evening, my telephone line was emitting clicks and noises that sounded very much like someone was listening. Every time I telephoned Henry in Coronado, I enjoyed prefacing the conversation by directing an arpeggio of choice profanity at the presumed spy.

I could not understand the reason for these clandestine operations at that late stage of the game. I was told that Olgivanna's telephone was also tapped. The whole thing seemed surreal. I needed to do two things: start a campaign to convince Henry of the folly of his project, and speak with Olgivanna. I could not telephone her just in case there was any truth to the rumor that her telephone was tapped. Luckily, my long-time friend and a member of good standing at Taliesin, Vern Swaback, had come to visit me in Los Angeles. I related to him the events that had been taking place and asked him to alert Olgivanna as soon as he returned and indicate to her that I needed to see her. He did.

Eventually, Olgivanna telephoned me to say that she was coming to Los Angeles with a woman of her inner circle. She asked me to have dinner with her at the Beverly Hills Hotel, where she was going to stay. In a relationship with Olgivanna, she had to be the master, the giver, while no one could be in any position to give to her. She could not make mistakes but she could point out everyone else's. She would be good enough to give advice but she did not need any herself. That way, she could keep the distance that highlighted her authority.

My father had a favorite saying about power: *wave the stick of power but never strike with it.* He meant that once you strike, you have exposed your own limitations. In this series of events, positions were reversed. This was not my preference nor was it to my liking because, like Olgivanna, I wanted to avoid an awkward change of dynamics. Now Olgivanna needed to depend on me to outline the problem. Even that was difficult for her to take.

When I walked into her hotel room that evening, she looked like she had seen a ghost, or at least been driven over by a truck. She was pale, drawn, with shoulders stooped, and she was very close to tears. As soon as I sat down she said, "Lloyd was here today." She needed to say no more. Over the years, Lloyd, Mr. Wright's oldest son, who was slightly older than she, had made a habit of devastating Olgivanna every time he saw her. She was stoic and strong and for the sake of everything she

had at stake, she took it without complaint though not without untold pain. Those encounters were the dues she had to pay in order to be in that family.

When she married Mr. Wright, she had in a way married the contenders for his legacy. The family considered her an intruder, but she knew her rights—and she certainly had Mr. Wright's ear and total devotion. When she and Mr. Wright started Taliesin in 1932, that was a phenomenon unto itself that by definition would not include anyone of the blood family. While formally welcome to visit, they were effectively cast out of the real workings of the Fellowship. All they could do was stand outside and scream objections to whatever was going on. Lloyd was a very difficult and complicated man. He nursed an inordinate amount of anger, perhaps because he was destined to remain in his father's shadow. But Olgivanna seemed to be a convenient target upon which he could pour his anger.

She described to me in general terms what had happened that day. Before she ordered dinner in the room, I suggested that she invite Eric, Lloyd's son. It was a spontaneous suggestion. I liked Eric, who was working in his father's office at that time. He is a gentle, reasonable man who became one of my best friends. I thought that in spite of divided loyalty, he might serve as a bridge of goodwill. Olgivanna did not think it was a good idea but she approved, after much discussion. I telephoned Eric's house but could not reach him.

As we sat down to dinner, I began to tell Olgivanna about Henry's book and my intention to block it in some way. She looked deep into my eyes with an inscrutable smile as though she was not concerned. That was all that was said about the book the whole evening. Through the convoluted means of communication that we had developed over the years, the smile in the context of the events of the evening meant that she was concerned and that she would like me to continue doing what I had started.

I was straightforward with Henry about his book. I told him that

the book was not interesting. I said that it was not good for him as an aspiring writer to start his writing career with such a negative account of an experience that made him look passive and ineffectual. Over a period of several months and many weekends in Coronado, I was able to persuade him to abandon, or at least postpone, the book about Taliesin and publish a poetry book he had dedicated to Joanne. He adopted the pen name Joseph Byron. I designed the cover for the book, which he called *Souls in Dance*. I further persuaded him to send a signed copy to Olgivanna.

SVETLANA STALIN

> *He is gone, but his shadow still stands over all of us.*
> *It still dictates to us and we, very often, obey.*
> —*Svetlana Stalin, on her father*

ONE DAY IN THE WINTER OF 1970, Olgivanna drove up to the house I had built for my wife and myself at the foot of the McDowell range on Taliesin property. It was a desert residence, comprised of three separate spaces connected with a breezeway open to the endless Sonoran Desert. It was built of desert masonry, glass, and steel and was located on the edge of an active wash. The steep terrain allowed for a lower level on one side of the house. The residence design won an award of merit from the American Institute of Architects in 1975. I had built a concrete bridge across the wash over a four-foot-diameter culvert, to allow the passage of torrential flash floods. One would have to drive over the bridge to reach the wide concrete steps leading to the house.

My wife and I were expecting Olgivanna. She had called earlier announcing that she would arrive with a guest. She stepped out of her Cadillac with an attractive redheaded woman of about forty or forty-two years of age. The guest was rather square faced, with blue eyes and a sweet smile. She looked down slightly, in a demure posture, communicating an apparent shyness. They reached the breezeway and Olgivanna introduced her guest. She was Svetlana Alliluyeva, daughter of Stalin, the dead Russian dictator.

207

We had been expecting Svetlana at Taliesin for several weeks. She had written to me in answer to a letter to express how much she was looking forward to meeting her "friends at Taliesin." Her book *Only One Year* had been published a year earlier to glowing critical acclaim. The saga of her trek from Moscow to Taliesin is worth summarizing.

On December 19, 1966, she left Russia for India, carrying the ashes of her dead companion Bragesh Singh for burial in India, his homeland. It was a trip she had tried to make in his lifetime when he became too ill and asked to die at home among his family. The Soviet government would not allow her to accompany him.

They had met in October 1963 in a suburban government hospital at Kuntsevo, where he was being treated for chronic lung disease and she was having her tonsils removed. During the liberal days of Khrushchev, hospitals were allowed to receive foreign Communists as well as Soviet citizens. After party reactionaries ousted Khrushchev, foreigners were viewed with suspicion.

Bragesh Singh was a respected member of the Indian Communist Party. His beliefs in communism were rooted in humanistic notions of social reform. He was a cultured internationalist who had lived in many places and spoke several languages. He had come to Russia with high-level recommendations from party chiefs, in order to work on translations with Soviet publishers. He was in his mid-fifties and she was seventeen years his junior, in her late thirties. Their distinctly different backgrounds and the disparity in their ages did not prevent a human, loving relationship which remained intensely close for the following three years, undiminished by his inordinate health difficulties. During those three years she watched over him, took care of him, and gave him all the comfort he needed.

They wanted to be married. The pervasive Soviet paranoia viewed every foreigner as a potential spy, influencing the social culture to regard them as lesser alien elements. From the beginning of the relationship at the hospital she was roundly criticized by everyone for spending so much time with a foreigner. Everything she did or said was recorded

REFLECTIONS FROM THE SHINING BROW

and she was under constant surveillance. Her extensive and intense efforts to secure registration of their marriage were uniformly rejected. The laws in the USSR recognized only civil marriages. But a church marriage had no legal standing.

One day she received a call from the Soviet premier, Alexei Kosygin, summoning her for an audience. On May 4, 1965, she walked through a familiar and dreary Kremlin to meet the premier, who was to receive her in her father's old office. Kosygin was a cold and rigid party operative, and the meeting was a chilly event. He gave her no room for discussion. She was to return to work in the collective that she had left in order to look after her *husband* (as she called Singh) and children. The word *husband* seemed to send an electric current through an otherwise limp presence. He said, "What would a young and healthy woman like you want to do with this old sick Hindu? Can't you find someone young and strong here?"

The long, unpleasant audience with the premier ended with him saying, "We won't let you register your marriage."

The tightening noose prevented her and Singh from acquiring any social recognition of their relationship. She could not accompany him to India. His body gave out eventually and he died after a series of asthmatic attacks.

Many came to pay their respects. In his will he had stated that he wanted to be cremated and his ashes scattered on the Ganges River. Svetlana could not part with the urn containing Singh's ashes and she wrote to both Kosygin and Brezhnev asking for permission to travel to India to fulfill Singh's wishes. For some reason, this time she received rapid approval. Within days she received her foreign passport, with an Indian visa for a month.

She was officially invited to be the guest of Denish Singh, a nephew of Bragesh Singh, whom she had met when he visited Moscow. His wife Naggi met her at the Delhi airport. But the long arm of the Soviet government was to shadow her every move. They had sent with her a companion, Mrs. Kasserova, to record all she saw and heard.

At the airport Svetlana was unexpectedly met by Soviet Embassy officials who rushed her to the embassy and forced her to reside in a Soviet hostel, within a Soviet colony. Without discussing it with her, they had planned a ceremony where the transfer of the urn containing the ashes would take place in the embassy under their watchful eyes. Then, according to the plan, she would be escorted to a plane bound for Russia within two weeks of her arrival and a long time before the end of her permitted time. It was a shocking reversal of her plans that she could not and would not accept.

Much arguing, maneuvering, bargaining, bad faith, and temper flaring followed. She had traveled to India to remain for a month. She had planned to scatter her friend's ashes on the Ganges and visit with his family. But suddenly she was fighting tooth and nail with an immovable, impersonal set of pronouncements, delivered capriciously by a faceless authority unaccountable to anyone. She was trying to salvage something that might remotely resemble the original intent of the trip. Her impatience with her country's heavy hand had reached a breaking point, and her unhappiness with the condition she was placed in was more than she could bear. If at any time of her life she had ever entertained the notion of leaving the Soviet Union, this experience confirmed that notion. Indeed, a few days later she requested Denish, who had become minister of foreign affairs in Prime Minister Indira Ghandi's cabinet, to ask the prime minister to facilitate her remaining in India.

With great difficulty she was allowed to go to the country to be with the Singh family. She traveled to Kalakankar, the family compound. The warm welcome and hospitality she received from that family gave her a sense of freedom quite unfamiliar to her experience. The heavy, shackled existence that had defined her life in the Soviet Union temporarily receded into the distance. She seriously wanted to stay in India. During Svetlana's stay at Kalakankar, Prime Minister Indira Ghandi, an old friend of the Singh family, came to visit and stay overnight. Svetlana's desire to remain in India was related to her by a family member.

Indira Ghandi's personal sympathy and warmth, which she freely expressed to Svetlana, could not change the fact that Svetlana had to stay in India several months until the next elections before the prime minister could extend that help. It was a setback.

Her disappointment was illuminated by the encouragement of the family members that she set her sights on America. She remembered that she had passed the American Embassy in Delhi once or twice. In her history studies in Moscow and through her reading of American novelists and occasional American movies reserved only for the higher-ups in the party, she had acquired more than a passing acquaintance with the United States. During her days in Kalakankar she came across a book by the then-American ambassador to India, Chester Bowles, a captivating narrative called *Ambassador's Report*. Had she ever subconsciously thought of America as a refuge? If she had, when? There is no way to tell. The image of the United States became clearer as she had the freedom to think in the Singh family's country home.

Certainly Bowles' book was a direct influence. The author showed vast knowledge, deep understanding, and wide experience. She thought that if she ever had the chance to speak with him, she would have a fair and sympathetic hearing.

Some of Svetlana's writing reveals the darkness that had engulfed her life and illustrates her hunger for a ray of light. In *Only One Year* she writes:

> In the family in which I was born and bred, nothing was normal. Everything was oppressive, and my mother's suicide was a most eloquent testimony to the hopelessness of the situation—Kremlin walls all around me, secret police in the house, in the kitchen, at school. And over it all a wasted, obdurate man, fenced in from his former colleagues, his old friends, from all those who had been close to him, in fact from the entire world, who, with his accom-

plices, had turned the country into a prison in which everyone with breath of spirit and mind was being extinguished; a man who aroused fear and hatred in millions of men. This was my father.

This was the burden that dominated her life in her young years and continued to shadow her existence as she grew up. If anything, life had become harder for her after her father's death in 1953. At least during his life she was protected by her blood relationship with him.

Another aspect of her thinking is also expressed in *Only One Year*. She writes:

At the university, I went through a course in history and social science. We seriously studied Marxism, analyzed Marx, Engels, Lenin, and, of course, Stalin. The conclusion I carried away from those studies was that the theoretical Marxism and Communism we studied had nothing whatever to do with actual conditions in the USSR. Economically, our socialism was more of a state capitalism. Its social aspect was some strange hybrid bureaucratic-like system in which the secret police resembled the German Gestapo and our backward rural economy made one think of a ninteenth-century village. Marx had never dreamed of anything of the sort.... Soviet Russia broke with everything that had been revolutionary in her history and got on the well-trodden path of all-powerful imperialism, having replaced the liberal freedoms of the beginning of the twentieth century with the horrors of Ivan the Terrible.

Clearly, with this mindset as background, in addition to the terrible and demeaning experience in India, the thought of leaving her homeland for a kinder, gentler place would be natural. She was already in a foreign land and she needed to seize the moment.

She had managed to extend her stay in India for three months as was allowed by Soviet law in case one was visiting relatives. But the inevitable was approaching fast and she was to leave for Russia on March 8. On the evening of March 6, she walked through the doors of the American Embassy in Delhi. The scramble that ensued engaged the few puzzled officers present at that time of night. Ambassador Chester Bowles was ill at home. The State Department in Washington was also confused. No one knew who she was. Even George Kennan, a nine-year ambassador to the Soviet Union, answered, when he was asked, "I do not know such a person."

The Cold War was particularly freezing at that time, and the effort at rapprochement hardly needed to be tested by throwing Stalin's daughter into the mix. However, of the options Ambassador Bowles had at his disposal, he elected to help her leave India—speedily, legally, and quietly.

Accompanied by a number of pleasant, accommodating embassy officers, Svetlana took Quantas, an Australian airline. The route was Delhi, Tehran, Rome, and London. When they landed in Rome, the officers told her that she would stay there under American protection for a few days.

Much was happening about which she was not privy. But she took it one day at a time, following directions without argument. Then a decision was made that she would go to Switzerland, a neutral country, for a time until the powers that be decided her fate. By that time the news of her defection had spread everywhere. The move to Switzerland was justified by spreading a rumor that she was going to collect the money her father had stashed away for her in Swiss banks. None of that was true, but it falsely portrayed her as a wealthy woman and placed her in some awkward situations later. She landed in Geneva, where she was given a permit for a three-month stay.

The U.S. State Department dispatched George Kennan to Switzerland to evaluate her. Kennan was a brilliant career diplomat and historian best known for his advocacy of a containment policy "to oppose the

Soviet expansion following World War II." The State Department had sent him in 1929 to the University of Berlin, to immerse himself in the study of Russian thought, language, and culture. He finished his studies in 1931, and in 1933 he accompanied American Ambassador William Bullet to Moscow following U.S. recognition of the Soviet government. He was ambassador to Moscow during the war.

Svetlana had written a book in 1963—ten years after her father's death. It was written in the form of twenty letters to a friend and it bore that title. It is a touching insider's view of her young years, with the opening scene describing her father's death. The book exposes a personal and sensitive account of her talented family and its many friends. It includes snapshots of historical happenings such as when, in 1917, Lenin stayed for a time at the Alliluyeva residence of her mother's family. But most important, the book illuminates her memory of her mother as the radiant source of love in her life. Her mother's differences with Joseph Stalin over his politics resulted in an inevitable suicide. Svetlana tells in some graphic detail the circumstances surrounding that terrible event. She was only six–and-a-half years old.

The book contains a number of endearing letters exchanged between her and her father, in which he called her "my little hostess" or "my little sparrow," and she called him "little papa." She saw less and less of her father as she approached adulthood. She seemed to have a true sense of religion and patriotism. She clearly straddled an apparently satisfactory life on the outside, with a severely conflicted one on the inside.

Her meetings with George Kennan, who had become assured of her legitimacy and the legitimacy of her desire to leave her homeland, resulted in an agreement that she would travel to America and stay long enough to publish her book.

Svetlana's saga ended temporarily in Princeton, New Jersey. George Kennan had graduated from Princeton University in 1925. She had no

funds and for nearly a year she lived in Princeton assisted by friends and acquaintances while her book was being published. After its publication she suddenly had access to money.

Her life in the Soviet Union had not prepared her for an existence defined by an abundance of money. She had lived on a monthly stipend without a reserve in the bank. Her father's needs were met by the state and he had no reserve either. His uncashed checks would pile up on his desk for months at a time. The notion of having capital that would automatically generate income was foreign to her naïve understanding. So she retained the services of a law firm, which managed her little fortune, paid her obligations and paid itself a fee. "I never knew how much they paid themselves," she told me.

Svetlana's second book, *Only One Year*, spans the time beginning the day she left Russia for India to scatter Singh's ashes on the Ganges and ends one year later as she is settled in at Princeton. It is a colorful, interesting and informative story written with sensitivity, insight, and strong views. The book became popular overnight and was widely read by a great variety of people.

A few days after Svetlana's arrival in America, she survived a press conference at the Plaza Hotel in New York. The event was aired worldwide. The outpouring of goodwill, the thousands of "welcome to America" messages, the flowers, the speaking invitations, and other expressions of American feeling were unexpected and overwhelming for her. They touched her deeply to the point of tears but also confused her and caused her to withdraw slightly from the unfamiliar attention. She was an overnight celebrity and was followed by the press everywhere she went.

The events surrounding Svetlana's arrival to America and the celebrity status she had acquired attracted Olgivanna's attention and ignited her fertile imagination. Olgivanna was a people collector with a genuine interest in human nature. From my observations, she was excited about the possible potential a new relationship might bring. From her reading of *Only One Year*, she found Svetlana's naiveté both

transparent and endearing. By 1969–1970, Svetlana had become a hot news item, pursued by reporters of all description. At the same time she had written two popular books and she probably had made a good deal of money. The collage composed of these components made a most attractive portrait. Indeed it almost looked providential that Svetlana had the same name as Olgivanna's dead daughter, who was Wesley Peter's wife.

Olgivanna turned to her daughter Iovanna and suggested that she write to Svetlana, inviting her to Taliesin. Then Olgivanna followed with a telephone call. Svetlana told me, "She continued to make frequent telephone calls for four months. I did not know who Frank Lloyd Wright was, and I had no idea where I was being invited."

I had a glimpse of that effort when Olgivanna asked me to write to Svetlana. I did, and I received a gracious response dated February 17, 1970.

Since Mr. Wright's departure, Taliesin had not been in the news a great deal, if at all. His polarizing personality and exciting presence had always attracted press commentary approving or disapproving, mostly disapproving. But it appeared that no one cared anymore. Svetlana's celebrity would surely bring attention to Taliesin. Her money would certainly be a help if she were to part with some of it. And—who knows?—maybe her presence would stimulate some business somewhere. Olgivanna took her in warmly when she arrived, the beginning of a saga that would persist for many years.

↩

During her initial days at Taliesin, Svetlana and I spent some quality time together. We went walking or swimming in a pool I had built a few years earlier. She was soft-spoken, attractive, and a pleasure to be with. But there was a peculiar vacant spot in her makeup. Occasionally she separated herself from our environment and disappeared into some inaccessible space, signaling an abrupt end to the encounter. Over the years this became a defining feature, which probably originated in her conflicted childhood and youth. Eventually, it was hard to have a mean-

ingful communication with her, as there was this built-in dead-end every time a contact started.

Svetlana spoke with me in general terms about her life in Russia. She had been a close friend to Dr. Murad Ghaleb, the Egyptian ambassador to Moscow, and his wife Shu-Shu. Svetlana worried about her children, from whom she had been separated. She had not heard from them for some time. With her *persona non grata* status, I offered to write to the Egyptian ambassador asking him for information. My letters went unanswered. No information was forthcoming.

Later on that year, at the Nile Sheraton Hotel in Cairo, while I was standing in the lobby with a group of diplomats, I was introduced to Dr. Ghaleb and his wife. I had never met them before, and I had not known what Dr. Ghaleb looked like. As soon as he heard my name his eyes dropped to the floor. Moments later he and his wife left the group.

Coming down the elevator that evening, my wife and I were joined by the Ghalebs at the ninth floor. Suddenly they were a captive audience, and I immediately brought up the subject I had been writing him about from America to Moscow. I asked him if he could possibly help in providing information about Svetlana's children. The elevator reached its destination at the lobby and they both departed without uttering a sound. It became abundantly clear to me that Svetlana's status in Russia was less than acceptable. Much later she told me that Dr. Ghaleb was particularly cautious to the point of fear.

Soon after that incident I learned about the derogatory statements made by Premier Kosygin during a United Nations press conference. He described Svetlana as a "morally unstable and sick person." The press followed with descriptions of a psychotic and unusually over-sexed personality. These statements did not have the intended effect in this fair country of the United States.

From knowing Svetlana at a close range, these statements, while made with malice in an attempt to diminish the effect of her defection, were rooted in some truth. It was not difficult to conclude that her life

with her megalomaniac, cruel father had deprived her of a sense of self and a feeling of permanency. He was playful with her as a child but distant as she grew up, to the point of slapping her on occasion. She observed at close range his orders to arrest, imprison, and often murder some of her friends and acquaintances and even some close family members, for personal reasons. She lived through the shattering experience of her mother's suicide. She coexisted with pervasive uncertainty, inconsistency, and insecurity about what her future held.

↩

In the meanwhile at Taliesin, Olgivanna wrapped Svetlana in an invisible, impenetrable layer of protection. She did that from the beginning. My good friend Ben Raeburn, publisher of Horizon Press, had been for years coming to Taliesin periodically to work with Olgivanna on her autobiography. He had published a number of Mr. Wright's books and all of Olgivanna's. He became a friend she could call upon for assistance. He was scheduled to come to Taliesin on one of his visits about the time Svetlana was to arrive. Olgivanna made sure that they would not travel on the same flight. "He will start a relationship with her," she told me.

At Taliesin Olgivanna spent a great deal of time every day with Svetlana. She invited her as a guest for every meal; Wesley Peters was also invited. Clearly, Olgivanna had a design, or at least a sketch that might develop into a design. Wes's height and his grand manner of expressing himself made him appear like a knight at King Arthur's round table. To this Communist princess, a slightly lost single woman at heart, he cut a larger-than-life figure. Olgivanna's design began to take form.

Thirty years later, I was talking with Svetlana at her public housing apartment in Wisconsin, where she had taken residence. She reminded me of a time during those initial days when I had brought her some red roses. She said, "I was so happy to get them. At lunch I told Mrs. Wright about them, and she twisted her face in disapproval. I was assigned to someone else."

My one-on-one times with Svetlana were reduced greatly, and I

began to enjoy the increasingly obvious whirlwind courtship between Wes and Svetlana as it progressed. Three weeks after they first met, they were married in the living room at Taliesin West, on April 7, 1970. Soon after, I was talking with Ben Raeburn and I suggested that her next book should bear the title *Only Three Weeks*.

No one was invited to the wedding except a handful of very close friends, who were not told the reason they were invited until they arrived. Also invited was Ed Murray, the editor of the local *Arizona Republic*. Ed had been a social friend for some time and in an attempt to further cement the relationship with the local media, Olgivanna singled him out for the scoop. The impact of the event was going to be felt worldwide, regardless of who was the first to report it.

The wedding was the peak of the relationship between Svetlana and the Taliesin community. The glow of the event lingered on for some time as the international media picked up the story, placing Taliesin at the center of intrigue—a favorite place for Olgivanna to be.

The dynamics of these interwoven relationships were complex. One snapshot showed Olgivanna as a reigning queen and Svetlana as a young princess with certain powers of her own. The princess had just married the crown prince and felt that age-long recognized accommodations were due her as a wife—mainly a husband who would keep his marriage as the centerpiece of his life.

↩

Around the turn of the twentieth century, some of the more enterprising East European immigrants eventually became the moguls who dominated the movie industry in Hollywood. The movies they produced represented the model they lacked and wished for in their hard lives in their own countries. It was an ideal where the husband reads the paper as the wife cooks breakfast in the middle of the lovable noise of the children leaving for school. The husband mows the lawn on Saturday, probably with a pipe sticking out of his mouth. The whole family goes to church on Sunday. That image described the standard story of contentment in American life in the movies of the thirties and forties. Svetlana's

view of a free lifestyle in the new world probably was not radically different from this picture. She married after three weeks of highly romanticized courtship and waited for her dream to be realized.

Wesley Peters had been an intrinsic part of life at Taliesin since he was the first young man to join in 1932. Everyone depended on him. There was no visible line where the Fellowship ended and he began. When his first wife Svetlana was killed with her children in 1946, his life was forever bonded with Taliesin. In spite of the conflicts with Olgivanna, which had diminished his stature somewhat, on some level there was an ironclad bond that never broke. His loyalty to Olgivanna was a complex phenomenon with two divergent components. On one level he felt like a big brother, almost a chauvinistic protector who must facilitate the mechanics of her life. On another level, he could not exactly separate himself from the undisputed power source in the community. By the time he married Svetlana Alliluyeva he had been in this posture forty years. It had become second nature to him. It was completely integrated with his belief system. It was unthinkable for him or for anyone who knew him to expect a suburban husband to emerge from behind this complex, rich lifestyle.

⌐

One of the features that intensified the mystery surrounding Gurdjieff was the invisible means by which he was able to raise funds to support his missions. He moved easily among some of Europe's aristocracy, which provided him with large infusions of funds. The Work itself was not a source of income. The money had to come from somewhere else.

I could plainly see that Olgivanna's views about money were not unlike Gurdjieff's. Two or three years after Mr. Wright's passing, the office began to earn some income. It was not enough to cover the expenses of the enterprise, which included the upkeep of two extensive physical compounds, one in Arizona and the other in Wisconsin. At the same time, it must support an extravagant lifestyle that had developed over time after Olgivanna was at the helm. I often heard her wonder out loud why the wealthy friends who were attracted to Taliesin during Mr.

Wright's lifetime, some of whom continued to stay close, were not forth-coming with help. Over time, a sense of entitlement was engrained in the Taliesin culture; people were expected to give us money. That sense remains today.

Olgivanna often said that Taliesin had sacrificed a great deal in or-der to keep alive a fountainhead of creativity that had benefited the community and the world at large. This had been true during Mr. Wright's life but was no longer true after his passing. The process of ob-taining money took on a life of its own and became the focus of a great deal of energy. Olgivanna was keen on cultivating wealthy friends and acquaintances by having them be a part of the Taliesin social life.

Svetlana's money did not hurt her chances of being invited into the fold. She told me much later, "A week after the wedding ceremony, I re-ceived a telephone call from my lawyers in New Jersey informing me that the treasurer at Taliesin had telephoned, asking them to make an annual payment of $40,000 to Taliesin. They were astounded and furi-ous. They could not understand what that was for."

I asked her, "Do you think maybe it was for your upkeep?" She was visibly offended by my remark. But from my perspective, on one level, it was not unusual to expect those who decide to live in a community to pay their way.

On the other hand, she was the wife of the number one man, and you would imagine that his forty years of sacrifice on behalf of that community would have paid for both of them manyfold. Except from my experience with Olgivanna, there was no carryover. The act of giv-ing was itself the act of receiving—a very Christian notion. Whatever Wes had done over the years, he had been paid for as he was doing it.

The manner of asking left a great deal to be desired. Svetlana was still baffled and angry as she talked with me many years later. She said, "I do not know, but this incident cast a shadow on my anticipated rela-tionship with the community, especially after I thought of a conversa-tion I had with Mrs. Wright the day after the wedding. She spoke of Wes's uncontrollable addiction to overspending, which had driven him

into bankruptcy at one time. She told me that her daughter Svetlana was aware of that side of his character and she wanted me to be just as aware and help him pull in his reins."

Her naiveté together with her fondness for Wes caused her to accept having a joint account with him. She had no objection to helping Wes pay his debts. But she was not going to give anything to Taliesin. Wes had a farm near Taliesin that he had called Aldebaran, the follower, after a first magnitude star in the constellation Taurus; it meant the follower in the Taliesin orbit. Aldebaran was deeply in debt.

One evening as we were having a drink, my wife said with an amused laugh, trying not to offend me, "Mrs. Wright is so funny. She said to me today that she encouraged Wes's son to 'go ahead and get some of that money.'" Later, Svetlana told me that she had spent in excess of $700,000. Her sense about money, or rather the lack thereof, but mostly her own desire to help Wes, had blinded her to any red flags that might have appeared along her path.

The disappointments, which took place on all sides as the various members of the cast seriously interacted, tarnished the glow of golden expectations.

The intensity of the life at Taliesin, while exciting for a few, was stressful for many. I for one enjoyed the sudden changes of pace and the unexpected urgencies.

One night at 1 A.M. the telephone rang in Wes and Svetlana's apartment (a few yards away from the main residence). It was Olgivanna urgently asking Wes to appear immediately at her quarters to help resolve a sudden crisis. Such calls were not unfamiliar in my experience. They were designed to cause disruption in the habitual pattern. I usually responded positively to such urgencies. Another reason for some of those unusually timed encounters was to assert a sense of importance of a particular issue or to a particular person. To be singled out for such crisis solving was almost flattering. In Svetlana's case, however, there was the other component: Olgivanna wanted to demonstrate that although Wes was

REFLECTIONS FROM THE SHINING BROW

married, she still had command of his life. That was the only message Svetlana would receive. She responded, "But, Mrs. Wright, it is one o'clock in the morning and we were asleep."

Olgivanna went into a (familiar to me) tirade about Wes's importance in the community.

"Don't shout at me," said Svetlana, "I do not like it when people shout at me."

There was silence at the other end of the line. Olgivanna had received the reaction she was looking for and that ended the conversation.

When the two women met at a formal dinner a few days later, there were meaningful looks without exchange of words. Confrontations such as this were a steady diet. They were eventually resolved but each one left a residue of resentment exaggerated by Svetlana's brooding nature. Over time, these resentments built a layer of plaque that eventually obstructed the flow of communication.

A prominent component in shaping the dynamics in this saga was Svetlana's makeup. Her soft, sweet demeanor camouflaged forty years of bottled-up anger accumulated during her life in the Soviet Union.

The lines of battle were drawn. Iovanna felt responsible for bringing Svetlana into the community because she was the first to write to her. At a small and very exclusive dinner that included Olgivanna, Svetlana, Iovanna, and myself, the air was rather thick to begin with but matters became worse when Svetlana began talking about her husband. Wes was out of town on business that evening, and Svetlana said how overworked he was. Her voice became a bit excited when she said, "He works too hard all the time; he is going to die."

After a moment of awkward and heavy silence, Iovanna's face changed and she said with teeth clenched in a tone that had the sound of cutting steel with a hacksaw, "So are you."

In its issue of June 11, 1971, *Life* magazine published a twelve-page spread on Taliesin, mainly Olgivanna. The text was written by Loudon Wainwright and the article was photographed by the legendary Alfred Eisenstaedt, an insightful photographer who could reach directly into

the heart of the subject. One full page was reserved for a regal, handsome and very severe portrait of Olgivanna. The article described in positive terms the legacy of Frank Lloyd Wright and the work Olgivanna was doing to honor and preserve it. There were photos of young, well-dressed, attractive women carrying wood boards across the roof as other young people were working and building on the premises. There were scenes of the dance and other activities.

The same issue carried a spread about the Kennedy Center Gala Debut. Edward and Joan Kennedy were on the cover. Inside, there were eight pages of frivolity.

The difference between the wholesome elegance of the Taliesin article and the seemingly aimless pursuit in the Kennedy party made for an unintended but welcome contrast. This article was a defining event, which properly put Svetlana in her place as an ordinary member of a community dominated by Olgivanna. If there was any idea that Svetlana's presence had in any way attracted the publicity, Olgivanna saw to it that that notion was put permanently to rest. She was on the telephone with Ralf Graves, the then managing editor of *Life* magazine, several times a day, trying to manage the content as well as the tone of the article. Svetlana and her husband, Wesley Peters, appeared in a group photo among the members of the community.

Wainwright and Eisenstaedt stayed at the Holiday Inn on Scottsdale Road, some twelve miles from our camp. A couple of times I joined them at the hotel restaurant for a few drinks after dinner. Loudon said to me once in light-hearted rhetorical skepticism, "So what is so important about Taliesin? I do not think anything will happen to architecture or to the world if Taliesin disappears tomorrow."

I said: "Do you think anything will change in the world if *Life* ceases to exist? I do not think so."

A number of years later, after *Life* magazine ceased publication, I was having dinner with Olgivanna when she was enjoying some reference made to that conversation. I said: "We should telegram Loudon, 'Taliesin goes on as *Life* expires.'"

In spite of his creative artistry, Alfred Eisenstaedt was somewhat personally rigid. He observed the life-style at Taliesin where everyone took part in the maintenance and service of the community. But he had a disappointingly simplistic perspective as he described members of the fellowship as slaves.

I said to him once: "To the extent that you are a slave, you *are* a slave. If you have a servant mind you will always be a servant no matter what you do, instead of being of service. You probably work fourteen hours a day, as long as a slave does. But the difference is that you work and the slave toils." When the subject came up again, I recounted to him a story I had heard from Mr. Wright. It was about a butler who despised his employer and hated his job. When a friend suggested that he leave that job and find another one, the butler said: "It is all right, I spit in his coffee every morning"—a mind of a servant.

Olgivanna had the unusual ability to design and implement conflict, then cleverly retire into a solitary posture, assuming the role of the victim. That is what she did here. In the process she gathered around her the small circle of yes people who in turn tried to widen the circle by disseminating a party line. It said that Olgivanna had done so much for Svetlana by allowing her into the community, facilitating and celebrating her marriage to an attractive husband, and giving her a chance to partake in an endeavor that could enhance her creative abilities. The line went on to describe Svetlana as stubborn and ungrateful for not immediately blending in and taking her place in line to be of service.

These statements were true. But they were made somewhat sordid by the tone Olgivanna cast on them. From my perspective, being immune to a party line as a matter of principle, I could not understand, given her background and her life in Russia, how Svetlana could automatically and effortlessly fall in line. Many young Americans who were brought up on American soil had found it difficult to function in that community and had to leave.

Although I spoke with Svetlana occasionally during that period, I

was essentially a sad observer, watching a relationship between two people I was fond of that was doomed for failure.

Svetlana's relationship with the powers that be reached a new low when she discovered that she had become pregnant. News such as this, potentially a source of joy, fell hard on Olgivanna, who had never encouraged parents to have children in the community; she felt they became a source of distraction without the certainty of a successful outcome. Svetlana told me that Olgivanna had ordered her to have an abortion. Svetlana adamantly refused. When Olgivanna's intense efforts to terminate the pregnancy failed, she telephoned George Kennan. He had visited Taliesin in Wisconsin the summer before and we had had a lively discussion about foreign policy. She asked him to bring his influence to bear on Svetlana to terminate her pregnancy. Svetlana told me, "She was on the telephone for so long making the case for abortion. Kennan was at a loss to deal with the issue. So, after what seemed like eternity, he motioned to his wife, who was present with him in the room, to come to his aid. Mrs. Kennan spoke loudly enough to be heard on the other end of the wire asking her husband to come quickly to deal with an emergency which had just arose and she took the receiver, spoke with Olgivanna briefly, and ended the conversation."

Svetlana had a lovely girl whom she called Olga. But this did not alleviate the stress that had become a feature of that marriage. Clearly, there was no way to continue. The once-glamorous couple divorced. Eventually, Svetlana left Taliesin and went back to Princeton, then London, then Russia, then London again, and finally back to the States, where she lives with her daughter.

When I saw her again at her residence in Wisconsin thirty years later, she said, "After Mrs. Wright died, I thought Wes would ask me to come back to be with him at Taliesin. He had kept a close relationship with Olga and me, all the years since I left. I waited in anticipation, but he never asked."

CHAPTER 22
DAMASCUS

> *I will proceed no farther, for if I do, I will not enjoy*
> *Paradise.*
> —*Unknown sheik, upon seeing the city*

IN 1975, THE UNITED STATES INFORMATION AGENCY contacted me and requested that I give a series of lectures on architecture in Damascus, Syria. It was not a total surprise. For reasons unknown to me, the USIA seemed to know that I existed.

A few years earlier they had telephoned me requesting that I write an essay discussing the influence of Islamic architecture on American building tradition. They wanted to translate it into Arabic and publish it in the Middle East. I said to the gentleman on the other end of the line, "I am not sure that such influence exists, but I will do some research."

I did, and I finally wove a yarn describing the trek of North African architectural sensibilities through Spain, South America, and then the American Southwest, as well as the trek through Florida and Louisiana.

I accepted the Damascus lecture series with pleasure, especially as I could fit it into the yearly trip I made to visit my family in Egypt. I traveled to Cairo as planned and within two weeks I took a Syrian Airlines flight to Damascus. From the hotel I telephoned the American cultural attaché, who sent me a car the next day to take me to the embassy. The attaché, a pleasant, articulate young man, told me that I would be giving two lectures: one at the school of architecture and engineering; the

other at an architects' association, a body similar to the American Institute of Architects in the States.

The question that had occupied my mind for days was: Should I speak in English or in Arabic? In spite of the fact that for the first twenty-two years of my life, as a citizen of Egypt, I had been steeped in Arabic culture, language, and literature, it was often difficult for me to attempt a reasonable intellectual exchange with my fellow citizens. Many of them had what seemed like a chronic, one-sided, argumentative view of the world. I did not look forward to such exchanges, which would surely spill over into politics.

A decided leftist tendency pervaded the Middle East at that time. My being an American citizen could appear as a betrayal to some who would surely bring it up and derail the purpose of my visit. After much consideration, I decided to put a distance between the audience and me and announced that I would lecture in English. An architectural professor was on hand for translation.

My first lecture, at the university, went smoothly before a standing-room-only audience of young people equally divided between men and women. The next day at the Architect's Association the audience was more aggressive. As I was showing slides of my work, one of the people present, presumably an architect, interrupted me and said loudly in a challenging tone, "You are an Egyptian architect. Egypt and its Arab sisters need the talent you squander on Americans. Why are you not here helping?"

That was just the question I had wanted to avoid. But after a moment of silence, I said, "Well, I am here now. I will be glad to talk with you about any project you want to discuss." That seemed to end the confrontation.

Toward the end of that lecture, my good friend Syrian architect Mohamed Bizem walked in, made his presence known, and waved discreetly. When I arrived in Damascus, I had inquired as to the whereabouts of my friend and had left a number of telephone messages for him at various places. I was delighted to see him. We had a great deal to

catch up on. He looked exactly as I remembered him from twenty-five years earlier—the last time I had seen him.

Bizem and I had been very close friends and colleagues during the last four years of architectural school in Cairo. We had sympathetic souls and we spent much time together studying, drinking, or just roaming around Cairo. The University of Cairo, called at the time Fuad University after King Fuad, who was King Farouk's father, was the most distinguished institution in the Middle East. Cairo was recognized as the oldest seat of culture in the region. Many of the individuals who had had significant political, literary, or cultural influence in the region had received their education at that university.

That evening Bizem took me to his home for dinner and to meet his family. He had married a lovely and very interesting Yugoslavian woman from Sarajevo, and they had a ravishingly beautiful daughter in her late teens, with green eyes and blonde hair. It was difficult for me to take my eyes off her the whole evening. Later, as the reminiscing went pleasantly on, I realized that the wife was a first cousin to a gentleman I had met a number of times at my brother's home in Zurich during the previous three or four years. He was a Yugoslavian national who had become a Swiss citizen, and he was an arms dealer. He eventually made the deal of his life with the Gulf State of Abu Dhabi. After ten years of work he had become instantly very wealthy.

The unexpectedly exciting meaning of this trip began to emerge as my friend Bizem told me that he had changed his professional career from architecture to railroad engineering. After he returned to Syria, he became an engineer in the Higaz Railway. Eventually, he became the director of the railway. I had heard of the Higaz, but I was not completely familiar with its rich history.

The Higaz was one of the principal railways of the Ottoman Empire. The main line of the rail was constructed between 1900 and 1908. It ran from Damascus to northwestern Arabia over Transjordan, ending in Medina, Saudi Arabia. The major branch line ran to Haifa on the Mediterranean coast of Palestine. During the conflicts that took place in

the region, the Arabs challenged the pervasive presence of the Ottoman Empire and, in 1915, inspired by T.S. Lawrence (Lawrence of Arabia), they put the southern segment of the rail north of Medina out of operation.

The railway station in Damascus is located in the middle of downtown in what is known as Hejaz Square. The train comes in and departs on the surface through a station building constructed by the French in 1908 and characterizes the area by its architectural period. Several layered blocks of medium-height apartment and office buildings surround the station. When I was there, the station building had been in place seventy years and had become an intrinsic part of the life in the city. By the seventies, traffic congestion had made it difficult to maneuver.

My friend had an idea about lowering the station to a level far enough below ground so as to free the twenty-acre space of Hejaz Square for development. Our meeting after so many years seemed to trigger an impulse to realize the dream. He asked me to team up with him to develop a concept that would make economic sense and be acceptable to the authorities. He asked me to develop an architectural vision describing the possibilities inherent in the idea. That was more than I could ever have dreamed of or hoped for—a project that could change the complexion of a 5000-year-old city. It was hard for me to contain myself.

For two days we visited the site, looked at maps, weighed alternative possibilities, and generally explored the many facets of the project and the power sources that might bear on its development.

I took my time returning to America since I was also nurturing some possible work in Egypt. Anwar Sadat was president, and he had opened the country to foreign investment after the long, dry eighteen years of Nasser's presidency.

When I arrived at Taliesin after my trip, I was carrying with me a potential large project for the office. Normally that would be cause for celebration. But I knew better. I braced myself for Olgivanna's onslaught that would, theoretically, save me from myself and shrink any

swelled-head potential that might feed my vanity. After twenty-four years of dealing with her, nothing surprised me. She wanted the project. That was a given.

During my first meeting with Olgivanna after my return, she made a great deal of my long absence abroad and the difficulty I had caused by having others carry my responsibilities while I was gone. Then she had a tepid response as I outlined the project. She wondered whether I might be disillusioned as I was so enthusiastic about a potential project that might not be there at all, given the political complexion of the region. Then without telling me to abandon the project she reiterated the office policy of not engaging in uncontracted work. After a long and not-so-pleasant meeting, the net result as I understood it through that convoluted process was that I could go ahead and develop the vision. But Olgivanna was not entirely supportive of my effort.

That was not the end of the confrontation. She communicated a message to the body of the community via her close network operatives. The message painted me as a renegade who had taken the interest of the office into his own hands, squandering it on a fantasy in a far-away land. She had endeavored to isolate me and she had succeeded. She could play the community like a Stradivarius.

By that stage of our relationship, I had for some time released myself from the grip of her control. As a result, what she felt about whatever I was doing or not doing no longer mattered to me, and she knew it. That was probably the first subtle signal to both of us that my days with the group were numbered. That break, however, did not take place for another two years. I had become immune to that kind of sideswipe and her underhanded efforts designed to make me uncomfortable.

I will always have Olgivanna to thank for giving me the opportunity to learn how to stand firm against difficult odds. This and other similar situations illustrate the complexity of her methods. I had always felt that she had my best interests at heart. I never failed to see that whatever difficulty she placed in my path was meant to teach me something, and I always looked for the lesson. But I also felt that part of the lesson was to

do battle with her. The environment of conflict was where it all happened. She herself never felt that she had arrived at the state of Nirvana where she could go no further. She, too, needed conflict to maintain the tone of her inner muscles. While the experience was hardly enjoyable, her interest in me and my loyalty to her provided the context that lent meaning to the experience.

My anger at the situation was genuine and my response sprang from that emotion. When I completed my work two months later and was ready to wrap my drawings to send them to Damascus, the treasurer of the Foundation, who was one of her closest circle, approached me. He expected me to show my work to Olgivanna, as was called for by the tradition established after Mr. Wright's death. I said, "No, I am not going to show them to her. She never seemed to approve of the whole idea anyway."

Then I mailed the material.

While I was waiting for feedback from Damascus, I had a full plate of architectural and engineering work in the office. It took the government of Syria a number of months to respond. The political climate was heating up as hostilities in the Middle East reached a new peak. Our project probably did not have the highest priority. Yet communications from my friend Bizem indicated that the Ministry of Public Works, the agency in charge of the railway, was working on establishing the potential. By the winter of 1976 I received preliminary approval of the schematic designs. I also received a request to go back to Syria to meet with the government. I responded that I would return in the spring and braced for the battle with Olgivanna.

She and I had not spoken about that project since our first meeting after my return from Damascus. The issue remained unresolved—a favorite status in which Olgivanna preferred to leave things. Muddy waters were always a most suitable medium for her to do her work. I was expected to feel guilty or at least lost and eager to resolve the situation. But I did not try, and I almost enjoyed the resulting tension that shadowed our relationship for the following months.

The simplistic view of this dynamic was that Olgivanna and I were on the opposite sides of an issue. The fact was that there was no issue. I wanted to go to Syria in pursuit of a project I had initiated. In truth, she was interested in the project and the possibilities it could bring. The problem was that whatever I was doing was out of her control. She was not consulted, and she had not outlined for me the path I must follow. That alone was sufficient to produce friction. There was no animosity. It was the eternal dance she choreographed, and it was up to me to take the right step at the right time.

I did go to Syria. I arrived in Damascus the day the Syrian army marched on Lebanon in June 1976. The air in Hejaz Square was electric and the city was agitated. I learned later that the day after I left, some terrorists had forced their way into the hotel where I had stayed and used their machine guns to demolish a fair part of it. They were caught and hung publicly in the square in front of the hotel.

As the Syrian project continued, another issue was pressing on my life. My marriage of six years, which had had some structural difficulties from the outset, was gasping for life. My wife Barbara was squandering the oxygen on which the marriage had subsisted, and I had grown tired of manufacturing any more. True, four years earlier I had had an affair with a young woman twenty years my junior, which my wife had known about.

The sunny disposition of our six-year union was fading into a pale twilight. I had met Barbara when we were seated together at a black tie dinner at the Biltmore Hotel in Phoenix. The occasion was a historical review of costume development in American social life. She had come from her home in Oakland, California, and was staying at Elizabeth Arden's Main Chance. I was a senior architect at the Frank Lloyd Wright Foundation. The pleasant conversation ended with my consuming her dessert. Whipped cream was not included in her Elizabeth Arden diet.

During the ensuing two years of courtship, I tried to evade the marriage question. But, like any truly strong male, I finally succumbed to the inevitable emotional pressure. We were both in our forties, so we did

not assume the starry-eyed disposition. But we liked each other and we were having considerable fun.

Olgivanna liked Barbara and she had often invited her to stay at Taliesin for extended periods of time so she could be with me.

When we decided to be married, Olgivanna was at the Plaza in New York with an entourage of half a dozen of her close associates. They were on their way to Durban, South Africa, where Olgivanna was to give a lecture.

"Why don't you get married here in New York, so I can be with you? I will be here another week," she had said when I telephoned her to tell her the news.

It did not take much persuading and we were in New York a day later. We had a suite at the Plaza, and a couple of days later we were married in another suite, which Barbara had secured for the wedding night. Olgivanna shed a few tears as we exchanged vows and lovingly took bites of the marzipan wedding cake Barbara had made, knowing my addiction to that flavor. The ceremony was to have been conducted by Norman Vincent Peale. But, due to his absence from the city that day, his assistant, Father Caleandro, filled in for him.

Ten-year-old Eve, Olgivanna's granddaughter, and by then my virtual soul daughter, flew from Phoenix for the occasion. She and I spent the day in Central Park while Barbara made the arrangements.

A highlight of the period before the wedding was a small, very private dinner hosted by Helen Benton at her Waldorf Towers apartment. The Bentons had been close friends to the Wrights. They had a winter house in Phoenix and they were frequent guests at Taliesin.

In 1929, William Benton had founded, with Chester Bowles, the New York advertising firm of Benton and Bowles. By 1935, it had become the sixth largest in the world, at which time Benton sold his share to his partners for a million dollars. He was thirty-five years old, and he retired to do what he enjoyed doing best, make money. Olgivanna often referred to him as King Midas because everything he touched turned into gold. He owned many profitable businesses, including the *Encyclope-*

dia Britannica. On the way, he became senator from Connecticut, vice-president of the University of Chicago with his friend Robert Hutchins, who was president. He developed the "University of Chicago Round Table," an extremely popular national radio forum. In 1945, he became assistant secretary of state and converted for peacetime the U.S. Information Agency. He also lobbied the Fulbright Scholarship Act in Congress. To hear him talk about it, you came away with the distinct impression that he thought the act should have been called, "The Benton Scholarship Act."

Helen Benton was a particularly close friend of Olgivanna's. Tall, regal, handsome, gracious, with a neatly arranged shock of white hair, she was uniformly liked by everyone. There was no way to avoid comparing her to Clare Luce, due to their equal proximity to Olgivanna. When that happened, the unpopular Clare always won on the grounds of interest and brilliance, without Helen losing any of her popularity.

After the festivities in New York, Barbara and I flew to Oakland in time for the Oakland Symphony Ball at the Kaiser Center. It was an opulent extravaganza, which included international fashion designer shows. Barbara had been a well-liked, visible and prolific fundraiser for the symphony. No one had known that we were just married. When the news was announced, the ball turned into a wedding party.

In answer to a question from *Oakland Tribune* society editor Robin Orr, Barbara said, "The first time we had dinner together, he ate my dessert. After that he figured he can have two desserts for the rest of his life."

One of the most delightful windfalls of my union with Barbara was getting to know seventeen-year-old Henry Kaiser, III, Barbara's only son, whom she affectionately called Henry Three. Brilliant and very well mannered, he had a wide spectrum of interests. He was accepted at Harvard before finishing high school and learned to play the guitar by correspondence. In 1975, he invited me to go with him on a two-week trip to Japan.

Behind these obvious vestiges of harmony, structural problems lurked. Barbara's first husband, Henry J. Kaiser of Kaiser Industries of Oakland, California, was a very wealthy man who had died young—in his forties—a victim of multiple sclerosis. During the long period of his illness she was in charge of the marriage and was consequently thrust into the lead position of social and business functions, a part of his corporate life. This gave her a feeling of importance beyond the reality of her makeup. In spite of the difficulty of caring for a terminally ill person, she had considered the marriage a great success. It gave her the sense of importance that she came to expect in all other circumstances.

Her marriage to me did not provide her with anything that resembled what she expected. I am a loner, perhaps even a committed bachelor, who never really understood the institution of marriage. Adding to that, she was a wealthy woman looking for a life of society and entertainment. I am a working man, completely committed to my work. I had declined her offer that I live with her in her large house in Oakland and insisted that she live with me in the desert on my turf where I worked and made my living. I did not need her wealth. I had a few years earlier given away my whole inheritance from my wealthy father to my family. There was nothing to hold us together except possibly similar aims or interests, if any.

My loner nature and my congenital roving eye for other women probably undermined my role as an ideal husband. My excessively long working hours left Barbara with much time on her hands to rethink the soundness of her decision to marry me.

In the summer of 1972, my mother came from Egypt. She stayed for a few weeks during which she observed our marriage. She liked Barbara immediately. Neither woman spoke a word of the other's language but they communicated so eloquently by looks and gestures that they at times made me feel left out. My mother took my wife's side, citing my temper as a cause for the disruption.

But I believe that we did not have enough love for each other to ride

out the difficult times. The pain she was causing me equaled only the pain I was causing her. I was not inclined to work at saving the marriage. To me, it seemed, as I said to a friend, like rearranging the furniture on the *Titanic*. I thought a divorce was the only way out for both of us. But she resisted with all her might.

What happened while I was in Damascus was vintage Olgivanna. In many intimate talks with her during the winter before I left, I had spoken about my marital problems. She had been aware of much of what I told her. She knew that I needed a divorce if only to preserve my sanity. She also knew that my wife was adamant about not giving me one.

When I returned from Damascus, I gathered what she had done on my behalf in my absence. She had taken Barbara into her confidence and used her formidable rhetoric to convince her that I was the worst husband she could possibly have chosen. It took all summer to bring Barbara to the point where divorcing me was the most urgently needed act she could do to save her soul.

Meanwhile, the railway project in Damascus was taking on serious dimensions. The government of Syria announced it internationally. At least thirty engineering firms, from most European countries and the United States, submitted their qualifications. I was to be the architect. I found myself in the unusual position of being wooed by all those well-established famous firms who wrote and called on a regular basis. For a time I did not quite know how to behave. But I got used to it. When Saudi Arabia learned of the project, it pledged one billion dollars toward carrying the work south to Medina and restoring the part of the rail that was destroyed by followers of Lawrence of Arabia.

The ending of my marriage helped define my current relationship with Olgivanna and Taliesin. Both she and I had for some time felt that it was time for me to leave. Usually she made a scene that would be cited in the party line as the cause for the break. But she did not do that with me. We simply became estranged from one another for a time. Then one evening I went to see her and announced my decision to

leave. It was a short and expected encounter. She wished me luck and I was on my way the same evening.

Over the years I was asked by reporters who interviewed me for a variety of reasons, "Why did you leave Taliesin after twenty-seven years? What happened?"

I always answered: "Nothing specific. But in any relationship, be it marriage, partnership, friendship, or a business relationship, when a time comes when you can no longer take from the relationship or give to it, then it has died. Then you have one of two ways to go. Either stay in it anyway for the sake of convenience, simply supporting a bad habit, or make a decision to live your life to the fullest, exit from the relationship, and continue to live in a different venue."

For some, this begged the question: "Why did you stay?" To this I answered: "For many years, the sense of mission which had developed in me during my years with Mr. Wright remained prominent in motivating my life endeavors. The work with Olgivanna was also worthwhile. But a moment came when it became clear to me that the desire for power and control overrode the expressed purpose of the community."

ANOTHER LIFE

> *Remember yourself always and everywhere.*
>
> *—G.I. Gurdjieff*

WHEN I LEFT THE TALIESIN FELLOWSHIP in November 1977 I did not have a dime. Nor did I have an office or a client. I borrowed $3,000 and rented an apartment in a new section of north Scottsdale. I asked an acquaintance contractor if I could rent, for $100 a month, a desk in his office where I could place a telephone and a chair so that I could sit next to the telephone. He agreed. For $1,000, I bought a wreck of a car from an acquaintance who owned a car agency.

Every morning I dressed up in a suit and a tie, drove to the office, and sat on my chair next to the telephone. No one knew I was there. The Damascus project was still in the early talking stages, and I did not anticipate accruing any revenue from it for years, if ever.

Olgivanna had tried to keep the Damascus project for Taliesin. I had done all the work, made all the contacts, and traveled several times to the Middle East at my expense. It was obvious that Taliesin could not do anything about the project without me. I pressed that point, and the group had no alternative but to relent with minimum grace. I wrote my friend in Damascus and the engineering firms I had been working with in New Jersey, Chicago, San Francisco, Geneva, Munich, London, and elsewhere.

The first dollars I made as I was leaving Taliesin came from a small

job I did for my good friend David Dodge. David and I had joined the Fellowship about the same time. He has never let me forget that he joined two months before I did, making him my senior. Fifty years later he is still there and remains the only one in whose heart the original flame continues to burn bright. That is remarkable considering the pressures of man's lower instincts and the justifications thereof.

David had bought one hundred acres north of Taliesin property in order to build his residence. It was a wise move that legally separated his property from that of Taliesin. When my wife Barbara and I built our residence, a project she financed, she insisted upon building it on Taliesin property. She lost it when she left.

David asked me to do the structural engineering on a small structure in which he and his wife would live while planning and building their main house. In my uncertainty as I was leaving penniless after twenty-seven years, that project was affirming and supportive.

Later, in the nineties, I engineered his spectacular, complex, and extremely demanding main residence. We pushed the technological envelope to its limit, and we shared a 2000 award of excellence from the American Concrete Institute.

⟿

After two weeks of waiting by the telephone in my office, it rang one morning. I said to myself, "Good Lord, someone knows I am here." A civilized voice on the other end of the wire introduced himself as though I should know him. I asked, "Do I know you?"

He said that he remembered hearing me talk, the year before, about energy in relation to building, and that he had liked what I had said. I did not remember the occasion but I said that I did. I further said that I remembered him, which I did not. Then he asked, "Can you come to San Antonio?"

"Sure," I said.

"Can you come the day after tomorrow?"

I was jumping with excitement but I contained myself and said

coolly, "Let me look at my schedule here for a moment." Seconds later I said that I could.

As I descended the plane steps at the San Antonio airport I looked hard at the waiting crowd, hoping to find a face I could recognize. Then I did. A tall, handsome youngish man, prematurely gray, stood out in the crowd. As soon as I saw him I remembered the entire occasion of our earlier acquaintance. He drove me sixty miles north through the Texas Hill Country to Kerrville, where I met a charming young woman from the Hunt family who owned a construction company. She wanted to build twenty-four homes on a property she owned. When I returned to Phoenix a day later, I had a signed contract that kept me going while other projects came into my new office.

DR. KARL

> *Set up as an ideal the facing of reality as honestly and*
> *as cheerfully as possible.*
>
> —*Karl Menninger*

Oɴᴇ ᴅᴀʏ ɪɴ Nᴏᴠᴇᴍʙᴇʀ 1978, the telephone rang in my office in Scottsdale. It was Dr. Karl Menninger calling from Topeka, Kansas. "Hello, Kamal," he said, "I am having a meeting here at my office Friday. I would like you to be here."

I had known Dr. Menninger, whom we affectionately called Dr. Karl, personally for eight years and had read his books regularly for some years. I had met him through my wife Barbara who, I found out after we were married, had spent a period of time at the Menninger Clinic in Topeka. After I built our home on the Taliesin grounds, she invited him and his wife Jean to dinner when they were on one of their frequent visits to Phoenix. I drove to their hotel in the valley to pick them up.

When I first met Dr. Karl, he looked larger than the image I had painted of him in physical size as well as compelling presence. There was immediate chemistry between us, which lasted until his death at age ninety-seven in 1990.

In 1975, knowing that I had read many of his writings and owned most of his books (some of which he had given me), he presented me with another, of which I had never heard. It was titled *A Guide to Psychiatric Books, in English.* It was simply a 220-page checklist of books on psy-

chiatry and related fields. He presented it with these words: "For Kamal Amin, who actually collects my books. Kamal, this is a dull one for your collection, not your studies."

His call came on a Wednesday, and I said that I would be there. Represented in the meeting were the University of Kansas at Lawrence and the Native American Research Institute, also at Lawrence. The meeting focused on the desire of five Indian tribes—Navajo, Zuni, Hopi, White Mountain Apache, and San Carlos Apache—to build homes and care facilities for their youth and elderly on the reservations. The tribes wanted the buildings to be modeled after those Dr. Karl had initiated in Topeka, which had quickly spread across the nation.

He called the Topeka project "The Villages." It was simply a series of homes for young children who had fallen through the cracks of federal programs and had lost their home environment for one reason or another. A couple would be hired as parents to care for about eight to ten children, providing a home environment to which the children could relate and return to for visits once they had left at age eighteen.

Dr. Karl had been for many years a trusted and revered kind of godfather for the Indian nations. He had frequently advocated their cause before governmental bodies. The Department of Housing and Urban Development was asked to fund the tribal project.

The next step was to determine the needs of the individual tribes so as to tailor the various programs to suit each tribe's needs. The purpose of the meeting at Dr. Karl's office that day was to outline a strategy to define those needs as a basis for individual proposals by each tribe for submission to HUD. Dr. Karl asked me to be his representative along with the representatives of the University of Kansas and the Native American Research Institute.

For two weeks our group traveled the Southwest deserts from one reservation to the next, meeting with tribal councils and their housing authorities, identifying the individual needs for each tribe, and organizing the basis for request proposals. It was to me a most enlightening experience.

To many, Native Americans are a homogeneous people with a one-size-fits-all solution to all their problems. The fact is that the only thing they have in common is the event of being removed from the heart of the American continent to be placed on designated areas that came to be called reservations. I worked with the Apache tribes. They had migrated from Canada to Arizona, where they split into a number of smaller tribes. They were nomads who lived on hunting before they eventually started planting corn. They were runners with extraordinary stamina rather than riders, although they later became skilled horsemen. The 6,000-member White Mountain or Sierra Blanca tribe with whom we worked lives in Arizona and New Mexico on 1,600,000 acres and owns the Sunrise ski facility.

The Hopis live on an enclave surrounded by the Navajo reservation. They looked to me to be the most at peace with the earth. Their name, Hipatu-Shinunu, means peaceful people. They have been skillful planters from their very beginnings.

As a young Hopi woman was driving me from the office of the Bureau of Indian Affairs to a potential building site, I suggested that the tribe develop a commercial project on their beautiful land in order to enhance the tribe's income. She was aghast at the idea. She told me gently but in no uncertain terms, "We cannot do anything with this land. This land is my mother."

The Navajo tribe is the largest of all the tribes in the United States. Probably 150,000 Navajos live in vast lands in Arizona and New Mexico. They learned silversmithing from the Spaniards, and they excel at it. However, basketry and pottery have been the mainstays of the tribal artisans. Weaving is another significant feature of their craft. The well-known Navajo rugs of today are the development of weaving practices begun in the mid-nineteenth century. I noticed that more than any other tribe, the Navajos had more Anglo consultants and participants in their life.

To me, the Zunis are the most talented artisans of all. Their jewelry is highly sophisticated, which sets them apart from most other Native

American art. Their houses are more environmentally friendly than any others. Theirs were the first pueblos to be encountered by the conquering Spanish. They fled to a high mesa in New Mexico, built a small village, and have lived there since.

The heart of the Native American project was to allow the Indians for the first time to become the client. We encouraged them to outline their requirements in the context of their own cultural heritage. We did not wish to impose on them a generic residence designed for an abstract client with presumed requirements decided by some bureaucrat in the regional HUD office. Clearly, this direction was new in the annals of HUD, so the project was dubbed "Demonstration Project."

After meeting with the individual tribes during our two-week trek in the Southwest, the Native American Research Institute and the tribal councils under the direction of Dr. Karl organized a week-long conference in Phoenix. The tribes were to have an open forum to voice their sentiments, requirements, and expectations for the project. I was asked to attend and nearly shut down my Scottsdale office for that week. We met in a motel on Van Buren Street in Phoenix, where Dr. and Mrs. Menninger took residence for that period.

↜

I did not know it at the time, but some months later Dr. Karl told me that President Carter had invited him to the White House to present him with the Medal of Freedom for his life of achievement. Dr. Karl had sent his nephew, Roy Menninger, to accept the medal and citation. Dr. Karl had apologized for not attending because of previous commitments he could not break.

The Phoenix conference was one reason he had cited for not attending. I was reminded of an occasion during one of my visits with Dr. Karl in Topeka. One evening after dinner, he asked me to accompany him for a walk around the block. It was late November. It was snowing and the streets were covered with sleet. He wore a wide cape-like overcoat draped over his shoulders and extended it so it covered me also. We started walking with his arm over my shoulder and my arm around the

waist of the eighty-six-year-old gentleman. He began one of his expansive ramblings. Among other things he told me was that he was hurt that with all her high-profile interest in mental health, Roslyn Carter had never once invited him for an opinion, advice, or consultation.

After the conference he sent me a copy of a letter he had written to President and Mrs. Carter, Plains, Georgia, dated August 21, 1981, well after they had left the White House, apologizing for his inability to attend the Medal of Freedom ceremony. He wrote in part:

> It was still winter in the East, as you will recall, and our traveling clothes were all for the West Coast climate. The invitation reached us only after some delay, and we had to make immediate decisions (in a hotel room) about numerous arrangements in Oregon and Arizona. We had given our word and promises to be with some thousands of your citizens in Oregon. On the day before the award was to be given, we were due in Phoenix to meet with the representatives of five tribes of western Indians—the White Mountain Apache, San Carlos Apache, Navajo, Zuni, and Hopi.
>
> They were gathered by appointment to confer with Mrs. Menninger and me and with government officials from Housing and Urban Development; Health, Education and Welfare; the Indian Health Service; and the Bureau of Indian Affairs. It was a climax meeting on a particularly precious project, one for which President Carter should, and I hope will, be long remembered.

Then he went on making the case for the Indian Nations.

The week-long Phoenix conference was enlightening in at least one aspect. One theme dominated the expectations of all five tribes. They all aspired to have everything done in the "Indian Way." As the speeches rambled on, they expanded beyond the parameters of the Demonstration Project into the general life of the Indians within the largely Anglo

society. Some speeches became flowery and sentimental. Clearly, though, there was a measure of anger, which could be traced readily to the last four hundred years of history.

Generally, however, the fact that the conference happened at all further placed the emphasis on the objective of the project, which was to respect the Indian sensibilities as we performed our work. In my report to Dr. Karl, I wrote in part:

> There is a critical emotional issue, which is never clearly verbalized yet is ever present. It is the ambiguity surrounding what we refer to as Indian culture. There is the difficult question of how to accommodate Native American values of religion, society, family, and the mechanics that must allow those values to flourish within the parameters of the white man's environment. Clearly, the white man's perceptions of what constitutes success, happiness, self-worth, have a profound influence on the Indian's evaluation of his own life. The white man's economic power impacts everything it touches, including Indian values. It is only human that the Indians would want to be a part of the white man's world. This begs the question: How do you do that and still remain Indian in the classic sense of the word? These are only questions that I believe will eventually need answers. I am acutely aware of the intensity of the challenge and I feel fortunate to be a part of this effort.

When the various tribes began the process of selecting an architect, the San Carlos Apache tribe retained my architectural engineering services for their project. HUD had approved the construction of four facilities: three for children and one for the elderly who had been living in culturally alien environments in Phoenix. They were to return to the reservation and spend the balance of their lives among their people.

I was working with HUD for the first time. From its reputation, I

had not looked forward to the experience. But it was not worse than I had expected—a blessing of sorts. Dealing with government forms was never one of my strong points. I hired a man who had that experience and left that aspect of the job to him. Besides the cumbersome mechanics needed for simple communication (everyone had to record every thought or conversation in a letter and send copies of it to everyone else, managing to lose continuity in a pile of papers). Once at a meeting with HUD and the tribe, I suggested that, since they all liked to write letters so much, they probably should write to each other and let me do my work. The most depressing aspect was the generic nature of the thought process. It tended to reduce every humanly inspired thought to a formula made more rigid by a long history of use without the benefit of fresh ideas. This process resulted in potential slums in many areas where HUD underwrote the development. This is particularly evident on Indian reservations where maintenance is at a minimum. Even on the Zuni reservation, where the tendency is to build with locally available stone in an environmentally friendly fashion informed by natural instincts, the areas developed by HUD pollute the environment with alien sameness.

I feel slightly guilty as I write this. I received a letter from the housing development division dated October 12, 1984, which said, in part:

> This is presented as a commendation to you and your staff for the excellent job performed on the design and construction of the Demonstration Housing Project at San Carlos Apache Reservation. You and your staff should be very proud of the exceptional project and your firm's performance....

The most culturally significant aspect of Indian life that needed to be considered was the presence of more than one generation living in the same environment. The interaction between the varying age groups at mealtime or during lounging and recreation was always an organic fea-

ture of the life of the Native Americans. While this may be different from urban life in Anglo society, it was not radically different from my experience as a child and young man within the extended family of my aunts, uncles, and grandparents. My office set out to plan the buildings that we eventually completed within the budget within the prescribed timeframe.

Partway through the work with the San Carlos tribe, as we all were subjected to the unyielding parameters of the government, it occurred to me that maybe I could partner with the tribal planning office. Together, we could get out from under the yoke of government regulations into a space agreeable to all of us. There, I thought, we could restore the Native American to his culture. During a meeting at my office with the tribal officers I said, "You people are the original inhabitants of this continent. You have for many years been building your dwellings with natural materials and you have done very well. What happened? Suddenly you cannot build anything and you have been forced into a position where you have to beg the government to provide you with shelter."

They listened and seemed to accept the picture as I had painted it. The head of the planning commission asked, "What are you suggesting?"

The answer to that question came in a letter I wrote later to the tribal council with a copy to Dr. Karl in which I broke down the operation into a few simple components that would need to be considered if we ever went beyond the talking stage. The list included:

MATERIALS

A. There is an abundance of building materials such as stone and adobe on the ground of the reservation there for the taking. All that is needed is to haul them to a building site. No high tech skills are needed to lay stones or to form adobe bricks and let them dry in the sun. A minimum of material would be imported for the roofs.

LABOR

A. There is 50% unemployment on the reservation. Some government agency is paying for that. The unemployed could work a number of hours corresponding to the unemployment pay they receive.

B. Young people incarcerated for minor offenses could possibly pay their debt to society by providing labor.

TECHNICAL ASSISTANCE

A. I offered to give that to the tribe at no cost to them.

Everyone in the Tribal Planning office was enthusiastic about the idea and left my office with the intent to discuss it among them. Clearly, the idea died in the process of discussing it, because I have never heard much about it since.

Dr. Karl's favorite preoccupation was The Villages, the model for the Indian housing project. He had taken me several times to visit some of the houses in Topeka. I had met some of the key administrators. I had become fond of the idea of The Villages and was impressed with the results I had observed. During Dr. Karl's frequent trips to Phoenix, I drove him and Jean to where we would go to dinner or look at art shows or visit friends. He always spoke of his plans for The Villages. One day he asked me to design a headquarters building for that project. I worked for a few weeks, met with the board of trustees, and generally had a rewarding time in a labor of love. One day the board of trustees received a gift of a large corporate office that had belonged to a corporation relocating to another state. I received from Dr. Karl a letter dated November 18, 1981, in which he wrote in part:

You are more than a friend of The Villages. You are one of us. You have helped us get where we are and will go further. And you are a personal friend of the Chairman of the Board and Vice President of The Villages, who send assurances of affection.

REFLECTIONS FROM THE SHINING BROW

Had my father lived, he would have been only one year younger than Dr. Karl. Since both were physicians, I sometimes transferred some of the feelings associated with father-son sentiment to Dr. Karl. This was particularly reasonable because I received from Dr. Karl the kind of consideration and deference I would loved to have received from my father. There developed a sense of personal caring where a familial atmosphere characterized the occasions when Dr. Karl and I were together, either in Topeka or in Scottsdale. He was often motivated to speak with me about his family, particularly his brothers.

He presented me one day with a book titled *Flowering Vines of the World*. In it, he wrote:

> To Kamal Amin, whose numerous "Menninger books" do
> not, I think, include this one by my brother, of whom I am
> very proud and fond. He is almost completely blind, but
> types (with two fingers of one hand—he has only one
> hand) his own letters and manuscripts. He is two years
> younger than I but more vigorous.

That was his brother Edwin. He told me that Edwin had, with a friend, made an explosive mixture in a test tube in their chemistry laboratory at Washburn College in Topeka. The wrong movement caused a massive explosion, in which Edwin lost most of his left hand and his right eye, as glass splattered into it.

His father, Charles Menninger, decided that medicine would no longer be a viable career for Edwin. The young man had a stint at editing local news publications before he moved to Florida to take up horticulture, an old interest of his.

When Dr. Karl spoke of his brother Will, the youngest of the three brothers, his face acquired a sad cast. Will had, during World War II, pursued an army career in neuropsychiatry. By 1944 he had headed the army psychiatric division and been promoted to Brigadier General. But

there were long periods of estrangement between the two brothers, which bordered on animosity. Dr. Karl loved Will deeply, but differences about the management of the foundation sometimes loomed large. Every time he spoke with me about it, he would end the conversation, "I do not know why."

Dr. Karl died in 1990 at age ninety-seven. I had heard Mr. Wright say a number of times: "You cannot do anything about age. But youth is a quality you can keep forever." Both men maintained their youth as they kept their enthusiasm, optimism and wonderment about life.

I received from Dr. Karl a letter dated December 21, 1989, six months before he died, in which he wrote, "A friend of mine sent me this beautiful stationery one day long ago and now it is Christmas and I am going to use a bit of it [he was referring to writing cards of my design]. I am going to use some to write to the dear man that had the idea and the artistry and had the generosity. How are you going to spend Christmas? I hope not alone, but somewhere there are people like yourself, friendly and kind and wise, trying to make the world better. The world has suddenly grown much better than it has been for centuries. Those funny human beings, here and there over the world, have stopped fighting and looked in a friendly way at each other in some area. It begins to be 'peace' on earth and good will to men, on earth as it is in heaven."

The last time I saw Dr. Karl was a few months before his passing. I had gone to visit him for a few days in Topeka as I had done many times. I stayed in a hotel nearby but took all my meals with him and Jean and their delightful daughter Rose Marie. Jean was beyond child-bearing age when, in 1948, the doctor and his wife adopted Rose Marie as she was just born, when her unmarried English mother arrived in New York to have her baby in the United States. Rose Marie grew up to be the joy of their hearts.

Dr. Karl took me to see the old property where he was born, as well as the various projects he was involved in at the time. We drove to the county jail, an avant-garde institution acquiring most of its organiza-

tional features from his ideas. His views on institutional punishment are well articulated in his book *The Crime of Punishment*. He wrote of crime against criminals, vengeance in the application of the law, and innate violence in a manner that causes one to have a multi-dimensional look at the whole issue of crime and its social implications. A few years before he passed, around Christmas time, he had a stroke. I telephoned his home in Topeka to inquire about his condition. Mrs. Menninger answered the telephone and informed me that he was fine.

"He is in the county jail," she said. "The prisoners are giving him a party."

CHAPTER 25

MADAME SADAT

> *I always feel what my husband started will never go in vain. I still believe the day will come when we see peace prevail.*
>
> —*Jehan Sadat*

In 1988, I RECEIVED A LETTER FROM Madame Jehan Sadat. To call that a pleasant surprise is a huge understatement. To my mind, Jehan Sadat—alone or at the side of her great husband Anwar Sadat, the Egyptian president who was assassinated on October 6, 1981—is one of the most graceful, dedicated, and interesting women in public life. She demonstrates all of those qualities in her personal dealings as well. I had for years wanted to meet her.

The letter came about by way of a gentleman, Suhail Bushrouy—a poet and former professor at Oxford University—who was then professor at the University of Maryland, where Madame Sadat was a senior fellow. Suhail, who is a Bahai, was in Phoenix to give a lecture about peace and the brotherhood of man as prescribed in the Bahai faith. After the event, Suhail and I had a long, pleasant conversation about everything. When he returned to Maryland, he must have spoken to Madame Sadat about the fellow Egyptian he had met in Phoenix.

In her letter, she asked me for lunch at the University of Maryland. Within hours I booked a flight to Washington National Airport and joined her for a lunch that included a number of university professors

and deans. I was seated next to Madame Sadat. During our conversation, I learned that she had known my uncle, who was the only civilian in Nasser's revolutionary cabinet. He was a civil engineer selected because of his extensive knowledge about the upper Nile. Later, my uncle became deputy prime minister and was instrumental in the development of the Aswan High Dam. He was a highly respected man of great integrity and personal force. When he was no longer in the government he worked hard at steering Egyptian foreign policy away from the East and to the West.

On April 4, 1972, five years after the six-day war with Israel, my uncle had written to Anwar Sadat:

> Egypt is fighting for her independence on two fronts, Israel's imperialistic ambitions on one side and the predatory designs of the great powers on the other...the time has come when we need to revise our policy of dependence on the Soviet Union. Without losing their friendship, we need to place our interests in a natural and secure place between the two great powers.

She also told me at lunch that she and Anwar Sadat were close friends of my mother's youngest brother, who was at one time a fellow officer of the same rank.

Toward the end of the lunch she asked me if I would like to serve on the committee she had formed and was chairing. Her goal was to raise funds to establish a chair at the University of Maryland to be named the Anwar Sadat Chair for Development and Peace. "Of course," I said.

My work with Madame Sadat has been a remarkably rewarding journey. For a time I was not sure what I should be doing to be of use to that committee, which included Henry Kissinger, presidents Ford and Carter, Gregory Peck, Stewart Mott, Marilyn Horn, and other illustrious personalities. Fundraising was not an activity I had ever engaged in

or even understood. But I was eager to be a part of something that interested her, which happened to coincide with my desire for service.

In 1991, I invited her to Phoenix for a fundraiser. I asked my long-time friend, Mae Sue Talley, to underwrite the dinner for Madame Sadat and her Maryland entourage. She graciously did, and the event was hosted by Mae Sue, Senator Barry Goldwater, and me. That event stimulated the raising of nearly $200,000. Most of the money came from one source: my friends James Cushing, who with others had produced the Tony award-winning Broadway play *Sideman,* and his wife, the late veteran actress Maureen O'Sullivan. James had pledged a generous sum, of which he paid half immediately.

Several weeks later, I received a telephone call from Tom Hiles, head of development at the University of Maryland. He said that James Cushing had read somewhere that President Sadat had been sympathetic to the Germans during World War II. He said that my friend was having second thoughts about the rest of the pledge.

The fact was that Sadat had only represented the general sentiment of the Middle East at the time. The British had ravished the region since the late 1800s. They had caused much harm and anguish both to the countries in the region and to their people. Egypt had been in a constant state of uprising for seventy years. The long-term anger and the resulting sentiment of the general population was simply that the enemy of my enemy is my friend. There was no truth to the notion that Sadat was specifically sympathetic to the Germans in any active way that would influence anyone or anything. I spoke with Maureen and eventually the pledge was fulfilled.

Madame Sadat's attractive personality is legendary. The moment she walks into a room, the room changes as everyone senses her presence. Gracious and accessible, she is surrounded by a crowd everywhere she goes.

In the matter of raising funds, she is the only drawing card that pulls people in. Her convictions about public issues such as women's rights and Middle East peace and her persistent advocacy for those

issues give her a multi-dimensional complexion. During the fund-raising events that I attended with her, she attracted such luminaries as the gracious President Ronald Reagan, charming and solid President Jimmy Carter, and Henry Kissinger, a knowledgeable and highly experienced man who always looked as though he were about to attack you with a joke.

Sometimes Empress Farah Diba of Iran would be present. Empress Farah had studied architecture before she married Shah Mohamed Reza Pahlavi. During the tragic period when the Shah was riddled with cancer, flying around the world looking for a place to die, no country would have him for fear of reprisal from Ayatollah Khumenie. That was a potent and cruel lesson in the limitations of power. Anwar Sadat, a man of true courage, welcomed the shah and his family to Egypt, where he died and was buried. Since then, a grateful empress has been a close friend of Madame Sadat.

In 1997, the Anwar Sadat Chair was established at the University of Maryland and occupied by Shibley Telhami, a bright, insightful young Palestinian resident of Israel, whose family and that of Ezer Weisman, the former Israeli president, were so close that Weisman thought of Shibley as a son. He was at Cornell University before his appointment to the Sadat chair.

A tradition has emerged since the establishment of the chair. Every year the University of Maryland holds a large meeting where a person of consequence delivers what has become known as the Anwar Sadat Lecture. President Ezer Weisman, then-president of Israel, gave the first one. He had become a close friend of Anwar and Jehan Sadat during the Camp David negotiations. President Jimmy Carter, who created the Camp David accords, gave the second. A charming man to be with, he started his lecture by telling a humorous incident:

> I was in Japan giving a talk. They did not pay me two mil-
> lion dollars. [He was referring to the amount of money
> President Reagan had received when he gave a talk in

Japan after he left office.] There was an interpreter to translate. I thought I would start the talk with a joke. When I finished the joke, the interpreter translated it to the audience. Everyone attending roared with laughter as they slapped their laps and practically rolled in the aisles. I did not think the joke was that funny. So I asked the interpreter, "What did you tell the audience?" He said, "I told them the president just said a joke, so laugh."

The third lecture was given by Henry Kissinger, who worked out the mechanics of bringing together the disputing sides in the region. Nelson Mandela lectured at the fourth event. United Nations Secretary General Kofi Annan gave the fifth lecture.

Over the years, I came to know Madame Sadat as a hard-working, loving leader with extraordinary humanity. Among her three daughters and son, she is like a lioness—strong, protective, and wise. They all relish her energy. I was many times in private dinners with just her small family. I was always in awe at the love richly exchanged among them.

My relationship with Madame Sadat, wife of the Egyptian president, brought me in touch again with my roots in Egypt. The journey that had begun at the American Embassy in Cairo had led me through the Taliesin years with Frank Lloyd and Olgivanna Wright and had influenced my own work after leaving the Fellowship. With Madame Sadat, I was coming home again.

EPILOGUE

Tʜᴇ ꜰᴏʀᴇꜱᴛ ꜰɪʀᴇ ɪꜱ ᴀ ɴᴀᴛᴜʀᴀʟ ꜰᴏʀᴄᴇ that has for many thousands of years occurred at critical intervals of the earth's life cycle as a means of renewal. Red stem, wedge leaf, snow, and deer brush, all of the shrub family Ceanothus, depend on fire for their survival. Their seeds need exposure to high temperatures in order to sprout. The reproduction of jack pine, lodge pole pine, and other evergreens is partly dependent on forest fires. High temperatures are needed for the resin to melt so the seed has a chance to emerge and reach the ground. The large needles of the ponderosa pines are designed to encourage fires. A ponderosa pine forest without fire does not have long to live. It is replaced by white and Douglas fir. We would not have forests if not for forest fires. The long-term benefits of this benevolent force, however, are largely ob-scured by the immediate devastation it causes to human life that hap-pens to exist within its orbit.

During the last years of her life, Olgivanna sometimes spoke with me about the futility of attempting to change the nature, and hence the destiny, of the human experience. She had worked with one individual at a time; after all, humanity is but a collection of single individuals. She had observed the result of fifty years of work and she was not gratified.

When I first met her in 1951, Olgivanna was a relatively young woman, fifty-three years of age. She had started her Work nearly twenty years earlier, and she was in full swing with the enthusiastic develop-ment of her project. She thought that if one could design an environ-

ment with the proper controls strategically placed, one could force the direction of behavior on the various individuals who lived in the community. One could cause everyone to confront situations unfamiliar to their experience, giving them the chance to rethink habitual responses that might no longer be useful in new situations. She had determined that conflict was at the heart of her teaching about self-awareness. Since she held all the cards in the deck, she could change the rules of the game at will, without prior notice. This gave her a quasi God-like status, resented by many and embraced by a few.

I had realized immediately that if I could get beyond these appearances, I could find a rich lesson worthy of learning, and I let myself be influenced by her. In the process, I did things I had habitually rejected before I met Olgivanna. This effort itself opened for me vistas in the human psyche I might have missed had habit remained the only criterion by which I lived.

I saw Olgivanna as a brilliant woman with near total command of her faculties. But unlike others around me, I never saw her as infallible, a saint, or a god. The education I received as our paths crossed was immeasurable. Many, of whom I know a few, have derived the same benefit from their association with her but some admit it only grudgingly. The benefit seems to be a function of the quality of the recipient's own insight. As her human fallible characteristics sometimes took over the ideological pursuit, the benefit became contingent on an innate ability to discern what to receive and what to reject.

Olgivanna's personal predilections often overlapped the declared objectives upon which the community was constructed. The seduction of power leads one to excess.

Some members of the Fellowship derived their sense of being from their closeness to Olgivanna. Their souls virtually fed on hers. They were her mouthpieces and the operators who transmitted her directions. Their function gave them a sense of illusive power. Often, when they were capriciously dispossessed by a flick of the finger, they crumbled. The devastating effect of her benevolent force took its toll on the lives of

those who could not develop a self separate from Olgivanna's. They stayed in the fold because the physical environment was the only remaining vestige of their fantasy.

As the relevance of Olgivanna's Work was misunderstood by many, so too was Mr. Wright's work. It freed architecture from the confinement of nineteenth-century classical forms, and it gave permission to architects across the twentieth century to explore every conceivable structural idea. Ironically, as it did that for architecture at large, it trapped those of his own disciples who stayed in the fold in a legacy too large for them to handle. Yet that legacy served as the only justification for their existence. Truth, which had resided at the core of Mr. Wright's life and work, was replaced with empty rhetoric, over-used phrases, imitative forms, and make-believe postures, all to help his students convince themselves and each other of an illusive relevancy.

I observed a telling incident in the fifties. During one of the occasions when Mr. Wright commented on our designs, he said to an apprentice who would, after Mr. Wright's passing, be assigned by Olgivanna to take charge of the design office, "I do not want to look at my own regurgitation."

Regurgitation was the order of the day, another devastating side effect of a benevolent force.

The life of a hero however, resides in the continuum which sustains an ascending motion in human existence. Heroes have gracefully shouldered the burdens of humanity. When people give their lives to causes greater than themselves, the energy generated from this act remains forever stored where it will be accessible. It might not be accessible to the heirs apparent. But it will be to others for many generations whose lives are touched by that heroic quest.

↪

BIBLIOGRAPHY

Bowles, Chester. *Ambassador's Report*, 1954.

Brandon, William. *Indians*. American Heritage Foundation, 1985.

Djilas, Milovan. *The New Class*, 1957.

Gill, Brendan. *Many Masks: A Life of Frank Lloyd Wright*, 1987.

Gracian, Baltazar (Spanish Jesuit monk). *Manual*, 1653.

Gurdjieff, G.I. *Meetings with Remarkable Men*, 1963.

Kennan, George. *Memoirs: 1950–1963*, 1972.

Kennedy, John F. *Profiles in Courage*, 1956.

Malaspina, Dolores, M.D., et al. *Advancing Parental Age and the Risk of Schizophrenia*, 2002.

Menninger, Edwin. *Flowering Vines of the World*, 1970.

Menninger, Karl. *A Guide to Psychiatric Books, in English*, 1972.

———. *Man Against Himself*, 1938–1966

———. *The Crime of Punishment*, 1968.

Moore, James. *The Anatomy of a Myth* (biography of Gurdjieff), 1992.

Ouspensky, P.D. *In Search of the Miraculous*, 1949.

Pfeiffer, Bruce Brooks. *Frank Lloyd Wright: The Crowning Decade (1949—1959)*, 1989.

Sadat, Jehan. *A Woman of Egypt: Jehan Sadat's Story of Her Love for Anwar Sadat and for Her Country*, 1987.

Sandburg, Carl. *Rutabaga Stories*, 1932.

Speeth, Kathleen Riordan. *The Gurdjieff Work*, 1976.

———. *Gurdjieff: Seeker of the Truth*, 1980.

Stalin, Svetlana. *Only One Year,* 1969.

———. *Twenty Letters to a Friend,* 1963.

Webb, James. *The Harmonious Circle,* 1980.

Wilson, Dr. Frank. *The Hand,* 1998.

Wright, Frank Lloyd. *On Architecture,* 1931.

———. *An Autobiography,* 1932.

Wright, Olgivanna. *Frank Lloyd Wright: His Life, His Work, His Words,* 1966.

———. *Our House,* 1951.

———. *The Roots of Life,* 1963.

———. *The Shining Brow,* 1960.

———. *The Struggle Within,* 1955.